THE
CROWN
IN
FOCUS

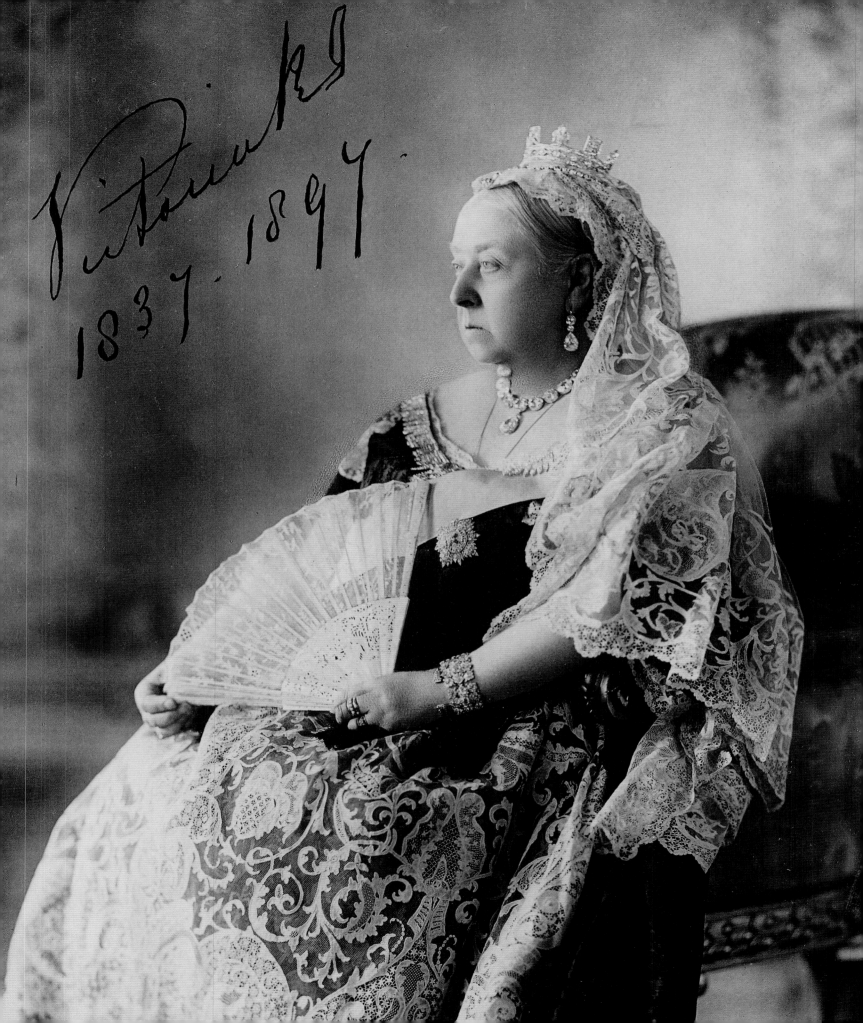

Victoria RI
1837 - 1897.

THE
CROWN
IN
FOCUS
TWO CENTURIES OF
ROYAL PHOTOGRAPHY

Claudia Acott Williams

With contributions from
Isabella Coraça
James Crawford-Smith
Matthew Storey

Foreword by
David Cannadine

MERRELL
LONDON · NEW YORK

In association with
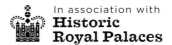
Historic
Royal Palaces

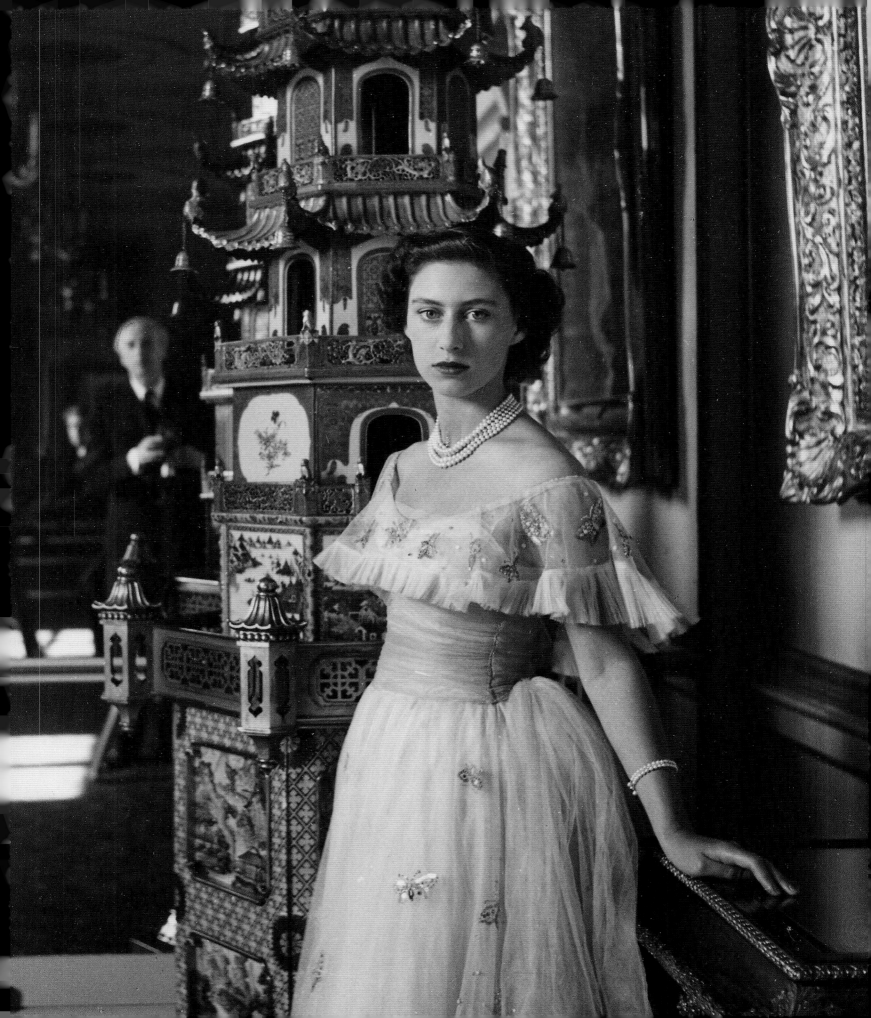

Contents

Foreword
David Cannadine

The history of British monarchy and the history of photography, as this book so vividly demonstrates, are inextricably linked in the case of the British throne, from the reign of Queen Victoria to that of Queen Elizabeth II. Yet in the centuries-long perspective of our royal house, this is a relatively recent development, beginning less than two hundred years ago. Before the invention of the camera and the royal photographer, the images of monarchs purveyed across Europe and in the world beyond were largely projected via coins, statues and portraits: solemn, static, formal likenesses, proclaiming power and prestige, honour and hierarchy, authority and deference, but with little if any sense of intimacy,

domesticity or connection with the peoples over whom they reigned and often also ruled. These depictions might have been early efforts at what would now be termed royal public relations, but all too often the inadvertent result was the creation of a credibility gap – a chasm of distance between sovereigns and subjects that was not easily bridged.

In traditional or pre-modern societies, this may not often have mattered. But in the later eighteenth century the American and French Revolutions both rejected divinely sanctioned royal authority, as well as the hereditary social hierarchies on which such command and control depended and which it also legitimized, instead proclaiming that all men were

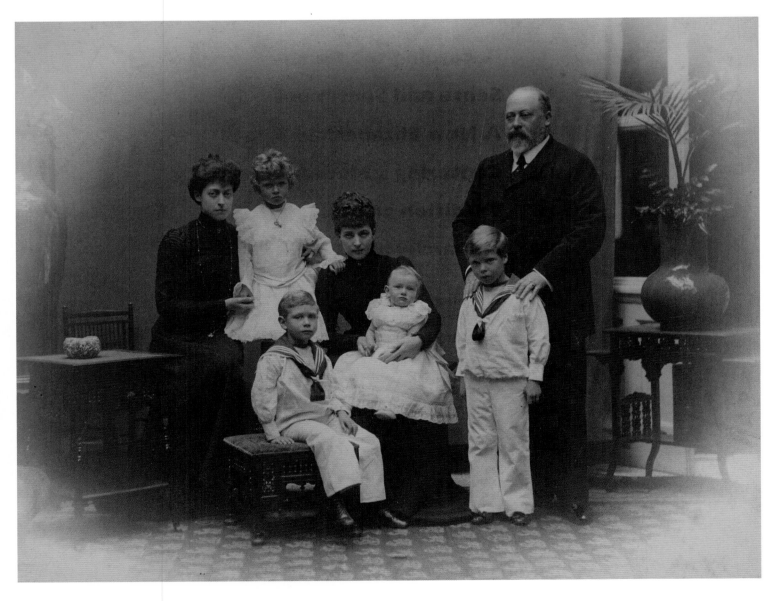

created equal (and, according to Mary Wollstonecraft, all women, too). Once this Pandora's box of revolutionary ardour and royal rejection had been blown open, it would be very difficult if not impossible to put the lid back on. So, while in 1815 the old royal regimes were restored across much of Europe with such success that they would last for a further hundred years until the outbreak of the First World War, things were never quite the same in the Continental courts and palaces. If monarchy was to survive in a new world of revolutionary ideologies, industrialization, urbanization, a broadening franchise and the advent of mass society, then sovereigns had to work much harder at connecting with their subjects in order to keep their thrones – and their heads.

There were many ways in which monarchs could do this, from the increasingly lavish public spectacles of royal coronations, weddings and funerals, via the patronage of charities, learned societies and cultural institutions, to royal tours and visits to different parts of their realms. But the advent of photography, as a new art form and as a new technology, also provided unprecedented opportunities for monarchies to connect with their peoples, by providing new sorts of images – often intimate, personal and familial – that could be distributed to a wide public audience. And since Britain's Prince Albert was interested in fine art, the applied arts, technology and industry, it is scarcely surprising that he was among the first of European royalty to understand the potential and possibilities of photography. To be sure, such images would not save the Russian royal house in 1917, nor the German and Austro-Hungarian monarchies in the following year; but other dynasties came to much more successful terms with the camera, and none more so than the British royal house, with different levels and sorts of engagement from Victoria and Albert, Edward VII and Queen Alexandra, Edward VIII, George VI and Queen Elizabeth, to Elizabeth II and Prince Philip.

During the twentieth century, and following the precedents established by Queen Victoria and the Prince Consort, the British monarchy became more closely involved with photography, and as a result more directly connected to the lives of ordinary people. At the same time, the marriage partners selected by the House of Windsor (as it had become in 1917) were ceasing to be drawn from European royalty, and came instead from the British aristocracy (or, in the case of Wallis Simpson, from American socialites) or, more recently, from the middle classes. One such figure was Antony Armstrong-Jones, who married Princess Margaret, the Queen's sister, in 1960. He was largely a self-made man, albeit with aristocratic connections. More significantly, he was a high-society photographer. In 2018, the Royal Family released an official wedding photograph of the Duke and Duchess of Sussex and close family, taken against the time-honoured backdrop of the Green Drawing Room at Windsor. The bride is the first biracial member of the Royal Family and an American citizen. Two hundred years earlier, such a royal marriage would have been inconceivable, as would such royal photographs. This important book helps to explain how the British monarchy got from there to here.

King Edward VII and Queen Alexandra (centre) with their daughter Princess Victoria and their grandchildren (from left to right) Princess Mary, Prince Albert (later King George VI), Prince Henry and Prince Edward (later King Edward VIII), 1901

Frederick William Ralph (1872–1944)

Introduction

I have to be seen to be believed.

QUEEN ELIZABETH II

Photographers and cameramen at London's Victoria Memorial in front of Buckingham Palace, waiting to photograph Princess Elizabeth (later Queen Elizabeth II) and the Duke of Edinburgh on their wedding day, 29 November 1947

Bert Hardy (1913–1995)

Throughout history, the dissemination of images of the sovereign has been a vital tool in the maintenance of royal influence, balancing an awe-inspiring representation of monarchical power and authority with a tantalizing glimpse of the person behind the crown. Artistic commissions for portraits of kings, queens and their heirs have served to reinforce notions of continuity and tradition, and promoted respect and even veneration for the sovereign. Such images were widely disseminated through a variety of means long before the development of the mass media, on coinage, medals, prints and engravings, jewellery, documents and in painted portraits, to ensure that the identity of sovereigns formed a part of the national psyche and that the public could recognize them. Today, in a context in which the monarchy has no political power, The Queen's statement (above left) that she must be seen in order that the people believe in her, and by extension in the monarchy, is perhaps truer than ever.

For most of world history, the figure of sovereign has been central to political and world affairs. In the twenty-first century, however, hereditary monarchy is the exception rather than the rule. Just twenty-seven crowned sovereigns head up forty-three nations, of which fifteen are reigned over by Queen Elizabeth II. But despite the steady march of republicanism around the world, The Queen remains secure in the affection of her people.

Even after the Restoration of the monarchy in 1660 following the period of Oliver Cromwell's Commonwealth, and, later, the inauguration of a constitutional monarchy in Britain, considerable political power remained vested in the sovereign until the reign of Queen Victoria. In 1837, this new queen had the power to declare war, command an army, pardon criminals and refuse the appointment of a new prime minister. Today, Queen Elizabeth II has limited constitutional powers. Yet the loss of royal political power, or *hard* power, has not necessarily diminished the monarchy's standing. Its potency now lies in the monarchy's political neutrality, its stability and, above all, its continuity. In the twenty-first century, it is in its *soft* power that monarchy finds its strength; in its symbolic and ceremonial functions with their unique ability to unify, to uplift and to influence.

Modern monarchy in Britain has accepted its loss of power to rule and

has embraced instead its mandate to *reign*: quite simply, to *be* monarch. The Crown has become symbolic of what it is to be part of the British or Commonwealth family and is rooted in tradition and nostalgia. The sovereign is a national figurehead and, as such, much of the Crown's power is vested in its *image*.

Queen Victoria came to the throne on 20 June 1837. The new technology of photography was 'announced' to the British public a little under two years later with a rather mysterious account of an invention by the Frenchman Louis Daguerre in a column of *The Athenaeum* magazine. His daguerreotype, as he called it, would change the nature of visual representation. While Victoria's reign heralded the type of modern constitutional monarchy we recognize today, photography would develop into one of its most potent tools of survival and popularity in a rapidly changing world.

As the role of monarch evolved into that of national figurehead, developments in photography allowed the sovereign to keep pace with changing national sentiment and to foster an image of a 'moral monarchy' defined by an almost bourgeois respectability. Central to this image was promotion of the technology in and of itself. Nineteenth-century Britain was characterized by a progressive, entrepreneurial zeal. The monarchy's

renewed patronage of arts, science and manufacture under Victoria and Albert, best exemplified by the Great Exhibition of 1851, appealed to the industrial classes, aligning the monarchy with forces of progress. The Crown's portrayal in what was, by the end of the nineteenth century, an increasingly egalitarian means of representation, further helped to democratize the image of monarchy in Britain, enabling it to withstand a growing tide of European republicanism.

The fortuitous timing of photography's invention and development allowed the monarchy to respond to its changing circumstances and to provide not just a tantalizing glimpse but also a seemingly unmediated study of the humanity of the Royal Family. The tremendous success of the first publicly sanctioned royal photographs released in carte-de-visite form (from the French for 'visiting card') in John Jabez Edwin Mayall's *Royal Album* of 1860 (see pages 48–49) was as much happy accident as it was design.

Did Victoria and Albert sense the seismic shift that this new form of engagement would beget? Prince Albert's enthusiastic collecting of early examples of the fledgling technology, his fanatical documentation of his own family and his decision to allow a photograph of himself to be included in the Manchester Art Treasures exhibition in May 1857 certainly seem to suggest that he recognized photography's potential as a vehicle for his own liberal and progressive vision of constitutional monarchy. His untimely death on 14 December 1861 at the age of just forty-two left his widow with the task of harnessing this potential. Crippled by grief, Victoria cast herself off from public life for almost a decade, during which time she first used photography as an active *tool* of monarchy. A regular flow of startlingly candid depictions of the widow and her family in mourning were released to the public (see pages 80–81), allowing the nation to share in a collective grief, and were for a time effective as a substitute for the physical presence of the monarch. Photographs of the Queen with her growing family – members of which were marrying into many of the ruling houses of Europe – also allowed

Prince Albert, 5 March 1842 (see page 24)

William Constable (1783–1861)

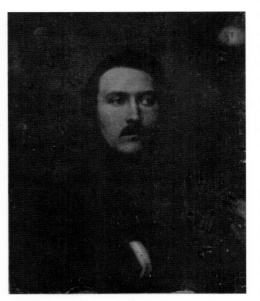

her to demonstrate the fulfilment of her duty to ensure the succession and build international ties (see page 54).

Amid the numbing ubiquity of photographic images today, it is easy to underestimate the profound impact of seeing such a realistic representation of the sovereign. For the first time in history, the public were able to see the Queen as she was. The use of photography enabled the monarchy to open an unprecedented window on to royal life and character, humanizing the monarch and creating a profound sense of intimacy between Crown and subjects hitherto impossible through the reproduction in print of painted portraits. During Queen Victoria's reign photography created a shared public experience of grief for the Prince Consort and, later, triumphant relief at the Prince of Wales's recovery from what was thought at the time to be the same disease that had killed his father a decade previously. Even within the staged confines of late nineteenth-century studio photographs the younger generations of royals continued to project the image of a loving family. A photograph of Alexandra, Princess of Wales giving one of her children a piggyback ride was a best-seller at the time (see pages 52–53), while images of Queen Victoria with her grandchildren and great-grandchildren not only confirmed the successful continuation of the dynasty, but also provided rare images of the Queen smiling (see page 184). The intermittent release of such photographs served to create a sense of empathy. They quickly became some of the most widely sold in the world.

The technology itself also served to foster a sense of connection and kinship between Crown and subjects. Painted portraiture has always been an elite form of representation, reinforcing a sense of hierarchical division between 'us' and 'them'. While early photography was an expensive and time-consuming process limited to the wealthiest of society, the decline of patents and the proliferation of commercial photographic studios after 1852, followed by the release of the first easy-to-use hand-held Kodak camera in 1888, meant that cameras became more

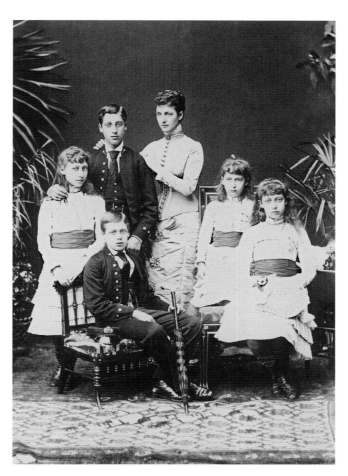

Alexandra, Princess of Wales (centre) with her children. Left to right: Princess Louise, Prince George (seated), Prince Albert Victor, Princess Maud and Princess Victoria, c. 1877

W. & D. Downey (active 1855–1941)

widely available to the public. With the $1 Kodak Brownie, which followed in 1900, they became easily affordable, enabling the public and the Royal Family to document their lives in the same way.

While these technological advances allowed photography in the home, or the palace, to become more intimate and spontaneous, professional photographic portraits became grander, with photographic studios specializing in formal, staged portraits. If Victoria and Albert's first public photographs, initially taken in domestic settings for private enjoyment, seemed to show personal moments of an 'ordinary' couple, Victoria's assumption of the title of Empress of India in 1876 saw the widowed Queen present an undeniably regal aspect to the public. She deliberately positioned herself within the genre of commercial studio portraiture, aware of a need to popularize her image through familiarity and ensuring that one sitting differed little from the next. Photographic portraits were now issued

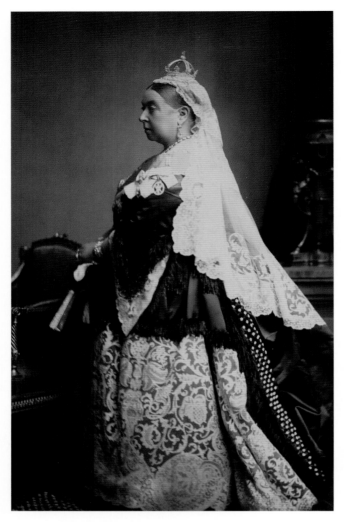

modern technology. He showed immense interest in the development of electric lighting and its use in commercial photographic studios, while his wife, Alexandra, Princess of Wales became a keen amateur photographer. The Prince and Princess made extensive use of formal studio portraiture to marry the domestic image of a family monarchy with more traditional royal portraiture. Alexandra was frequently pictured lofty and elegant, surrounded by her children (see page 11); Edward in shooting attire, uniform or homburg hat and suit, gaining increasing gravitas with age. In contrast to Queen Victoria's preference for modest simplicity, the reign of Edward VII witnessed a rejuvenation of royal ceremony and spectacle, now made accessible to a wide audience thanks to photography. Queen Alexandra's well-known love of photography led to a number of public exhibitions and publications of her work in the early years of the twentieth century, providing a hitherto unseen account of royal life 'behind the scenes'.

The reign of King George V witnessed significant political reform in Britain, the horrifying events of the First World War and the toppling of nine European monarchies. Yet over the course of the next twenty-six years, the British monarchy would not only survive, but also thrive. Central to the Crown's success was a careful rebranding of monarchy as the embodiment of bourgeois values: a 'family monarchy' led by the 'People's King'.

George V and Queen Mary achieved this through the promotion of two seemingly contradictory images: the first a magnificent display of royal ceremony; the second a demonstration of unwavering hard work. Combined, they projected the supremacy of duty and a reassuring stability in the face of considerable social change. These images were also designed to exploit a new mass media that allowed them – and subsequently demanded of them – to be seen enacting their royal duties. By the end of the First World War, advances in printing quality thanks to photogravure and rotary presses had firmly established photography as an

to mark important occasions: for example, Alexander Bassano's portrait of the Queen in her small crown and wedding lace taken at the wedding of her son, the Duke of Albany, in 1882 and released publicly to mark her Golden Jubilee in 1887 (above); and W. & D. Downey's almost identical portrait of 1893, taken at the wedding of her grandson, the Duke of York, released four years later to mark the Diamond Jubilee (see page 64). Issued just four years before Queen Victoria died, it would become the defining image of the (then) longest reigning monarch. The Queen's strategic removal of copyright ensured that the photograph was widely reproduced, travelling across the Empire and into people's homes on postcards, commemorative souvenirs and everyday household items.

Like his parents, Albert Edward, Prince of Wales was aware of the benefits of

important means for the communication of news. To help navigate and capitalize on a growing media frenzy for royal photographs, George V employed the royal household's first press secretary, Clive Wigram, who was responsible for cultivating a good working relationship with the media. He also established the royal rota, a system for the management and dissemination of royal press coverage that continues today.

George V's 'rebranding' became explicit in 1917 with a change of the Royal Family's name from Saxe-Coburg-Gotha to Windsor. In doing this, George cast off centuries of German dynastic heritage and family to assert the monarchy as decisively and decidedly British. The resurgence of ceremony and the associated photographic representations not only served to reinforce the long tradition of *British* monarchy, it also supported another important shift in its role, from a 'welfare' monarchy to a 'service' monarchy. As the expansion of state welfare usurped the Crown's traditional role in the philanthropic support of health, education and social services, monarchy focused attention instead on rewarding an ever-wider circle of individuals for their contribution to society and modelled itself as the exemplar for public service.

Edward VIII became King on 20 January 1936. His brief reign saw little opportunity for formal photographic commissions but the flowering of modern photojournalism during the interwar years, which had catapulted the charismatic Prince of Wales to international celebrity, continued after his accession. An insatiable public were provided with a steady supply of novel and candid photographs of the King, which secured his continued popularity in Britain. Relaxed, informal photographs were also released of the young family of his brother Prince Albert (the future King George VI) (see page 100), coupled with those of the marriages of his younger brothers, the Duke of Kent in 1934 and the Duke of Gloucester in 1935. All contributed to maintaining a successful balance between the continuation of

King George V and Queen Mary visiting the North East Shipbuilding and Engineering Works, 14 June 1917

Photographer unknown

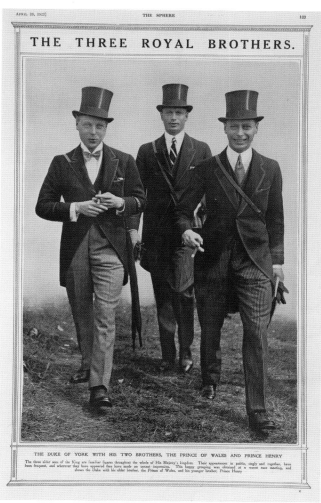

'The Three Royal Brothers': (left to right) Edward, Prince of Wales (later King Edward VIII), Prince Henry, Duke of Gloucester and Prince Albert (later King George VI), photographed in *The Sphere* newspaper on Derby Day, 1 June 1921

Photographer unknown

their father's 'family monarchy' alongside Edward's bachelor charisma.

Edward had, however, fallen in love with American socialite Mrs Wallis Simpson. As head of the Church of England, he was prevented from marrying a divorcee. His suggestion of a morganatic marriage – one in which Mrs Simpson and any children they might have together would receive neither his hereditary titles nor his property – was rejected by Parliament, and he was left with no choice other than either to accept that they could never marry or to renounce the throne. Less than a year after his accession, on 10 December 1936, he became the first British monarch to voluntarily abdicate.

Within days of the abdication, years' worth of photographs of the couple, hitherto carefully guarded by the press, were suddenly released in a sensational and detailed illustrated account of the affair. It is testament to the continuing political importance of a stable monarchy and a deeply entrenched respect for the private lives of the Royal Family that word and pictures of Edward's affair with the twice-married Mrs Simpson were kept out of the British news until just days before the abdication, despite stories abounding in the international press.

In the aftermath of the abdication crisis King George VI and Queen Elizabeth sought to re-establish the same image of selfless duty and ceremonial tradition established by George V. A resumption of studio and art photography, with an emphasis on traditional depictions of royal splendour, helped to restore a sense of stability in the wake of scandal. Foremost among the new sovereign's photographic representation, however, is the careful projection of a wholesome image of a close-knit family, 'us four' as the King famously dubbed them.

Prior to the accession of King George VI and Queen Elizabeth, children's photographer Marcus Adams and family photographers Studio Lisa played an important role in presenting a down-to-earth and spontaneous picture of a young family, which felt refreshingly new. Their reign predated the all-pervasive ubiquity of photography that current members of the Royal Family must contend with today, allowing them the now-enviable luxury of establishing a well-defined photographic identity for the family that was founded on the visual stylings of three key photographers: Dorothy Wilding, Lisa Sheridan for Studio Lisa and Cecil Beaton. The sophisticated minimalism of Dorothy Wilding's work, with its reassuringly familiar roots in studio portraiture, allowed the Royal Family to be up to date while retaining a sense of tradition, making her the photographer of choice for important ceremonial occasions (see page 75).

Throughout the Second World War, it was felt imperative that the monarchy should disseminate an image of the King as a figure of steady and reliable focus for the nation, surrounded by a united and seemingly unshakeable family. The young Princesses were sent to the relative safety of Windsor Castle but the King and Queen's decision to remain living primarily in London throughout the war was widely promoted as a show of solidarity that was, rather helpfully, reinforced by the bombing of Buckingham Palace during the Blitz (see page 197). Lisa Sheridan's 'off-duty' photographs of the family in comforting, earnest domesticity are perhaps the first, since those very early and initially private

King George VI and Queen Elizabeth with their daughters, Princess Elizabeth (later Queen Elizabeth II, left) and Princess Margaret, in the grounds of the Royal Lodge, Windsor, July 1946

Lisa Sheridan (1894–1966) for Studio Lisa

family photographs released by Queen Victoria, to consciously suggest to the public that 'we are just like you', and were published with the intention to bolster the nation's mood and retain a sense of normality against the backdrop of conflict (see, for example, page 108).

In contrast, Cecil Beaton ensured that a sense of the tradition, continuity and majesty of monarchy was not forgotten among the dreary hardship of war. By the 1950s photography was unquestionably the primary means of royal representation and Beaton expertly and effectively stepped into the role of court painter, offering the public a fairy-tale image of monarchy to be enjoyed but one rooted in Victorian artistic traditions of royal representation (see, for example, pages 106 and 111)

The combination of images produced by these three highly distinctive and different photographers appears to have produced the perfect blend of intimacy, splendour and ceremony, and married modern political demands and photographic trends with historicism. The work of each photographer subtly and effectively counterbalanced and complemented that of the others, allowing the Royal Family to navigate the choppy waters of the post-abdication years and the war unscathed and indeed, thriving.

Queen Elizabeth II ascended the throne on 6 February 1952. On his death, her father had left a diminished but distinctly popular monarchy. His daughter made plain her desire to keep it that way and to continue to promote the image of family, duty and dignity established by her parents.

The Queen's patronage of the principal photographers used by her parents ensured this continuity in the early years of her reign. The minimalist elegance of Dorothy Wilding, chosen to record the engagement of Princess Elizabeth to Prince Philip of Greece and Denmark in 1947 (see page 115), was once again employed to present the new Queen to the world in the official accession shoot. Copies of the photographs were distributed among embassies around the world, were used as the basis for images on bank notes and appeared on millions of postage stamps

between 1953 and 1971, quickly establishing an iconic image of the new sovereign (see pages 120–21).

After the birth of her first child, Prince Charles, in 1948, Princess Elizabeth frequently commissioned Beaton to provide official portraits of her growing family, but perhaps the most glittering testimony to the strength of his approach came in the commission for the coronation (right and pages 124–28).

While the scandal of abdication had necessitated a conservative approach to the official coronation portraits of King George VI and Queen Elizabeth, the prevailing popularity of monarchy in the 1950s allowed the new Queen to be more creative. Although the ceremony itself was steeped in tradition, the growing prevalence of television was freeing photography from its primarily documentary role, allowing it to become more artistic and expressive. The images produced by Beaton on 2 June 1953 have become perhaps the dominant visual representation of monarchy in the twentieth century.

While a traditional portrayal of monarchy provided reassurance to the public in the immediate aftermath of war and a continuing climate of austerity, Princess Margaret's ill-fated romance with the married Group Captain Peter Townsend, the terminal decline of Empire and with it Britain's place on the world stage, followed soon after by the onrush of the Swinging Sixties, all prompted renewed debate about the relevance of the monarchy and precipitated a rethinking of the royal image. As a result, the 1960s and 1970s saw the Royal Family using photographic and film technology to present a new face of monarchy that aligned it with popular family values, emphasizing The Queen's

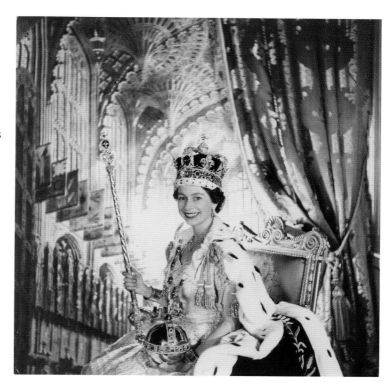

Queen Elizabeth II on her Coronation Day, 2 June 1953

Cecil Beaton (1904–1980)

The official Silver Wedding group photograph of Queen Elizabeth II (seated, centre) and Prince Philip, Duke of Edinburgh (standing, centre), 26 December 1971

Lord Lichfield (1939–2005)

'other' role as a wife and mother, and that carefully fostered her image as head of a Commonwealth 'family' of nations, freely and willingly entered into.

The work of photographers Antony Armstrong-Jones and Patrick Lichfield (Lord Lichfield, The Queen's cousin), as well as the continued patronage of Studio Lisa, created a sense of relaxed informality thanks to the close family ties of photographer and subjects. Lichfield was present at many family occasions and his work brought a uniquely personal perspective and sense of fun and spontaneity to the royal image (see above and, for example, pages 150–51), in contrast with the standard ceremonial and regal photographic portraits being widely distributed throughout the Commonwealth. The marriage of fashion photographer Armstrong-Jones (later Lord Snowdon) to Princess Margaret in 1960 introduced a more fashion-world approach to royal portraits. Snowdon's unique relationship allowed him to create more intimate and affectionate images of his royal sitters.

The year 1981 saw the hotly anticipated announcement from Buckingham Palace that the Prince of Wales was engaged to be married. The relaxed elegance of Snowdon and Lichfield's work was employed to introduce Prince Charles's nineteen-year-old fiancée to the nation. Lady Diana Spencer appeared in the February issue of British *Vogue* as part of a 'Portrait Portfolio' of young aristocratic women photographed by Lord Snowdon. The magazine's publication coincided with the announcement of her engagement and Snowdon's photograph was widely reproduced in the press. Lichfield was given the task of photographing the wedding at St Paul's Cathedral some five months later, on 29 July. The ceremony was broadcast to an estimated global television audience of 750 million people but Lichfield's intimate photographs caught candid moments that portrayed the spectacle from the perspective of those at its centre. Photographs of Diana comforting one of the bridesmaids helped to establish the empathy that would soon characterize her public image (see pages 154–55).

During the 1980s, photographs of The Queen were predominantly documentary and formulaic: ceremonial group portraits as each of her children married and had families of their own. The younger generation assumed the role of promoting an image of 'family monarchy'. Charles and Diana's young family became the focus of intense media attention, and despite eventual widespread speculation about the state of their marriage they successfully portrayed an image of themselves as relaxed, affectionate parents (see page 159).

However, their marriage coincided with a period of notoriously intrusive and as yet unregulated tabloid interest in the private lives of public figures, whose images were a staple of print media and were obtained by ruthless paparazzi photographers. The relationship between the media and Princess Diana was at times distressing and invasive, and ultimately may have contributed to her untimely death. Yet amid the frenzy, Diana became the first member of the Royal Family to

effectively harness this unprecedented level of interest in royal activities in order to shine a light on important and often little understood causes. The Princess's demonstration of candour and warmth during her public engagements earned her the reputation as the 'People's Princess', and she quickly mastered the use of gesture and dress to convey powerful messages to the public through the static medium of photography.

Following the separation of the Prince and Princess of Wales in 1992, Diana's photographic commissions emphasized her retreat from royal life and helped to rebrand her as an independent public figure and humanitarian. She did this through patronizing such international photographers as Patrick Demarchelier and Mario Testino, who helped her to distinguish her new position, and harnessed continued fascination with her image to attract global attention and funding for causes including the danger of landmines (see page 207) and research into HIV/Aids (see page 205) and cancer.

Diana, Princess of Wales died in a high-speed car crash in Paris on 31 August 1997. A shoot by Testino published in *Vanity Fair* magazine a few months prior to her death produced the last official photographs to be taken of Diana. They showed a modern woman with none of the trappings of royalty, exuding sophistication and confidence (see page 163). Amid intense public shock, The Queen's failure to make an immediate public statement provoked anger but the misjudgment was quickly corrected by a live broadcast and the publication of press photographs showing The Queen and Prince Philip surveying mountains of floral tributes outside Buckingham Palace (right).

In the twenty-first century, The Queen has celebrated her Golden and Diamond Jubilees, and has emerged from the difficult final decade of the twentieth century to enjoy immense public popularity. As was the case with Queen Victoria before her, such milestones of longevity have afforded a certain comfortable dignity to her public image. To mark her Golden Jubilee in 2002, ten photographers from across the Commonwealth were commissioned to photograph The Queen (see pages 164–65), and each presented their own interpretation of this iconic face of monarchy.

Much of the success of the royal image today can be attributed to the younger generation of royals. Princes William and Harry have thus far left the traditional displays of royal ceremony largely to their grandmother, and have focused instead on creating a more modern, approachable image of monarchy that has centred on their role as public servants – and now, for the Duke of Sussex, on his new role as a philanthropist and patron.

In the age of digital photography, mass media and camera phones, constant photographic surveillance has meant that much of the Royal Family's control over the shaping of its image comes from the creation and choreography of photo 'moments' rather than the composition of the image itself. Where they are photographed, with whom, what they are wearing, their gesture, their expression and their warmth of public engagement have all usurped pose, angle and lighting in the creation of the image of monarchy. Royal engagements are now organized with photo opportunities for the press and the public in mind so as to ensure maximum exposure for both the royals' work and the causes they are promoting (see pages 19 and 214). The Queen's famous and opinion-dividing use of colour-blocking in her wardrobe is

Queen Elizabeth II and Prince Philip, Duke of Edinburgh looking at the flowers and tributes left outside Buckingham Palace in memory of Diana, Princess of Wales, 5 September 1997

John Stillwell

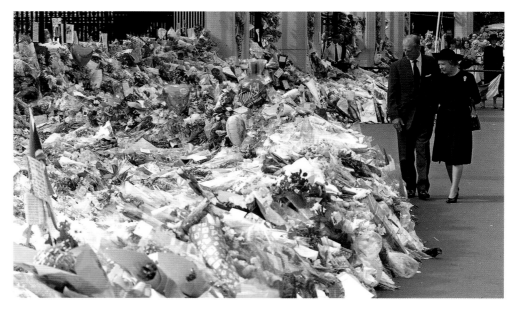

a direct response to the omnipresence of the camera lens and the need to be easily seen in a crowd. No longer able to control the image itself, the royals place greater emphasis on shaping the circumstances in which it is taken.

The support of the media has become a necessity to the continued success of the monarchy. While present in royal image-making for decades, press photographers have become vital in creating official images of the younger generation too. Conversely, a reining in of aggressive paparazzi intrusion since the Leveson Inquiry into the practices and ethics of the British press (2011–12) and the advent of social media have afforded the Princes and their families more control over their 'off-duty' image, which has seen the rise of new and personal methods of sharing aspects of their day-to-day lives. The royal household has embraced social media platforms such as Instagram, which allows a direct channel for the publication of

Prince George of Cambridge, sixth birthday portrait, July 2019

Catherine, Duchess of Cambridge (b. 1982)

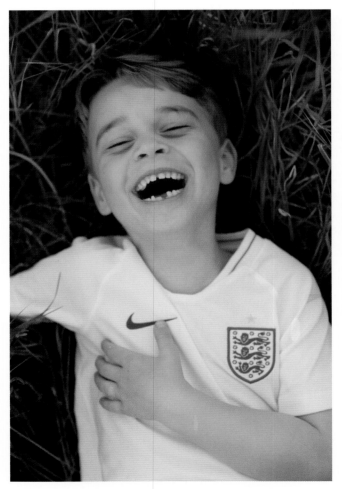

their images, unmediated by the press. In 2016, the first Head of Digital Engagement was employed to manage the monarchy's social media accounts, which continue to expand. The Duke and Duchess of Sussex in particular have made unprecedented use of the platform as the first outlet for release of their photographs before they are made accessible for other media channels. In 2020, they made the decision to step away from royal duties and became the first members of the Royal Family to remove themselves from the royal rota, the century-old system for the management of royal media coverage, entirely. The Duchess of Cambridge, herself a keen photographer, has followed in the footsteps of Queen Alexandra by releasing her own photographs to share

intimate family moments with the public (see below left, and page 173).

In recent years, The Queen's use of photography has evolved to include hugely varied and at times surprising photographic commissions that not only document her life and reign but also are an important reflection of changing times and values. Having firmly established her position and image as the epitome of continuity and stability, in her later years The Queen has had greater freedom to experiment, presenting herself in new and sometimes provocative ways. Photographers as diverse as Rankin, Chris Levine and Annie Leibovitz have responded to the challenge of photographing one of the most recognizable faces in the world, negotiating the delicate balance between representing the exalted monarch and revealing the individual behind the icon (see pages 165, 169 and 170). Many have remarked that they were given surprising freedom in their approach to the sitting, and the royal hand is thus perhaps in evidence in the photographers carefully selected for such exalted commissions.

What emerges from the relationship between monarchy and photography from its beginning to the present day is a pattern of representation that, as in traditional royal portraiture, sees conventions established and repeated across three centuries and six reigns. Yet with each successive generation, social and technological advances move the royal image on. What remains consistent is that each generation has understood the power of photography and has embraced its developments wholeheartedly. Not only has the Royal Family been keen private practitioners, but also it has been enthusiastic patrons. Victoria and Albert's patronage helped to ensure widespread support for and investment in the fledgling technology; Princess Alexandra's support of the Kodak company helped to promote their cameras to a wide audience; and Queen Elizabeth II and Princess Margaret's patronage of the Royal Photographic Society, subsequently handed to the Duchess of Cambridge, is a

potent message attaching royal support to the continuing development of the technology.

Almost two hundred years after its invention, photography remains the dominant medium of visual representation and, in many respects, the construction and contents of the royal image has changed very little in this time, as successive generations look to precedence in the portrayal of continuity and stability. Rather it is in the development of the technology and the means and speed of dissemination that they have concurrently fostered a sense of modernity and flexibility in the face of vast social change.

In the nineteenth century, the publication of cartes-de-visite brought the royal photographic image to the public for the first time; in the late nineteenth and early twentieth century, the development of press photography on the printed page made the royals' image widespread and showed a more candid, uncensored side of monarchy; in the twenty-first century, social media and the digital sphere has made the royal image instantaneous and ubiquitous. Its success, however, remains founded upon its carefully designed ability to straddle the lines between informality and formality, intimacy and splendour, and relatability and mystique.

Much of the British monarchy's success today lies in its projection of its charitable purpose, family values, the integrity of individuals and the Crown's political neutrality. The Queen has managed to retain almost unfalteringly consistent popularity by saying very little but ensuring that she is seen. As a national figurehead she is expected and required to represent the vast and wonderful diversity of her subjects. In doing this, photography has been perhaps the most valuable tool at her disposal, arguably more so even than television or radio, for an image is worth a thousand words and by saying nothing, she can therefore stand for anything.

Incrementally, monarchy has opened itself to the public and lifted the lid on the mystique that has surrounded and sustained it for centuries. By appearing to let the people in, to share in the

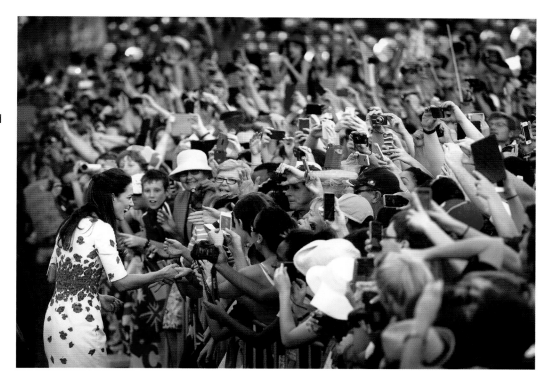

splendour, it has bestowed upon the public a sense of pride, participation and ownership and a comfort in the notion that it exists by our sanction. So long as we can partake in the pomp and the pageantry through the sharing of images, we are content for it to continue. As intermittent events reveal, monarchy is at its most vulnerable when it attempts to shut a loving and voyeuristic public out.

Photography's unique ability to connect Crown and country and to offer a more intimate view of this previously distant institution has undoubtedly ensured the continuing popularity of the British monarchy. But it has also presented difficult challenges and required an ongoing negotiation between what can and should be made public and what can and should remain private. It is a challenge that the current generation of royals continue to grapple with in the atmosphere of 360-degree surveillance that defines the social media age, and one which is inevitably destined to persist as long as monarchy continues to thrive in Britain.

Catherine, Duchess of Cambridge in Brisbane, Australia, 19 April 2014

Chris Jackson (b. 1980)

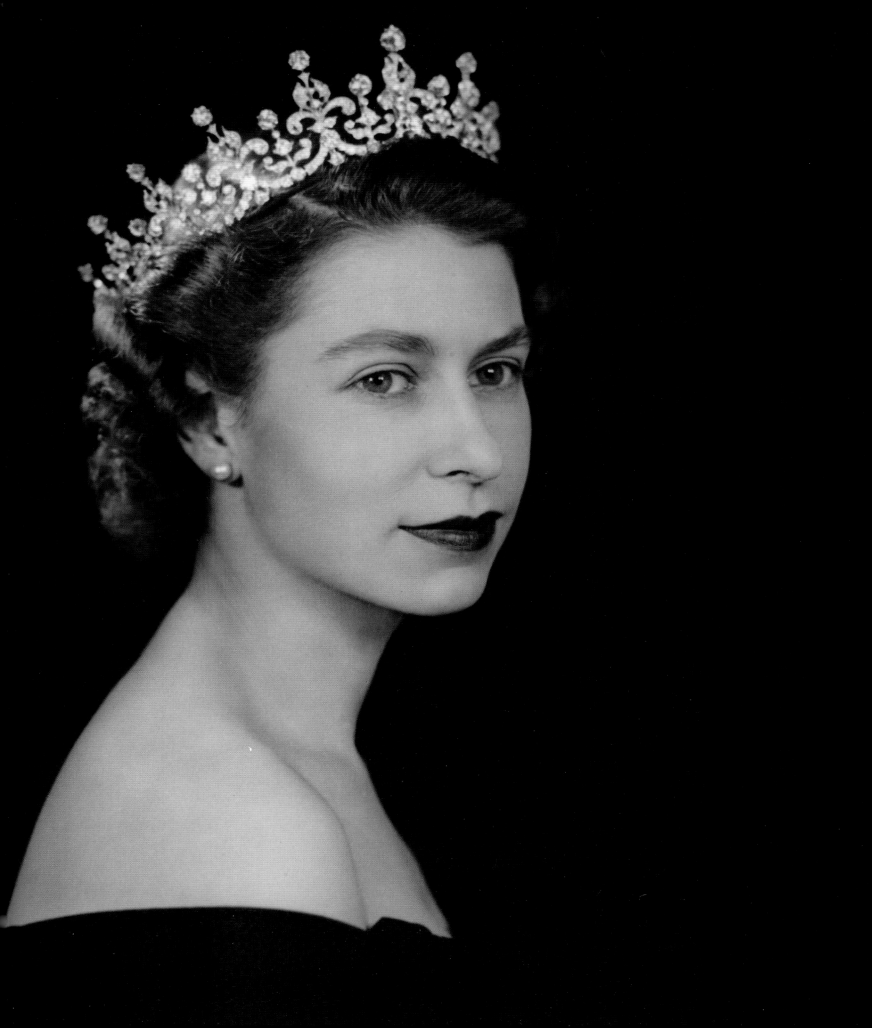

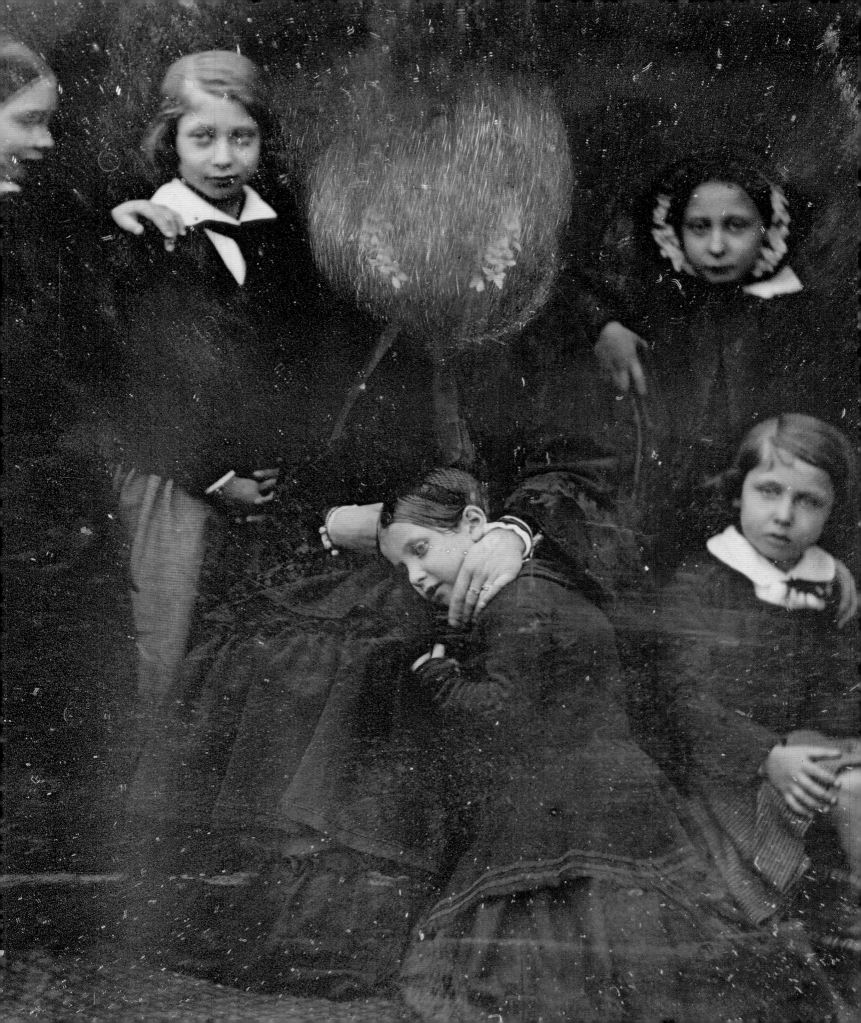

The Dawn of Photography

[A] little photograph from our family group…it has such truth about it & represents us as we are.

QUEEN VICTORIA TO KING LEOPOLD I OF BELGIUM, MAY 1854

On Saturday 5 March 1842, a young man walked into the photographic studio of William Constable in Brighton. As he sat, holding still for the long exposure, an image of his appearance formed on the surface of a polished metal plate coated with silver iodide. The young man was Prince Albert, Queen Victoria's consort, and that day marked the beginning of the relationship between the Royal Family and photography (see overleaf).

Queen Victoria and Prince Albert were keen patrons of the new invention and began collecting photographs in the 1840s, embracing photography as an art form and laying the foundations for the extraordinary holdings of photography in the Royal Collection today. At the same time, they turned the camera on to their growing family, commissioning early pioneers of the new art-science to record their children's faces. Outspoken advocates for photography's development, the royal couple became joint patrons of the Photographic Society in 1853.

For the first half-century after its invention, photography remained technically challenging, and the province of professionals or keen and moneyed amateurs. A new era of photography began in 1888 with the release of Kodak's easy-to-use and affordable camera. Now many more people could enjoy taking photographs. The Royal Family were, as ever, enthusiastic adopters of the new technology and their own photographs, taken with these new portable cameras, allowed the first truly informal snapshots of royal life.

Queen Victoria (with smudged face) with some of her children, 1852; see page 28

William Edward Kilburn (1818–1891)

The first known surviving photographic likeness of a member of the Royal Family is not a majestic portrait of a monarch but rather this ghostly image of the intellectually and artistically curious Prince Albert (later Prince Consort; 1819–1861), husband of Queen Victoria (1819–1901). It was taken by the photographer William Constable in the spring of 1842, just three years after the new technology had been publicly announced in Britain. Victoria recorded the auspicious occasion in her diary: 'Albert sat yesterday to a man who makes photographic likeness.'

These remarkably detailed early images, known as daguerreotypes, were created by coating highly polished sheets of metal with chemicals and exposing them to light before the images were 'fixed' or stabilized. Daguerreotypes were very fragile, one-of-a-kind images and were often mounted in cases for protection. Only one original daguerreotype from the sitting now survives (below right), still mounted in the brown leather case lined with red velvet in which Albert presented it to his wife.

The fleeting image that was captured in chemicals on the mirrored plate's surface is now irretrievably lost to time, but this print (below left) after the original photograph as it gradually faded away, along with others of the various poses captured during the sitting, was made in 1891. Even at the time it was taken, Victoria would have had to tilt the photograph at just the right angle to reveal the image. Viewing early photographic portraits was an intimate and private experience and they would not have been seen widely.

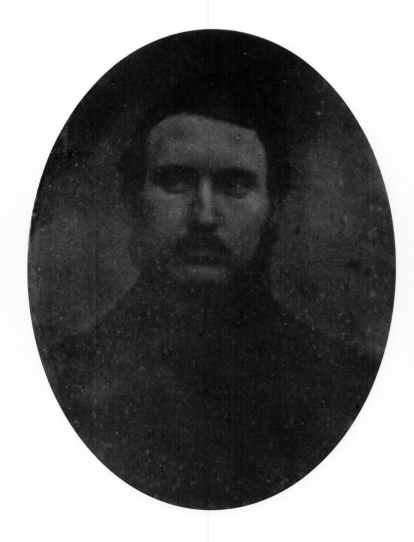

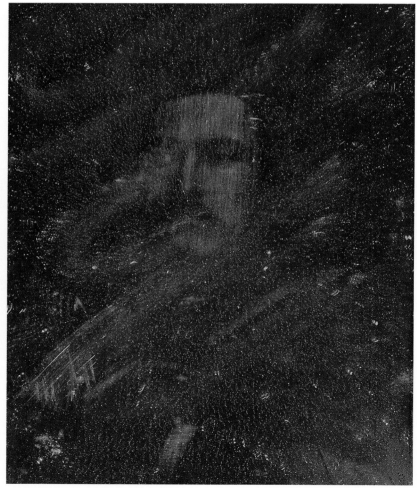

Queen Victoria and Victoria, Princess Royal, 1844

Photographer unknown. Carbon print c. 1889–91 by Hughes & Mullins (active 1883–1910)

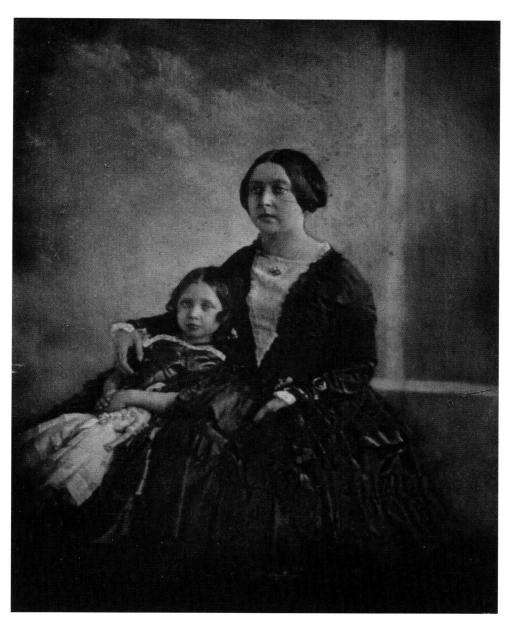

This surprisingly humble image is thought to be the first photograph taken of a British monarch. Who the photographer was is not certain and Victoria does not record her own extraordinary first in her diary, but the Queen shared Albert's curiosity about this new technology. To the modern eye, the picture is extraordinary in its simplicity. There are no aggrandizing props or elaborate background. It is a seemingly unremarkable image of a mother and her child; an experiment in documentation and an exploration of the new medium's potential.

As is the case with Albert in the images opposite, Victoria's expression is uncertain and a little stiff, reflecting the long exposure time required to make a photograph using the early daguerreotype process. Victoria is pictured with her eldest daughter, Victoria, Princess Royal (later German Empress and Queen of Prussia; 1840–1901) who was then three or four years old. The Queen's arm is draped tenderly around her daughter, whom she holds close, for comfort perhaps or to keep her still. Vicky, as she was called by her family, in turn grips her doll.

This first image of the monarch established an important precedent, which still continues today: from its very beginnings, photography was the ideal medium for depicting the monarch as a maternalistic figure.

Prince Albert, 1848

William Edward Kilburn
(1818–1891)

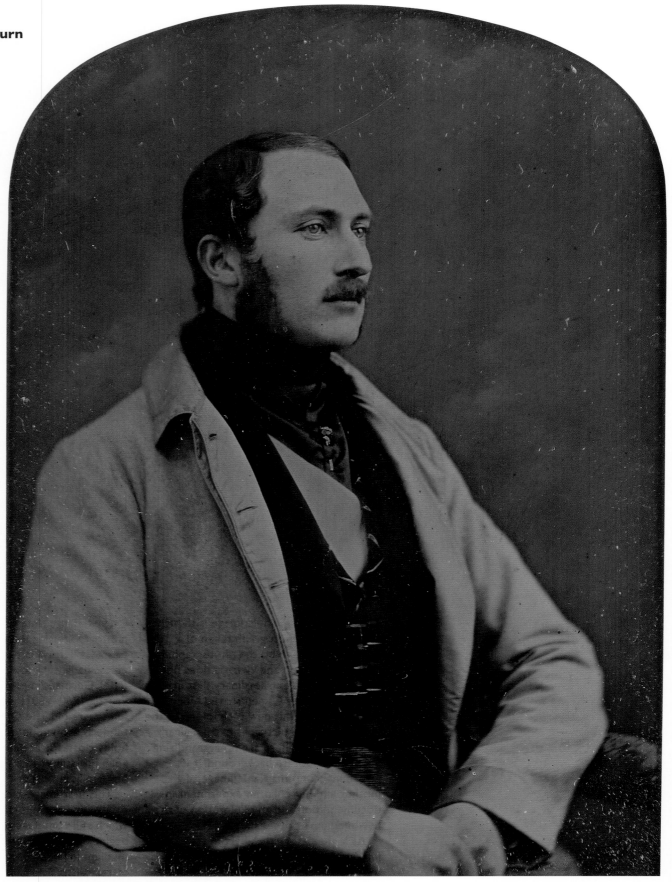

Queen Victoria, April 1854

**Antoine François Jean Claudet
(1797–1867)**

Photography was the perfect marriage of Prince Albert's twin passions for the arts and the sciences. Having made plain his desire to become a patron of 'artists … men of learning and science', Albert closely followed the latest developments in the new technology. In 1848 the twenty-nine-year-old Prince commissioned this hand-coloured daguerreotype (opposite) from William Edward Kilburn. It was the first coloured photograph of a member of the Royal Family.

Kilburn, 'Photographist to Her Majesty and His Royal Highness Prince Albert', opened his photographic studio in London's Regent Street in 1846 with an advertisement in the press that read: 'They have when finished all the delicacy of an elaborate miniature, with the infallible accuracy of expression only obtainable by the photographic process.' Early daguerreotypes were often marketed as the modern version of a miniature portrait, which explains the familiar regal poses adopted by the couple in these photographs.

At the Great Exhibition of 1851, Victoria and Albert experienced another new invention, the stereograph. When seen through a stereoscopic viewer, this playful invention allowed an image to appear in 3D. Three years later, the couple commissioned their own. Photographer Antoine Claudet wrote to the *Morning Herald* to share that he had 'the honour to be commanded by her Majesty to take my daguerreotype equipment to Buckingham Palace in order to take her portrait for the stereoscope'.

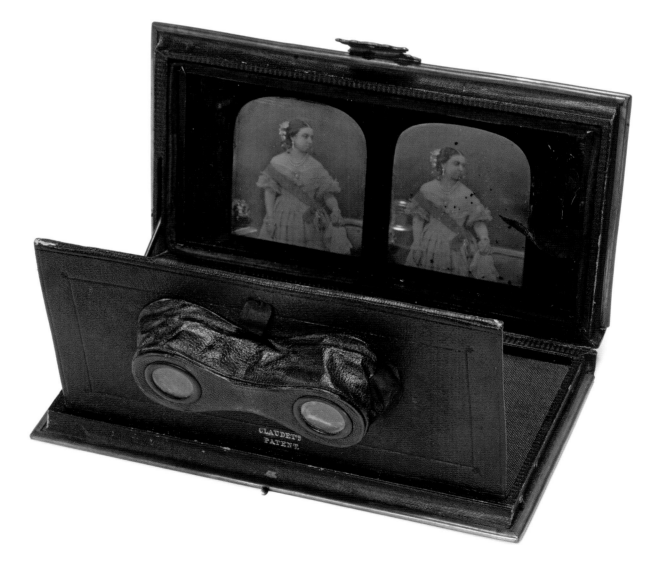

Queen Victoria (centre, with smudged face) with (left to right) Victoria, Princess Royal; Albert Edward, Prince of Wales (later King Edward VII); Princess Alice; Princess Helena and Prince Alfred, 17 January 1852

William Edward Kilburn (1818–1891)

Early photographs of Queen Victoria suggest that she was initially a camera-shy young mother. She was rarely depicted alone, and in this early group portrait of the Queen and her five eldest children, Victoria has obscured her face by smudging the negative.

Photography posed a new and unsettling dilemma. While formal portrait painting was designed to flatter and elevate, photography was distinctly less sympathetic a medium. Its perceived objectivity and ability to portray a 'truth' free from human interference had the potential to shock and surprise. The new medium revolutionized the way we saw the self. Of course, photography is not and never has been 'objective'. As this image clearly shows, from its earliest inception photography could be altered and manipulated, and its ability to convey 'truth' was tempered by its technological limitations, but the extraordinary detail and shocking realism posed by the new medium had considerable psychological impact on Victorian society.

Victoria experimented with poses, often positioning herself facing away from the camera so that her face was not visible, was obscured by a bonnet or was cast in shadow. After this sitting with William Edward Kilburn she confided in her diary: 'Went back to the Gardens, where a daguerreotype by Mr Kilburn was taken of me & 5 of the Children. The day was splendid for it. Mine was unfortunately horrid, but the Children's were pretty.'

Group portrait at Osborne House with (left to right) Victoria, Princess Royal, Albert Edward, Prince of Wales (later King Edward VII), Princess Alice and Prince Alfred, c. 1880 print of an original of August 1853

Dr Ernest Becker (1826–1888)

This informal group portrait is typical of the type of photographs taken of the royal children during the 1850s that were intended purely for private viewing. It shows Queen Victoria's four eldest children in their outdoor play clothes. There is no suggestion of their royal status or palatial surroundings; it is a remarkably simple domestic scene.

The photograph was taken by Prince Albert's librarian and tutor to the young Princes. Dr Becker was a keen amateur photographer and a founder member of the Photographic Society of London in 1853. His close relationship with the family is evident in the informality of the composition, and he captures the children's relaxed and, in the case of Prince Alfred (1844–1900; far right),

sullen, expressions. Becker was called upon to take 'behind-the-scenes' photographs of everyday life in the royal household, often at their rural homes at Osborne House on the Isle of Wight and Balmoral Castle in Scotland, both places where the Royal Family could retreat from public view and be themselves. Victoria wrote of one of his photographs, 'it has such truth about it & represents us *as we are*'.

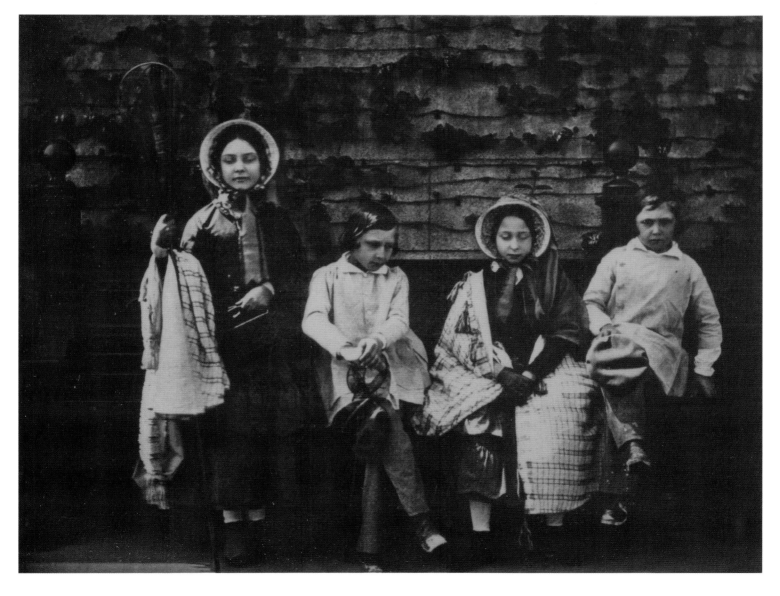

Group portrait of Albert Edward, Prince of Wales (later King Edward VII; seated, in white) and Prince Alfred (seated, far left) with their friends, Buckingham Palace, 1854

Dr Ernest Becker (1826–1888)

This charming photograph of Queen Victoria's two eldest sons and their friends has a timeless quality, and yet it is unusual to see royal children represented among their peers. Although the image feels natural and spontaneous, it is carefully composed: both Princes are seated and the Prince of Wales (1841–1910), positioned at the centre of the picture, stands out in white against his darkly clad companions. On 22 June 1854 he wrote in his diary: 'in the afternoon the 2 Farquarsons, the 2 Dawsons, Charlie Phipps, St Maur, Arthur Clinton came to play with us'.

Ernest Becker and Prince Albert took photography lessons together, and as his skills developed Becker wrote to his mother saying that 'photography takes up more and more of my time'. It became so central to his role within the royal household that occasionally the Queen would become angry if he was distracted by other tasks.

Victoria and Albert were evidently excited by the medium's potential to capture all aspects of royal life and took great pleasure in sharing the results with their close circle. Becker noted with pride that the Queen was having his pictures framed and 'in the evening they provide a major topic of conversation with the ladies'.

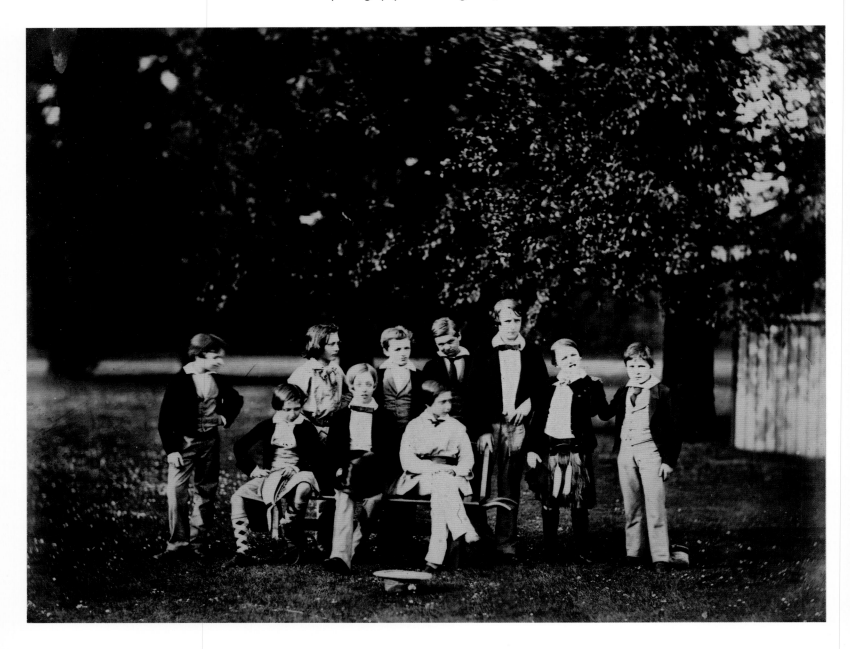

Queen Victoria (seated) with her four eldest children, (left to right) Albert Edward, Prince of Wales (later King Edward VII), Victoria, Princess Royal, Princess Alice and Prince Alfred, c. 1880 copy of an original dated 8 February 1854

Roger Fenton (1819–1869)

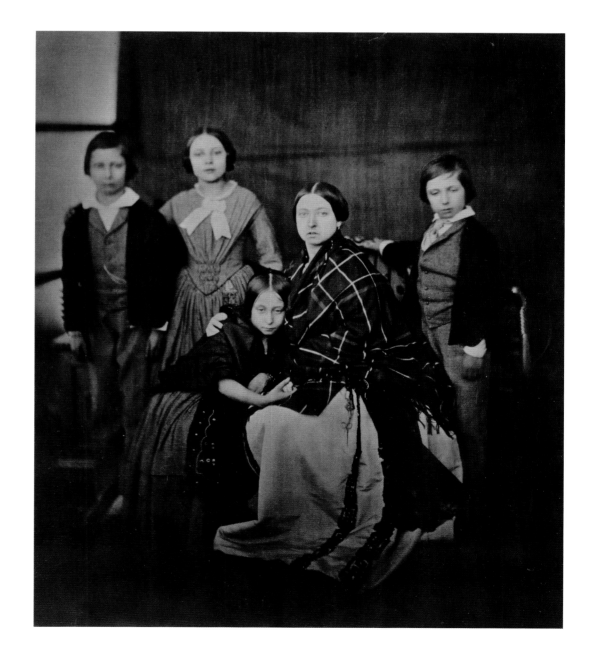

Victoria's intense and direct gaze in this photograph is unusual for the Queen, and the formality of the composition hints at the man behind the lens. Roger Fenton was a pioneering photographer and a founding member of the Photographic Society of London. Victoria and Albert purchased some of his landscape and architectural photographs before commissioning him to photograph the Royal Family in 1854.

The stiffness of the children's poses and the severity of their expressions might derive in part from their sense of reserve with the photographer and in part from the lengthy exposure required to produce the image. In 1839, daguerreotype plates required exposures of between fifteen and thirty minutes. By the 1850s this had been reduced to around a minute or less, but to remain still for that long was nevertheless enough to make the eyes water and the smile slip.

Unlike Ernest Becker's work (see, for example, opposite and page 29), this was a formal photographic portrait commissioned from a recognized artist. Yet despite this, there is still no indication of the sitters' royal status. The image is carefully posed against a photographic backdrop, but Victoria is once again pictured as a woman and mother, not as a queen.

The seven eldest children of Queen Victoria and Prince Albert, dressed as the Four Seasons for a tableau at Buckingham Palace. Left to right: Princess Alice, Prince Arthur, Victoria, Princess Royal, Princess Helena, Prince Alfred, Princess Louise and Albert Edward, Prince of Wales (later King Edward VII), 10 February 1854

Roger Fenton (1819–1869)

The royal children frequently dressed up to perform 'tableaux' for their parents. Roger Fenton was commissioned to capture their performance of *The Seasons*, by the poet James Thomson (1700–1748), staged to celebrate their parents' fourteenth wedding anniversary on 10 February 1854. From left to right, Princess Alice (1843–1878) is dressed as 'Spring'; little Prince Arthur (1850–1942) and the Princess Royal as 'Summer'; Princess Helena (1846–1923) stands on a plinth holding a cross in her hand to represent 'The Spirit Empress'; Prince Alfred, as Bacchus, wearing a panther skin and grasping a goblet, represents 'Autumn'; Princess Louise (1848–1939), sitting next to a fire, and the Prince of Wales, shrouded in a long white beard, represent 'Winter'. The Queen was delighted, declaring it '*such* a pretty idea' in her diary.

Behind the heavily curtained backdrop one can glimpse the roof and windows of the building that now houses Buckingham Palace's swimming pool, used here as a makeshift studio. This photograph was not intended as a finished piece but rather as a foundation on to which the artist Carl Haag (1820–1915) would colourfully overpaint the scene. The photograph was mounted, along with the finished artwork, in an album and presented to Victoria by her husband as a birthday gift. 'Nothing', she wrote, 'could have given one more pleasure.'

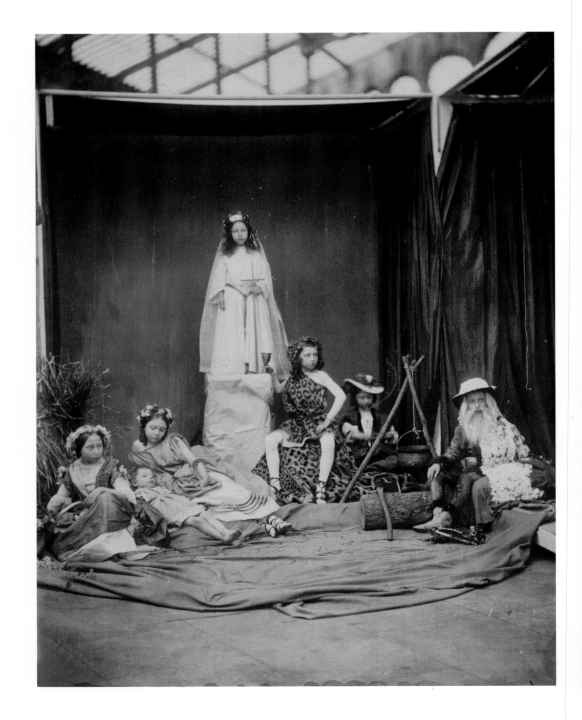

Queen Victoria and Prince Albert, 30 June 1854

Roger Fenton (1819–1869)

Roger Fenton encouraged Victoria and Albert to experiment with composition in his portraits of them and helped to develop their understanding of how a photograph, like a painting, could be carefully constructed to portray meaning.

This double portrait is one of the earliest to hint towards a potential audience outside the private family albums and to evoke an artistic as well as purely documentary sensibility. The composition is carefully arranged; both sitters are elegantly dressed and Albert gazes deferentially at his wife, alluding to her sovereign status. Victoria recorded in her diary entry for that day that both she and Albert were 'very successfully photographed, but it took a long time'.

Hand colouring was the only reliable method for making coloured images until almost a century after this image was created. The albumen print has been coloured by hand using watercolours in an attempt to make it appear more realistic. Victoria was fond of this approach, as it was reminiscent of conventional portraiture. Indeed, the effect is to render it somewhere between the two disciplines.

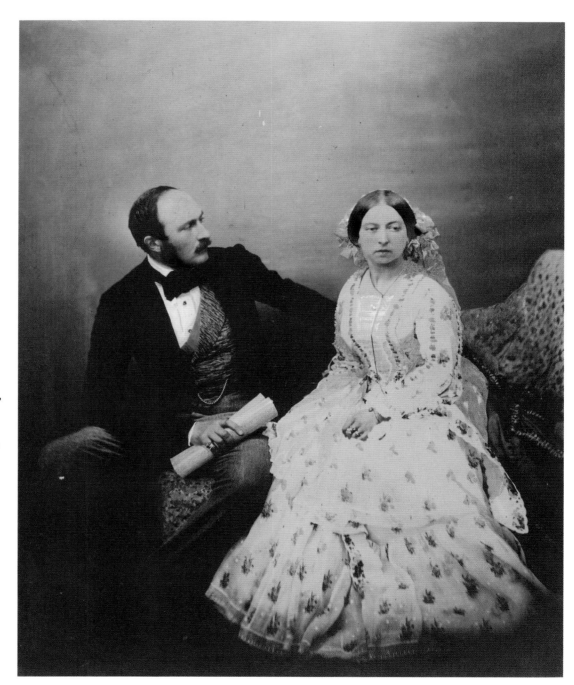

**The Maharaja Duleep Singh
of Lahore at Osborne House,
23 August 1854**

Dr Ernest Becker (1826–1888)

Duleep Singh (1838–1893) was the last maharaja, or prince, of the Sikh Empire but his reign was short lived. He succeeded his father as a young boy but at the age of ten was deposed by the East India Company, separated from his mother and placed under British guardianship. In 1854, at the age of fifteen, he converted to Christianity and travelled to London where he was granted an audience with Queen Victoria.

The Queen was fascinated by India and felt great empathy towards Duleep Singh thanks to their shared royal status. She was immediately taken by the young Maharaja's beauty, writing in her diary after their first meeting that he was '16 & extremely handsome ... [he] has a pretty, graceful & dignified manner. He was beautifully dressed & covered with diamonds.'

In the summer of 1854 Duleep was invited to Osborne House where he developed a close bond with the family. In keeping with their careful documentation of life at Osborne House, Singh was photographed by Ernest Becker along with the royal children, and his image, revealingly, was placed in the 'Portraits of Royal Children' albums (see page 77).

Prince Arthur (left) and Prince Alfred dressed as Sikh princes, September 1854

Dr Ernest Becker (1826–1888)

The family was in awe of the new vision of royalty presented to them by the Maharaja (see opposite). Duleep Singh taught the children how to tie a turban and they commissioned Sikh outfits, which Prince Arthur and Prince Alfred are shown wearing.

This photograph is characteristic of those taken by Ernest Becker, recording a moment of unbridled ease and affection between the two brothers that only he could capture. Yet at the same time the princes are luxuriously dressed, Alfred wears strings of pearls around his neck and the backdrop is a sweeping draped curtain reminiscent of formal royal portraiture.

The picture shows how both the family and Becker experimented with the medium and with the construction of image. In 1855 Becker wrote: '[T]he great attraction of this art and the importance of its use make it seem like a wholly new element of the artistic life, indeed of everyday life. It is not only that the magnificent collection formed by the queen and prince is growing larger every day – they are constantly making use of photography for all kinds of different purposes.'

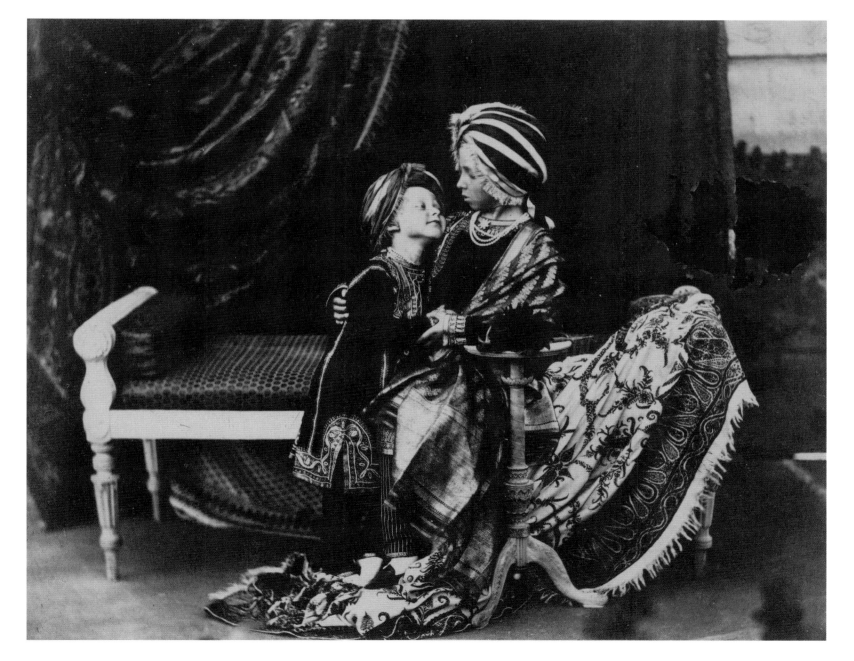

Prince Alfred, June 1855

**The Maharaja Duleep Singh
of Lahore (1838–1893)**

The time, expense and extensive equipment required for the pursuit of the earliest photographic techniques, notably the daguerreotype and calotype processes, and later the wet-collodion and dry-plate techniques, confined photography until the 1880s to a polite amateur pastime limited to the upper classes or commercial studios.

Victoria and Albert's enthusiastic patronage had made photography a central part of royal life by the 1850s. Albert was keen that the Royal Family be leaders rather than followers of technological change. His children were encouraged to learn how to take photographs, and it was probably during stays with the royal household that Duleep Singh developed his own interest in photography. Certainly, the royal children were willing sitters with whom he could practise his technique. He took this carefully composed photograph of Prince Alfred holding a rifle in 1855, the same year that he too became a member of the Photographic Society of London. Victoria included it in the 'Portraits of Royal Children' albums (see page 77) alongside images by eminent photographers of the day, captioned 'By the Maharajah'.

Prince Arthur, 1857

Leonida Caldesi (1823–1891)

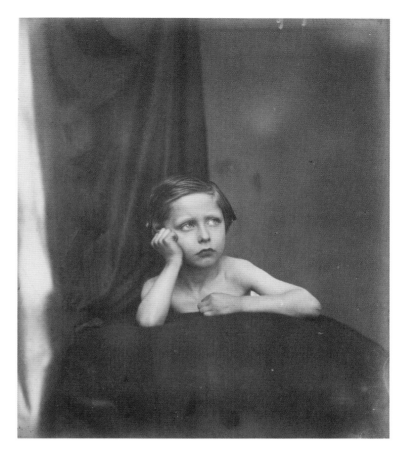

Although based on the science of photo-sensitive chemicals, photography has always been considered to be a creative artistic medium, and early photographers took inspiration from the compositions of academic paintings to place their art on an equal footing. Prince Albert collected the work of fine-art photographers, while Queen Victoria preferred portraits. These two delightful photographs of their seventh child, Prince Arthur, taken when he was about seven years old, combine both his parents' interests.

Prince Arthur's poses are inspired by two putti, or little angels, from *The Sistine Madonna*, a painting by the Renaissance artist Raphael (1483–1520). Raphael was Prince Albert's favourite artist, and at this time Albert was assembling a collection of images of every known work by the master. The Prince Consort embraced photography's objectivity and he prized reproductions of Raphael's work. Albert also owned a photograph of two children, similarly inspired by Raphael's putti, by the artistic photographer Oscar Gustav Rejlander (1813–1875). The photographs shown here capture the connection between the established art of painting, the new art of photography, and Victoria and Albert's love for their young family.

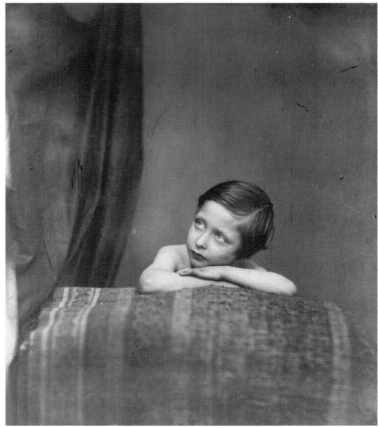

Self-portraits, 1864

OPPOSITE
Princess Louise, 1864
Prince Alfred (1844–1900)

Perhaps surprisingly, considering the frequency with which they were photographed, only one of Victoria and Albert's children showed any real interest in learning to take photographs themselves until later in life. Prince Alfred was given professional lessons aged sixteen before travelling to South Africa as a midshipman in the Royal Navy, in order to give him a useful hobby with which to occupy his time during the long voyages. Alfred was so keen that his parents employed a professional photographer, Frederick York (1823–1903), to accompany him and continue his training. The Prince became an enthusiastic and talented amateur, undertaking all of the processing himself.

A sequence of self-portraits and another of his sister Princess Louise are included in Victoria and Albert's 'Portraits of Royal Children' albums (see page 77) and show a technical ability and a creative flair. His self-portraits with the family terrier, Corran, capture a teenage boy experimenting with composition and pose. An air of fun and performance is evident in Alfred's nonchalant demeanour and fashionable clothing as he shows off in front of the camera.

Louise too was a flourishing artist and evidently keen to support her brother's interest. Her composition references a popular pose for photographing young women in the 1860s in which the sitter's reflection is visible in a mirror. Alfred was probably inspired by similar photographs of Princess Alice taken by the leading photographer Camille Silvy (1834–1910) in 1861.

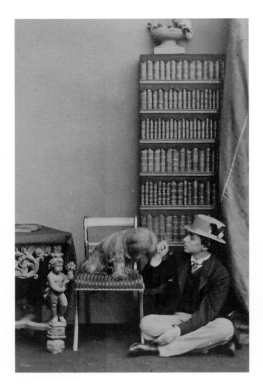 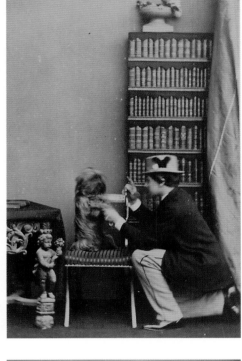

BELOW

Balmoral Castle tableau vivant: 'India'. Left to right: Khairat Ali, Princess Alix of Hesse, Abdul Karim, Princess Beatrice, Sheikh Mohamed Bukhsh, Princess Louise of Wales and Saiyad Ahmed Hussain, 6 October 1888

Charles Albert Wilson (1864–1958)

BELOW RIGHT

George, Prince of Wales (later King George V; right), and his cousins Prince Alfred of Edinburgh (left) and Ernest Louis, Hereditary Grand Duke of Hesse, 1890

Eduard Uhlenhuth (1853–c. 1900)

The photographs collected in Queen Victoria's 'Portraits of Royal Children' albums (see page 77) capture both light-hearted family moments and posed examples of formal portraiture.

Performing tableaux was a favourite pastime of the royal children, young and old, and the playful image below left records 'India', staged for the Queen on 6 October 1888 during a stay at Balmoral Castle. Victoria declared it 'very gorgeous & effective'. Describing the scene in her diary she said, 'Beatrice impersonated the Indian Empire, draped most correctly in beautiful stuffs, which Abdul had helped to arrange & wearing quantities of my Indian jewellery … one of the servants made a salaam in front of Beatrice, presenting a golden plate to her.'

Queen Victoria's forty-eight grandchildren were scattered all over Europe, and family weddings offered the opportunity to enjoy one another's company. Prince George of Wales (1865–1936) married Princess Mary of Teck (1867–1953) in the Chapel Royal at St James's Palace, London, in 1893. During the celebrations, the family marked the gathering with both formal and informal photographs. In the image below right, the royal cousins clearly jest with the then established formality of posed portrait photography. Prince George feeds a stuffed peacock as the Grand Duke poses on bended knee in a pastiche of subject paintings.

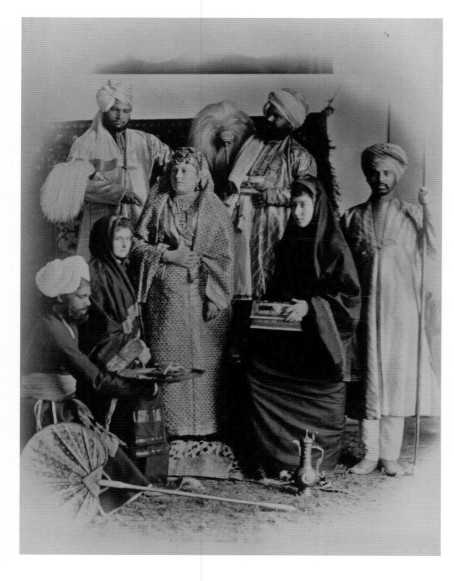

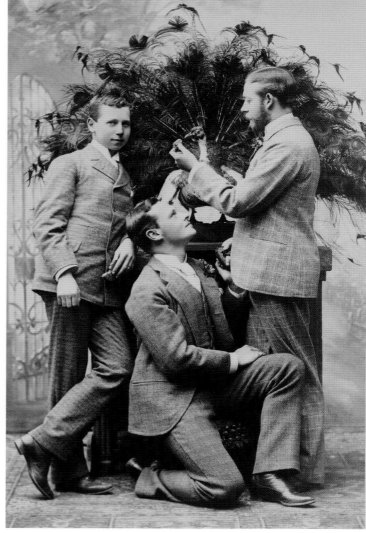

**Queen Victoria and Princess
Louise of Wales, Duchess of Fife,
Abergeldie Castle, 9 October 1890**

**Alexandra, Princess of Wales
(later Queen Alexandra)
(1844–1925)**

In 1889 the Princess of Wales acquired
a fashionable new Kodak No. 1 camera.
It had been released with the slogan
'You press the button, we do the rest'
because the innovative roll-film negatives
could be sent off for processing and a
set of prints would be returned to the
sender. A collection of 240 small round
photographs, characteristic of the Kodak
No. 1 camera, is the earliest of Alexandra's
known to survive.

The images range from artistic seascapes
to snapshots of family dinners, life on board
the royal yacht and action shots of her
family. This rare and very natural image

of Queen Victoria, with granddaughter
Princess Louise (1867–1931), shows her
making her way across the garden of
Abergeldie Castle in Scotland.

The spontaneity enabled by the latest
Kodak camera prompted a new age of
snapshot photography, allowing the Royal
Family and their subjects to record simple
and joyful aspects of everyday life as well as
important family moments. Alexandra was
so delighted with the results that she came
up with the novel idea of having some of
the images reproduced on a porcelain tea
service; this image of her mother-in-law
and her daughter decorated a plate.

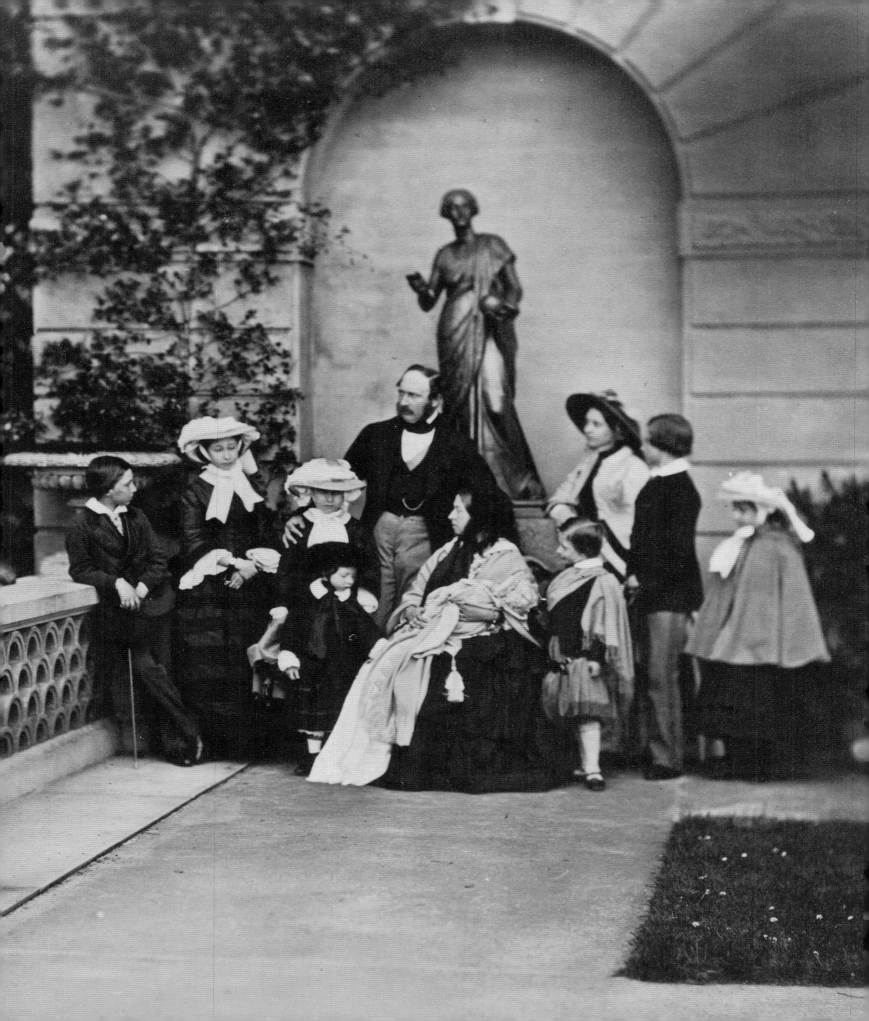

Creating a Public Image

In 1857, a photograph of a member of the British Royal Family appeared in public for the first time. Prince Albert, ever aware of the potential of this new medium, allowed an image of himself to be included in the Manchester Art Treasures exhibition. Queen Victoria's photographic likeness made its public debut in May 1858, when Leonida Caldesi's portrait of the Royal Family at Osborne House, Queen Victoria's holiday home on the Isle of Wight, was exhibited at the London Photographic Society's annual exhibition (see opposite and page 46).

Photographs of the Royal Family were initially taken for private consumption, but Victoria and Albert soon realized the potential of the medium for the wider dissemination of the royal image. The introduction of the carte-de-visite format in 1854 allowed multiple copies of small portraits to be printed cheaply. The public voraciously collected photographs of well-known public figures, and in 1860 Queen Victoria gave permission for a series of royal photographs to be released in carte-de-visite form (see pages 46–49). For the first time, the public could hold an accurate likeness of the monarch in their hand.

The spectacular popularity of the royal cartes, which sold in the tens of thousands, prompted a more conscious approach to the construction and messaging of 'public' photographs (see page 50). Those first released depicted Victoria as a wife and mother rather than a monarch. From the 1860s onwards, however, they also took on a more considered purpose. The Queen adopted an increasingly regal demeanour in her photographic commissions, more akin to painted portraiture, and the technology began to be applied as a public relations tool: communicating royal news, promoting royal tours and engagements (see page 50) and, in the final decades of the century, reinforcing Queen Victoria's reputation as 'the Grandmother of Europe' (see page 54).

The Royal Family on the terrace at Osborne House; see page 46

Leonida Caldesi (1823–1891)

**The Royal and Imperial Visit to
the Crystal Palace, 20 April 1855**

**Negretti and Zambra
(active 1850–c. 1999)**

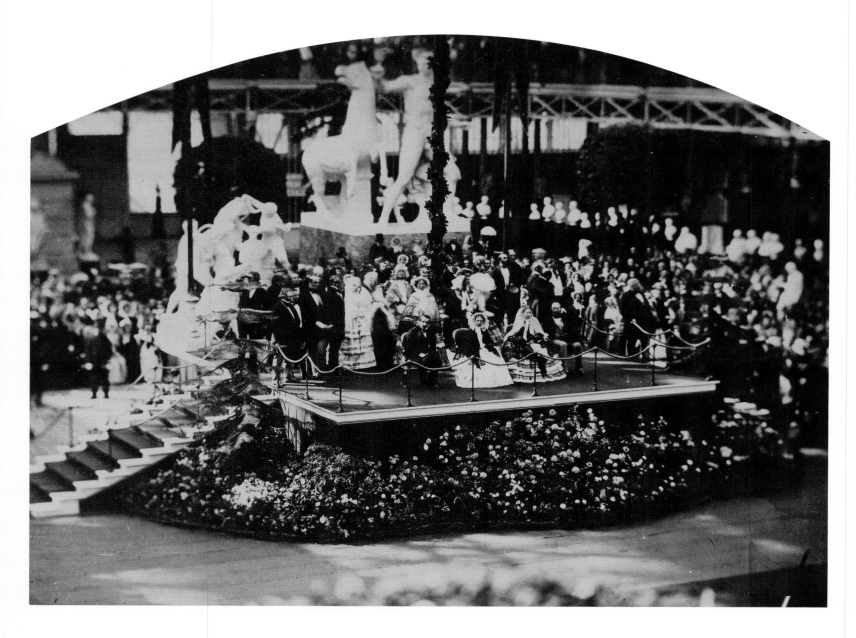

Queen Victoria and Prince Albert at the Manchester Art Treasures exhibition, June 1857

Alfred Brothers (1826–1912)

The photograph on the page opposite is one of the first of the Royal Family performing public duties, at the Crystal Palace at Sydenham Hill in 1855. Queen Victoria and Prince Albert (on the dais, right) sit by the French Emperor, Napoleon III (1808–1873), and his wife, Empress Eugenie (1826–1920), who were paying a state visit. At the time, Britain and France were allied in war against Russia in the Crimea; this visit, and Queen Victoria's return stay in Paris later that year, were intended to make a show of unity between the two former adversaries.

The development of a portable glass negative, known as the wet-collodion process, by the Englishman Frederick Scott Archer (1813–1857) in 1851, and the capacity to photograph a dense and moving crowd, created new potential for royal exploitation. When the Negretti and Zambra company, scientific instrument makers and official photographers of the Crystal Palace Company, recorded this momentous visit, it became one of the first royal press photographers.

Two years later, in 1857, the Royal Family were photographed in public again, visiting the Manchester Art Treasures exhibition (below). For the first time photographs were displayed alongside paintings and sculpture, confirming the medium's status as an art form. The Queen is seated, centre, with Albert to her left, perched on the arm of a chair. The image is a blurred buzz of activity, but Victoria and Albert's faces are pin-sharp, and the potential for the monarch to now be 'seen' by a much wider audience is undeniable.

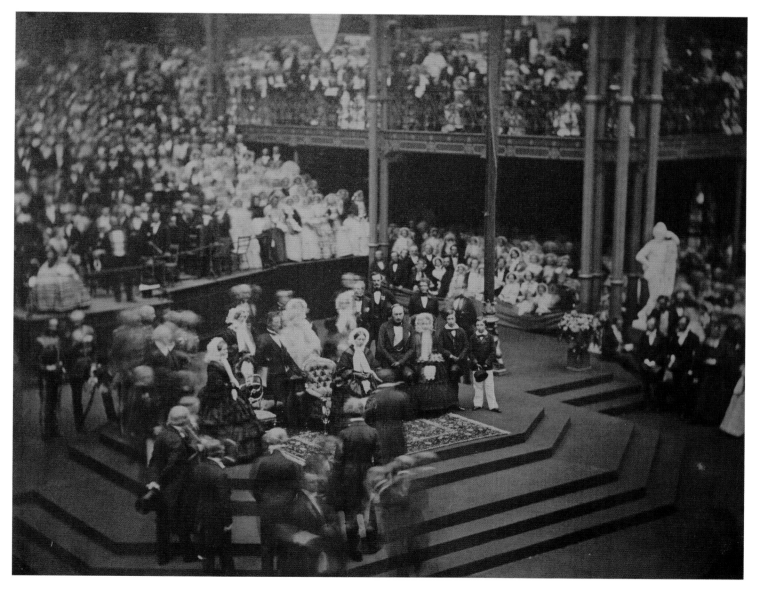

The Royal Family on the terrace at Osborne House. Left to right: Prince Alfred, Princess Alice, Princess Helena, Prince Leopold, Prince Albert, Queen Victoria holding Princess Beatrice in her arms, Prince Arthur, Victoria, Princess Royal, Albert Edward, Prince of Wales (later King Edward II) and Princess Louise, 26 May 1857

Leonida Caldesi (1823–1891)

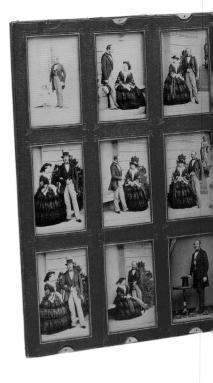

In 1858 a photograph of a reigning British sovereign slipped quietly into the public arena for the first time when Leonida Caldesi's family portrait, one of very few that show both Victoria and Albert with all of their nine children, went on display at the London Photographic Society's fifth annual exhibition. Admittedly, only the few privileged attendees saw it, but still this was a watershed moment. Like almost all royal photographs taken until the end of the 1850s, it was intended to be private. Queen Victoria had just given birth to her last child, Princess Beatrice (1857–1944), and had retreated to Osborne House on the Isle of Wight to recuperate with her family. She summoned Caldesi to photograph the children as a birthday gift to Albert and to record the last happy moments before her eldest daughter, Victoria, was to marry the following year.

The *Liverpool and Manchester Photographic Journal* described it as 'well executed and highly interesting, as displaying most vividly the domestic character'. In contrast to later studio portraits, it is indeed distinctly informal, and, interestingly, this first photograph of the Queen to be made public depicts her precisely as she endeavoured to be seen during her marriage, as a woman, wife and mother.

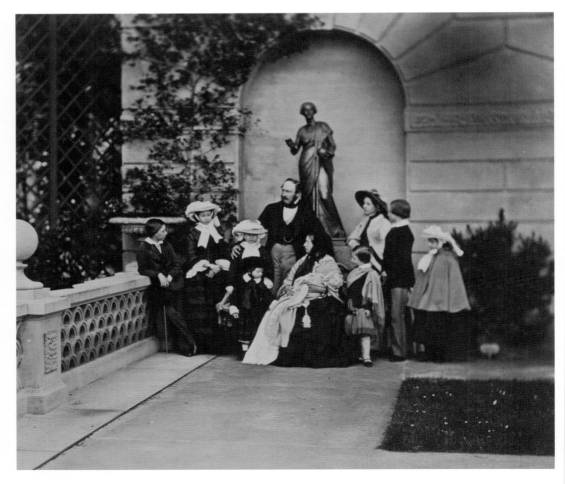

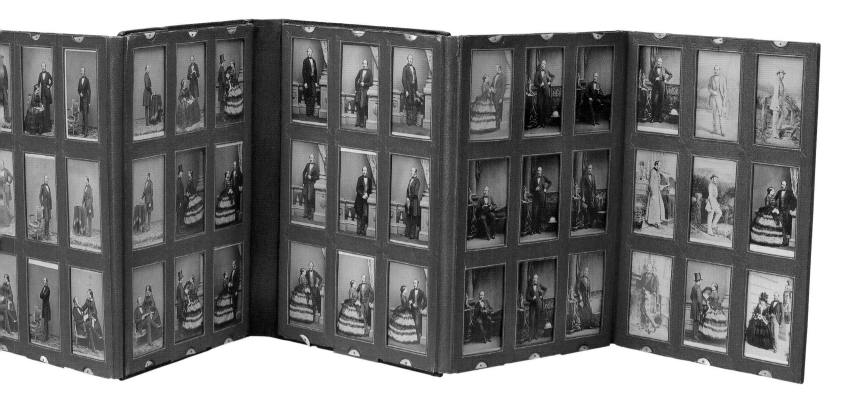

A collection of cartes-de-visite of Queen Victoria and Prince Albert, 1859–61

John Jabez Edwin Mayall (1813–1901)

Camille Silvy (1834–1910)

William Bambridge (1820–1879)

Frances Sally Day (c. 1816–1892)

By the late 1850s Europe was in the grip of a 'cartomania', a complete frenzy around the collection of cartes-de-visite. This innovation, consisting of small photographs pasted on to a card backing, was patented in 1854 by the French photographer Alphonse Disdéri (1819–1889) and enabled the relatively cheap production of large numbers of portraits.

Within a few years, cartes-de-visite had become widely popular across Europe as a relatively affordable and accessible means of having one's portrait taken. Print-sellers capitalized on the trend by selling cartes-de-visite depicting well-known public figures. Politicians, actors, writers and royalty were all popular collectables.

Like their subjects, Victoria and Albert enjoyed collecting these small photographs in specially designed albums and frequently sat for their own cartes, to be shared privately among family and friends. The Honourable Eleanor Stanley (1821–1903), one of Victoria's ladies-in-waiting, wrote on 24 November 1860, 'I have been writing to all the fine ladies in London, for theirs or their husband's photographs, for the Queen … I believe Miss Skerrett is right when she says "she [the Queen] could be bought, and sold for a Photograph!" '.

Together Victoria and Albert compiled this album, which contains cartes created by several photographers that the Queen and Prince Consort were patronizing towards the end of the 1850s.

Queen Victoria and Prince Albert

Princess Helena

Prince Arthur

Prince Albert

Princess Helena (left) and Princess Louise

Princess Beatrice

Queen Victoria and Princess Beatrice

Prince Albert Edward, Prince of Wales and Princess Alice

Princess Louise

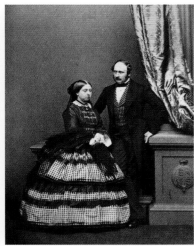

Queen Victoria and Prince Albert

Prince Leopold

Princess Alice

A selection of photographs of the Royal Family taken in 1860 and 1861, from which a number were chosen for publication as cartes-de-visite

**'Group of Roayl [sic] Family',
photomontage, early 1860s**

**John Jabez Edwin Mayall
(1813–1901)**

In 1860 Queen Victoria gave permission for the photographer John Mayall to publish in carte-de-visite form a series of photographs he had taken of her family. These were the first photographs of the Royal Family to be made widely available to the public and they proved an instant success. *The Times* newspaper reported on 16 August 1860 that wholesalers had ordered 60,000 sets, far outstripping requests for other celebrity portraits. Public demand was so high that in February 1861 Mayall visited Buckingham Palace once again to make a new set of negatives.

The publication of Mayall's *Royal Album* had a profound impact on the relationship between the monarchy and the public. Photography's realism gave the Royal Family an unmatched immediacy, transforming them into real people who could be brought into the nation's homes. The carte format also created an unprecedented sense of intimacy as the photographs were designed to be viewed up close.

By now, Victoria and Albert were wise to the ways a photograph could be contrived to convey a desired image. It is significant that the first photographs they allowed for widespread public release showed them to be, in essence, 'normal people'. Queen Victoria again chose to be depicted as a wife and mother, simply dressed against a plain backdrop; here she is a woman rather than a sovereign.

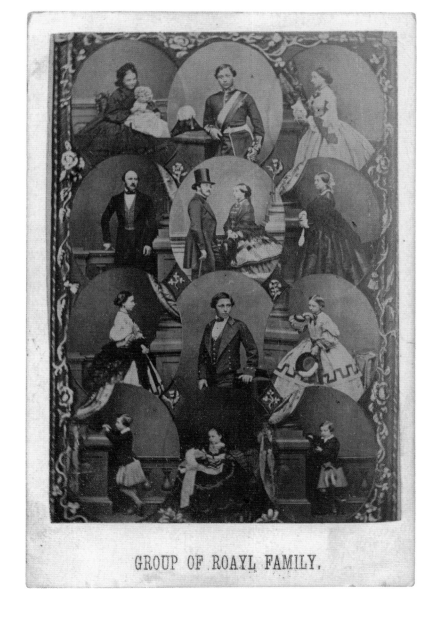

GROUP OF ROAYL FAMILY.

Albert Edward, Prince of Wales (later King Edward VII), 4 July 1860

Attributed to John Watkins (1823–1874)

In addition to offering a window – albeit a carefully stage-managed one – into the Royal Family's private world, the growing commercialization of photography also created potential to promote their public work.

Amid rumblings of republicanism across Europe and after the bloodshed of the Crimean War and the humiliation of the Indian Rebellion of 1857, Imperial confidence had been dented. A royal tour was planned to the USA and Canada to bolster British power and prestige. The eighteen-year-old Prince of Wales was dispatched on what was to be a royal spectacle, designed to prepare the heir apparent for his future vocation and to introduce him to the British North American provinces.

John Watkins was commissioned to photograph the young Prince at Buckingham Palace prior to his departure. The resulting image was publicly displayed in Britain with a mount hailing his welcome to America.

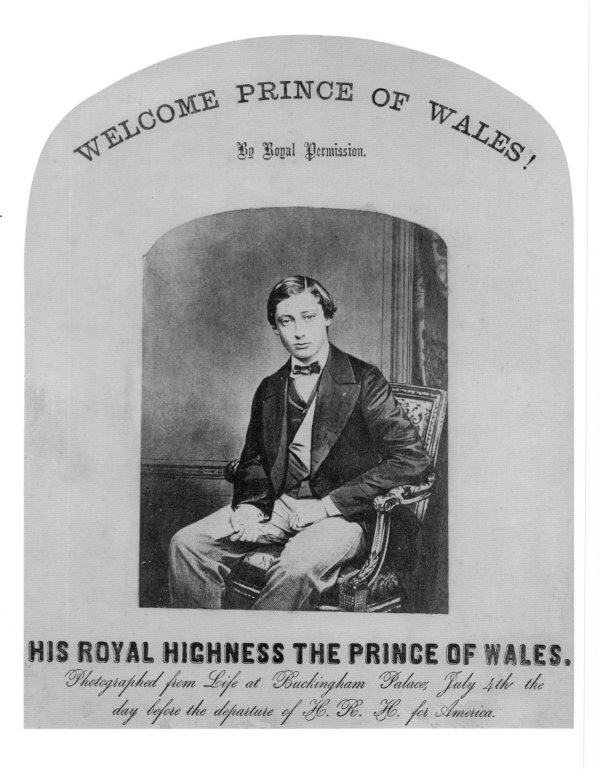

WELCOME PRINCE OF WALES!

By Royal Permission.

HIS ROYAL HIGHNESS THE PRINCE OF WALES.

Photographed from Life at Buckingham Palace, July 4th the day before the departure of H.R.H. for America.

Queen Victoria, 14 November 1861

Charles Clifford (1819–1863)

The popularity of Mayall's cartes-de-visite (see pages 46–49) initiated a more conscious approach to the construction of Queen Victoria's 'public' photographs.

When Victoria received a photograph of Queen Isabella II of Spain (1830–1904) dressed in an opulent gown and royal jewels, along with the request that she send one in return, modest family portraiture did not seem appropriate. She commissioned the same Spanish court photographer, Charles Clifford, to take her own photograph.

The resulting photograph is probably the earliest distributed publicly to depict Victoria as queen. All of the traditional motifs of royal portraiture are present: the Queen is framed by a sweep of curtain, the camera captures the fluid opulence of her silk moiré evening dress, and the riband of the Order of the Garter, the oldest British order of chivalry, is draped across her chest. Any lingering uncertainty about her identity is quashed by her diadem.

The Queen noted in her diary that she had 'dressed in evening dress, with diadem & jewels' and was 'photographed for the Queen of Spain by Mr Clifford. He brought me one of hers, taken by him.'

The image was widely reproduced and sold throughout the 1860s.

Alexandra, Princess of Wales (later Queen Alexandra) with Princess Louise of Wales, September 1868

Carbon print by Hughes & Mullins, November 1884, from the original of 1868 by W. & D. Downey (active 1859–1941)

OPPOSITE

Montage of photographs of Alexandra, Princess of Wales (later Queen Alexandra), with Princess Louise of Wales, September 1868

Carbon prints by Hughes & Mullins, November 1884, from original photographs of 1868 by W. & D. Downey (active 1859–1941)

This image of a fashionable young Alexandra, the wife of Albert Edward, Prince of Wales (later King Edward VII), carrying her daughter Louise on her back was the most widely reproduced photograph in Britain until 1885.

The grouping of portraits from the sitting (opposite) show the Princess of Wales and her two-year-old daughter playing with composition. Alexandra, renowned for her sense of style, appears to have brought a number of dresses for the sitting. The published carte-de-visite (right) was an instant sensation. It was designed to reassure the British public that the Princess of Wales was well after an illness, but the unusual dynamism of the shot also introduced the nation to a refreshing new image of monarchy: youthful, informal and fun.

In the 1860s and 1870s the market for photographs of famous people was dominated by politicians, artists, clergy and royalty. Amid this sea of predominantly middle-aged male faces, Alexandra would become the nation's pin-up princess and the royal couple the most photographed pair of the century. Their youth, vibrancy and fashionability made them the epitome of high-society glamour and placed them firmly among the burgeoning class of 'celebrity' created by cartes-de-visite.

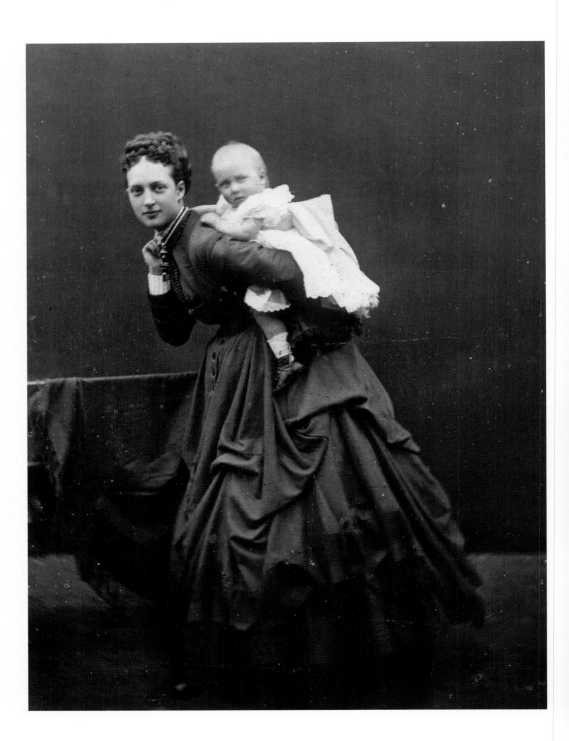

September
1868

a 2901978

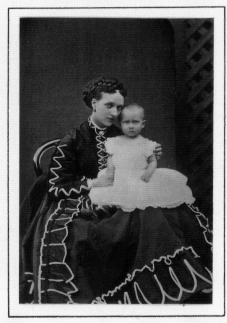

b

2901979

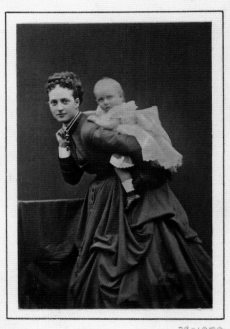

c

2901980

Princess of Wales & Princess Louise of Wales.

d

2901981

September
1868
Reproduced and printed in Carbon, by Jabez Hughes & Mullins, November 1884. Downey.

Queen Victoria (second row, centre) and her descendants, including Kaiser Wilhelm II (second row, far left), the future Tsar Nicholas II (third row, second from left) and Albert Edward, Prince of Wales (later King Edward VII; fourth row, far left), Coburg, Germany, 21 April 1894

Eduard Uhlenhuth (1853–c. 1900)

As Victoria's family swelled to include her children's spouses and her grandchildren, so did the repertoire of faces featured in the 'Portraits of Royal Children' albums. Important family occasions offered the opportunity for the Queen to revel in her progeny, documenting private family moments but also celebrating the political ties of her influential descendants, which earned her the nickname 'the Grandmother of Europe'.

This extraordinary group was photographed when the various branches of the family convened in Coburg, Germany, in 1894 for the wedding of two of Victoria's grandchildren: Princess Victoria Melita of Saxe-Coburg and Gotha (1876–1936) and Ernest Louis, Grand Duke of Hesse (1868–1937).

The photograph depicts reigning monarchs and heirs including Kaiser Wilhelm II of Germany (1859–1941; Victoria's eldest grandchild), the soon-to-be Tsar Nicholas II of Russia (1868–1918; married to Queen Victoria's granddaughter, Princess Alexandra of Hesse and by Rhine, 1872–1918) and of course Victoria herself, as well as her son and heir, the future King Edward VII, and their extended families. Victoria noted in her diary on 21 April 1894: 'the whole of our large family party were photographed by English, as well as German photographers. Many groups were taken, & some of me with Vicky & my 3 sons, & William.' The use of British and German photographers implies a political element to the commission, hinting towards its potential for public release in both countries.

Queen Victoria and Princess Beatrice in the Queen's Sitting Room, Windsor Castle, 21 May 1895

Mary Steen (1859–1939)

Danish photographer Mary Steen was commissioned to take a series of photographs of the Royal Family at home at Windsor Castle in 1895. Steen was among the first women to capture the Queen's likeness, and the influence of a female eye is noticeable.

Queen Victoria and her youngest daughter, Princess Beatrice of Battenberg, are depicted in the Queen's Sitting Room at Windsor Castle, and the photograph appears to give an insight into the private life of the monarch. Victoria is knitting, which was considered at the time to be a uniquely female occupation. Beside her, Beatrice reads a newspaper, probably aloud to her mother. The image is at the same time intimate and splendid: everyday activities being carried out in palatial surroundings.

This was the image chosen to grace the cover of the *Illustrated London News* on 19 September 1896, the day Queen Victoria became Britain's longest-reigning monarch. The image was captioned: 'The Longest Reign in English History: A Glimpse of the Home Life of the Queen'. This summed up a fundamental shift that had occurred over the course of Victoria's previous sixty years on the throne, and was arguably what would be the key to the monarchy's ongoing success into the twentieth century: the feminization of the royal image.

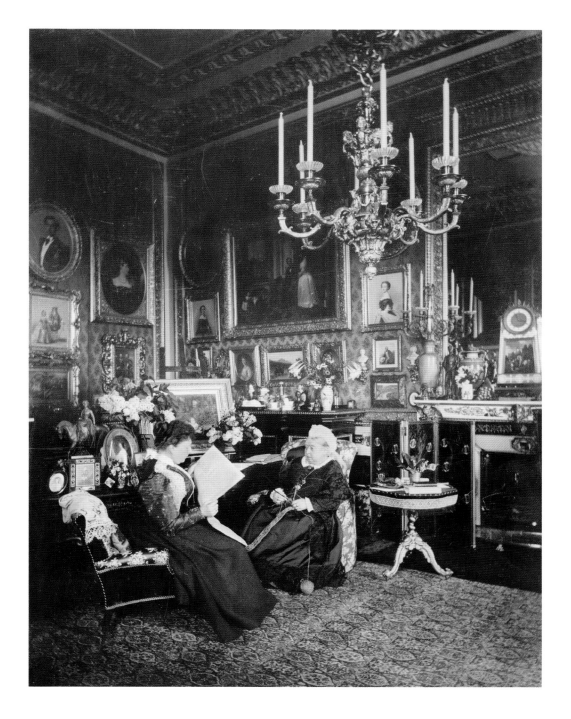

Dressed for the Devonshire House Diamond Jubilee Ball, 2 July 1897:

TOP
The Duke and Duchess of York (later King George V and Queen Mary)

BOTTOM
Albert Edward, Prince of Wales (later King Edward VII)

OPPOSITE
Alexandra, Princess of Wales (later Queen Alexandra) attended by Louvina Knollys (1888–1958)

James Lafayette (1853–1923; studio active 1880–1952)

The Devonshire House Ball was *the* social event of the London Season for 1897. To celebrate the Queen's Diamond Jubilee, the Duke and Duchess of Devonshire organized a glittering spectacle of costumed pageantry, with a dress code of 'allegorical or historical costumes before 1815'.

Although the Queen was not present, many of the younger generations of royals attended as guests of honour. They responded enthusiastically to the sartorial challenge: the Prince of Wales (bottom) was surprisingly clad in skin-tight hose and *cuissardes* (thigh-high boots), as a Grand Prior of the Order of St John; the Princess of Wales (opposite) looked resplendent as Marguerite de Valois, a French princess who became Queen of France when her husband acceded to the throne in 1589 as Henry IV; her daughter-in-law, the Duchess of York (top), dressed as a lady of Marguerite's court and her husband as George Clifford, 3rd Earl of Cumberland, a courtier of Elizabeth I.

Society photographers Lafayette studios were invited to set up a workshop in the house to photograph the costumes of the hundreds of guests. The images of the Royal Family were widely circulated after the event. They show a youthful and playful side of the Royal Family, who seemed able to parody themselves while also providing the public with the ostentatious extravagance that they wanted from monarchy, under the usefully diplomatic guise of fancy dress.

Mary, Princess of Wales (later Queen Mary) with Prince George of Wales, 1906

Photographer unknown

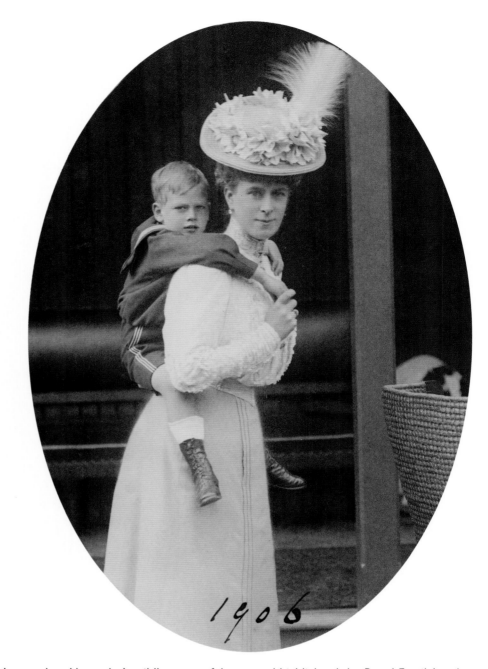

1906

In a nod to Alexandra's wildly successful portrait of 1868 (see page 52), Mary, Princess of Wales (later Queen Mary) adopted her predecessor's 'piggyback' pose with her son Prince George (later Duke of Kent; 1902–1942) in this photograph of 1906. Mother and child had just been reunited after Mary and her husband, George, Prince of Wales (later King George V) had been on an eight-month tour of India.

The warm reception of Alexandra's similar photograph demonstrated the public's fascination with seeing a fun, as well as a splendid, side to monarchy, and highlighted the Royal Family's role as 'entertainment'. Mary's attempt does not capture quite the same spontaneity of her mother-in-law's pose but it nonetheless shows a maternal and affectionate side to an otherwise often austere figure.

Princess Mary of Teck had been a favourite of Queen Victoria's thanks to her strong will and sense of duty. As was the case with Victoria, her approach to public image-making was at times serious and sombre, emphasizing duty and stability and making this a rare glimpse into a different side of her character.

Queen Alexandra's love of photography was well known and did much to popularize the discipline as a hobby. She was frequently seen recording public occasions, prompting the *Daily Mirror* to report in 1905 that, having seen the Queen raise her camera to take a photograph of a gathered crowd, '[a] correspondent with a camera promptly levelled his lens at Her Majesty, who seemed greatly amused and smiled upon him as the cameras clicked simultaneously.'

Public interest in the Queen's hobby prompted Kodak to include her photographs, along with those of other members of the Royal Family, in a number of exhibitions in London designed to promote their cameras. But Alexandra's talent was made accessible to a much broader audience with the publication of *Queen Alexandra's Christmas Gift Book* on 12 November 1908, a collection sold to aid more than thirty charities.

The book was so popular that the following year forty-six photographs were selected to be released in postcard form. Among them, *The Sketch* reported, were 'many which are decidedly humorous, many which are historic and many which are unique'. These everyday photographs showed an officially sanctioned human side to the monarchy, which, according to the *Daily Telegraph*, was what made them 'so intensely interesting'.

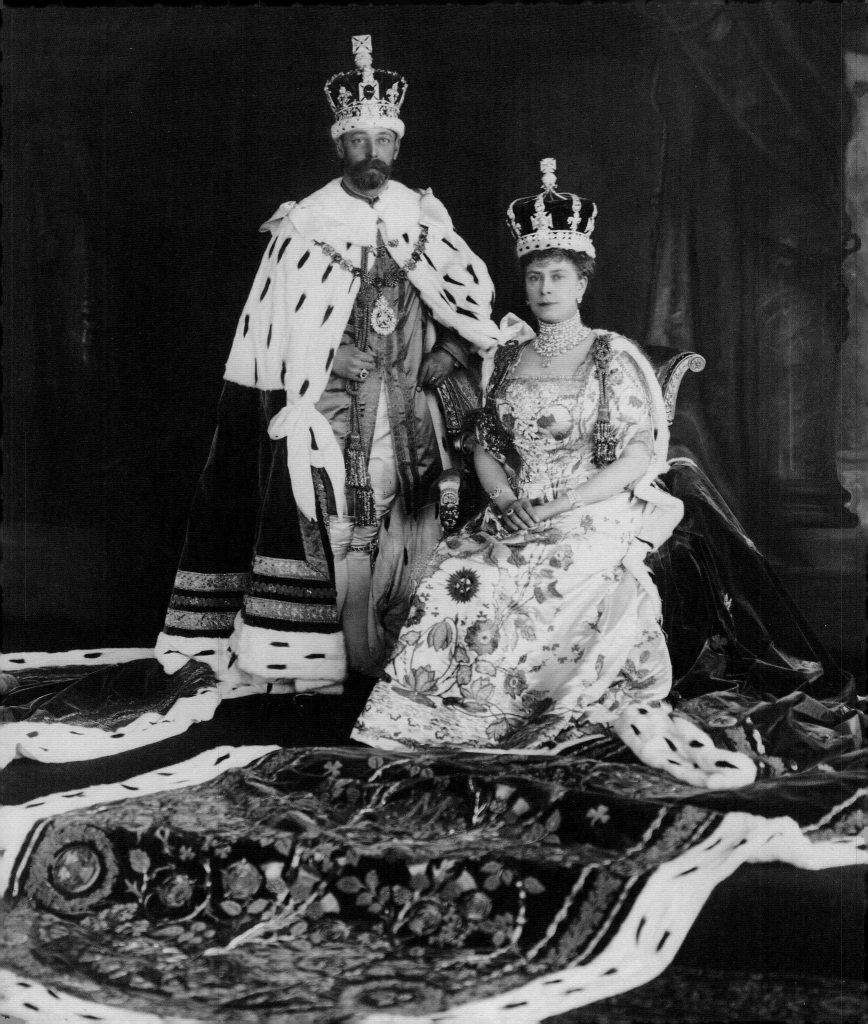

Recording the Reign

The monarchy must always retain an element of mystery. A Prince should not show himself too much. The monarchy must remain on a pedestal.

SIR FREDERICK PONSONBY, KEEPER OF THE PRIVY PURSE, C.1910

King George V and Queen Mary in coronation robes, 22 June 1911; see page 68

Attributed to W. & D. Downey (active 1855–1941)

By the final years of the nineteenth century, photography's central role in the creation of a public image of monarchy was officially acknowledged with the sanctioning of the first authorized official photographic portrait of Queen Victoria, to mark her Diamond Jubilee in 1897 (see page 64). As the medium gradually replaced painted portraiture as the primary visual means of royal representation, splendid dress and settings and other recognizable emblems of monarchy, such as the crown, orb and sceptre, all became commonplace features of royal photographs, alongside the more informal representations of photography's early years.

King Edward VII's accession to the throne in 1901 heralded a new era of royal pomp and pageantry. Grand ceremonies had been scaled back during the reign of his mother, but the Golden and Diamond Jubilee celebrations had confirmed public appetite for royal spectacle. The development of new and improved techniques for photography and printing, which from the start of the twentieth century enabled photographs to be reproduced in newspapers and magazines, meant that a global audience could now share in the splendour of these ceremonies.

Photographs of the State Opening of Parliament in 1901 (see page 66) and King Edward VII's coronation in 1902 were widely reproduced and circulated. During the reigns of Edward VII and George V, royal ceremonial occasions, including the Trooping of the Colour, the Order of the Garter ceremony, the Investiture of the Prince of Wales and vast processions and balcony appearances at Buckingham Palace, were all revived or created, to meet the insatiable public demand for a supply of exciting images.

BELOW

Queen Victoria, February 1872

BELOW RIGHT

Queen Victoria as Empress of India, January 1876

W. & D. Downey (active 1855–1941)

The Queen's prolonged withdrawal from public life after the death of Prince Albert in 1861, combined with an almost continuous release of images of her as a bereft widow, eventually began to undermine the image of a strong and stable monarchy. Victoria was persuaded that in order to restore public confidence in the institution, it was essential that she become visible to her people.

The recovery of the Prince of Wales in 1872 from typhoid (the disease that was believed to have killed his father a decade earlier) presented the perfect opportunity to celebrate, give thanks and bring the Queen back into the public eye. In this carte-de-visite published that year (below left), the Queen was depicted in an ermine-trimmed coat, the outfit she had worn to the thanksgiving parade held to mark the Prince's recovery. The small concession to 'colour' marked a departure from the unrelieved black of her mourning pictures of the 1860s.

Photographs of the Queen from the 1870s presented a more sombre and regal figure than previously. Victoria had humanized herself in the minds of her subjects as a mother figure and a grieving widow. Now, with Victoria resigned to governing a vast and growing empire without Albert by her side, photographs of her began to depict her as stateswoman. The photograph below right of the Queen on an ivory throne, presented to her by Maharaja Uthram Thirunal Marthanda Varma of Travancore in southern India (ruled 1847–60), was released to mark Victoria's assumption of the title Empress of India in 1876.

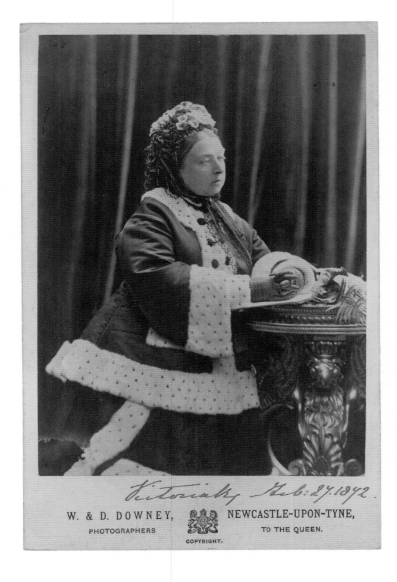

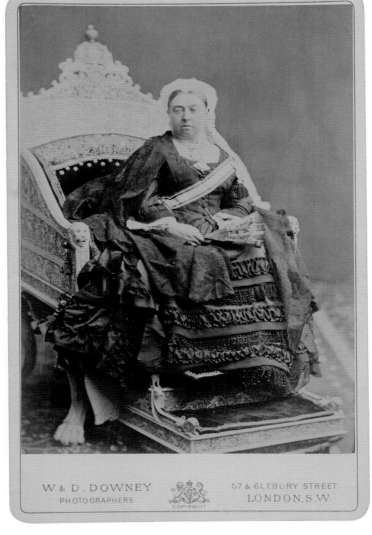

'The Four Generations'. Left to right: George, Duke of York (later King George V), Prince Edward of York (later King Edward VIII), Queen Victoria and Albert Edward, Prince of Wales (later King Edward VII), White Lodge, Richmond, 16 July 1894

W. & D. Downey (active 1855–1941)

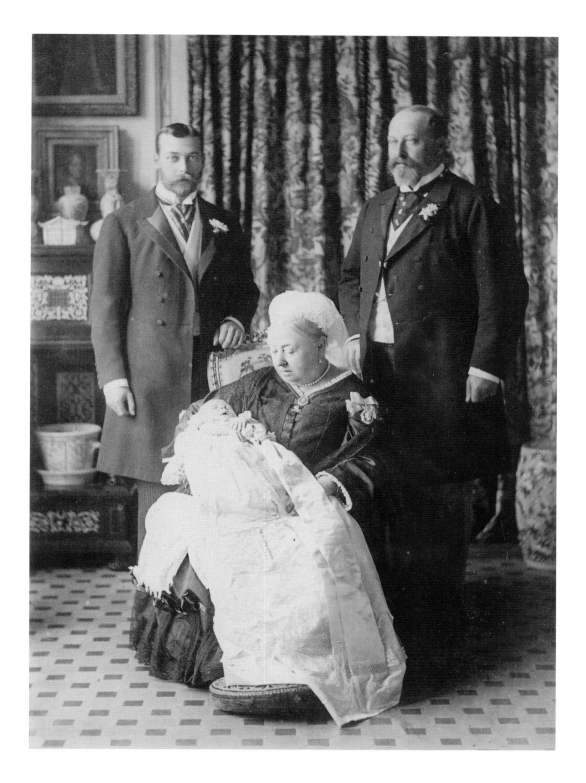

By the 1890s, Queen Victoria appeared to have established a successful two-pronged approach to her photographic image-making. She ensured she was portrayed either surrounded by her progeny as an affectionate or at least prolific maternalistic figure, or else as a stoic stateswoman. Occasionally, the photographs she released masterfully blended these two messages.

Queen Victoria was the first British monarch to live to see the next three generations of the royal line secured. This photograph was released to mark the christening of Prince Edward of York (later King Edward VIII; 1894–1972) on 16 July 1894. The image is simultaneously an intimate moment of celebration and a demonstration of the continuity and stability at the heart of monarchy. In a nod to iconic state portraiture, Victoria commands the centre of the picture, having fulfilled her duty by securing the royal lineage while at the same time promoting the model of respectable domesticity she and Prince Albert had established.

As photographs of the Queen increasingly began to resemble official portraits, so photographers, like painters, began to be appointed official warrants. In 1879, W. & D. Downey were made Photographers in Ordinary to Her Majesty.

Queen Victoria, 1893

W. & D. Downey
(active 1855–1941)

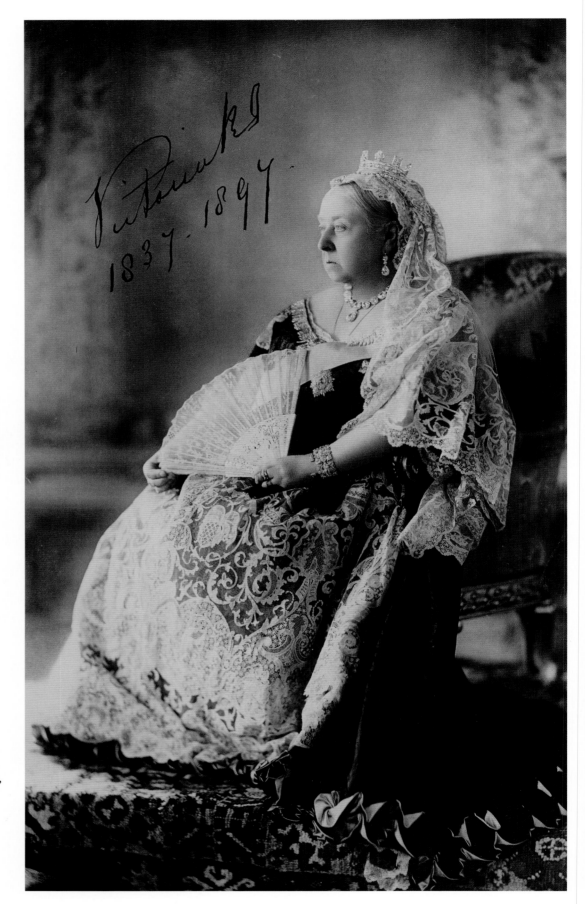

In 1897 Victoria celebrated her Diamond Jubilee, as the first British monarch to reign for sixty years. This majestic image of the Queen was the first official royal photographic portrait to be sanctioned for release in response to public demand.

The photograph had in fact been taken four years earlier for the marriage of the Duke of York (later King George V) to Princess Mary of Teck. The viewer looks up at the Queen–Empress resplendent in her wedding lace and a small diamond crown designed to be worn over her widow's cap. The choice of commercial portrait photographers W. & D. Downey reflects Victoria's understanding of the need for a formulaic approach to the construction of 'iconic' images. Official photographs of the Queen from this period are deliberately similar, providing a visual representation of the symbolic stability and continuity of monarchy.

Tellingly, a strategic decision was made not to copyright this image. This allowed – and encouraged – it to be distributed widely and reproduced at will on anything from tea towels to commemorative china. This photograph became the authoritative, iconic image of the sovereign across the Empire and it has stood the test of time, remaining the defining image of Queen Victoria into the twentieth and twenty-first centuries. By standardizing her identity, Victoria had firmly established her 'brand'.

King Edward VII sitting for a bust, 1901

Photographer unknown

By the beginning of the twentieth century, technological advancements had established photography as the primary medium of royal representation and documentation. For occasions when a more traditional medium, such as painting or sculpture, was preferred, photography could still be used to record the creative process and to document the finished results.

This photograph shows the sculptor Sydney March (1876–1968) working on a bust of Edward VII to mark the King's accession to the throne in 1901. The artist began by creating a clay model from life, which served as reference for the final stone carving. March's blurred image demonstrates the dynamic nature of this initial stage and contrasts with Edward's stillness in the background. The King is seen dressed in his day clothes; he would wear his less comfortable Coronation robes once the sculptor had finished perfecting the bust's expression.

The artistic integrity of photography as a medium was by now well established, but its dualistic potential for documentation as well as creative expression is thoughtfully employed here to show the person behind the icon being created in clay.

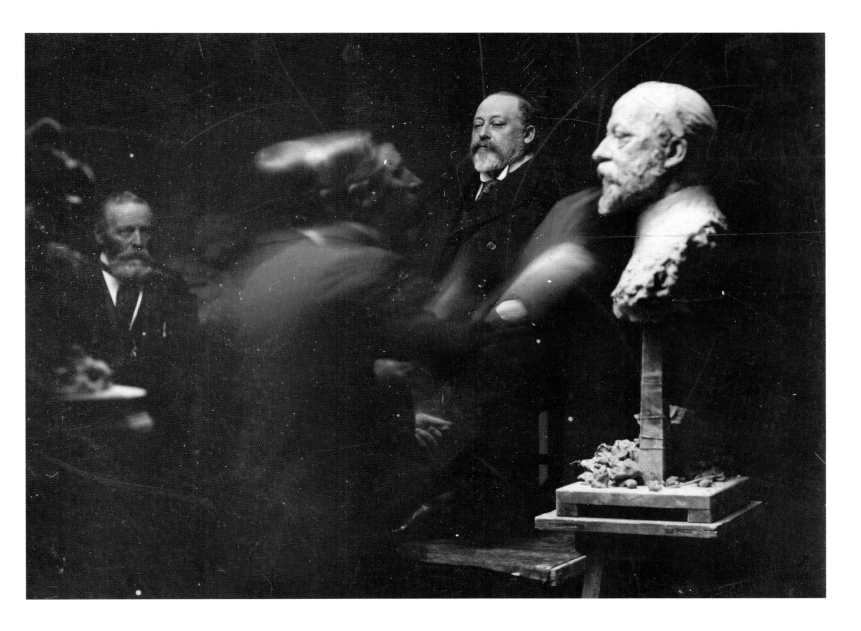

King Edward VII and Queen Alexandra, 1901

W. & D. Downey (active 1855–1941)

OPPOSITE
King Edward VII and Queen Alexandra dressed for their first State Opening of Parliament, 1901

Princess Victoria (1868–1935)

Edward VII ascended the throne on 22 January 1901. His reign was the first for which photography was considered to be a core component of royal life.

His mother, Queen Victoria, had reigned for sixty-three years, making her history's longest-reigning monarch until Queen Elizabeth II usurped the title on 9 September 2015. Photographed here dressed in black, still mourning the loss of the late Queen, are King Edward VII and Queen Alexandra about to attend their first official opening of parliament.

The photograph was designed to create a sense of continuity between one reign and the next, and to breathe new life back into the court after the rather dowdy late Victorian era. Queen Alexandra's decision to wear Queen Victoria's Small Diamond Crown for the occasion, and the use of Royal Warrant holders W. & D. Downey, provided a visual link with the past but with her dazzling display of diamonds and fashionable dress Alexandra firmly established the opulence that would become synonymous with the Edwardian age. Also present at the official portrait sitting was Princess Victoria, Edward and Alexandra's second daughter, who was a talented amateur photographer. Armed with her Kodak camera she took a sequence of candid photographs (opposite) that give an intimate behind-the-scenes look at the proceedings.

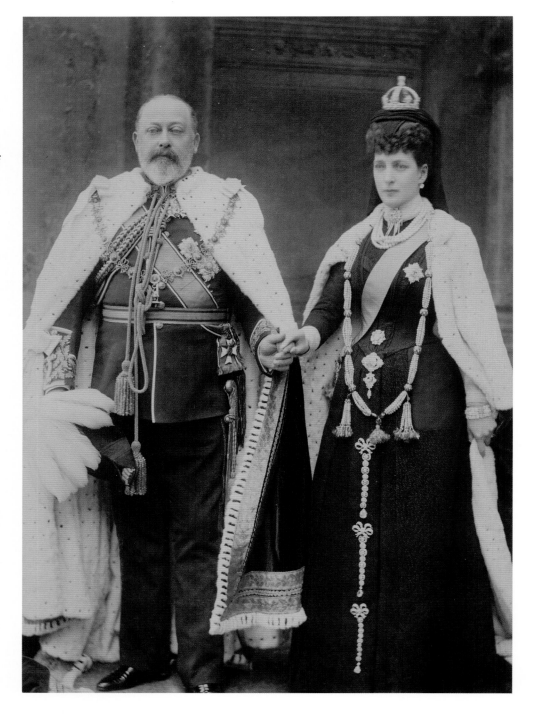

King George V and Queen Mary in coronation robes, 22 June 1911

Attributed to W. & D. Downey (active 1855–1941)

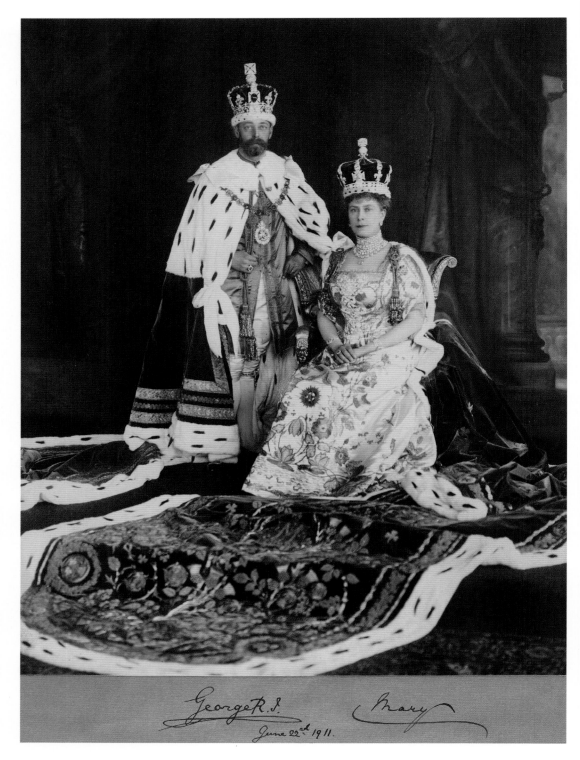

At George V's coronation on 22 June 1911, cameras were for the first time allowed into Westminster Abbey, the traditional place of coronation for English monarchs. The King ascended the throne amid a challenging political climate for monarchy in Europe. An expanded franchise and a constitutional crisis over the House of Lords at home, coupled with encroaching republicanism on the European mainland, prompted a reconsideration of the importance of royal ceremony in 'democratizing' the image of monarchy by bringing it to the masses.

The official photographs taken and widely distributed both in Britain and throughout the Empire to mark the occasion showed the usually shy and retiring King George V and his consort, Queen Mary, meticulously adhering to ceremonial tradition.

Mary wrote to her aunt on her accession, 'Yes, I regret the quieter, easier time we had, everything will be more difficult now & more ceremonious.' Indeed, the expansion of the photographic press would both aid and necessitate the augmentation of royal pomp and pageantry in order to appease the growing political power of the electorate. This photograph was again probably the work of W. & D. Downey, reflecting a continuing determination for continuity from one reign to the next.

**Edward, Prince of Wales
(later King Edward VIII), 1911**
Photographer unknown

The decline of monarchy's political power at the turn of the twentieth century corresponded with a rise in its symbolic power. In the midst of political and social change, the monarchy positioned itself as a focal point for patriotism, national unity and stability. The coronation of King George V in June 1911 was quickly followed by another seemingly ancient royal ceremony, the Investiture of the Prince of Wales, at Caernarfon Castle on 13 July.

Investitures had for centuries taken place in private. The public nature of the 1911 ceremony was in fact a newly invented tradition, designed to unify the country with a state-sanctioned acknowledgement of the cultural differences encompassed by the United Kingdom and the British Empire, and to promote a picture of 'unity in diversity'.

Mass participation enabled by photography was an integral component of the rationale behind such spectacles, and an express train service was set up from Caernarfon to London with a darkroom on board so that photographs could be processed and quickly made ready for the newspapers on Fleet Street to distribute across the globe.

Seventeen-year-old Edward, Prince of Wales, is pictured here in one of the official photographs taken at Buckingham Palace prior to the investiture. He wears the regalia with which he was invested by his father, George V, in the courtyard of Caernarfon Castle before being presented to the people of Wales in accordance with a tradition that dated back to the fourteenth century.

Queen Mary

OPPOSITE
**King George V (right) and
Edward, Prince of Wales (later
King Edward VIII), 13 March 1914**

Jean Desboutin (active 1914)

On 10 June 1907 French brothers and film pioneers Auguste and Louis Lumière (1862–1954 and 1864–1948) gave a public demonstration of a new photographic process they had developed to capture colour. Known as autochrome, the process used dyed potato starch grains to create a coloured filter through which light passed on to the negative. The complex industrial process involved in manufacturing autochrome plates made it more expensive than its monochrome counterparts, and it required longer exposure time, but the results were astonishingly beautiful, with a depth of colour reminiscent of painting. However, the glass transparencies it created did not readily lend themselves to reproduction without further processing, so it never became a commercial success.

In 1914 autochrome of George V and his eldest son Edward, Prince of Wales, and Queen Mary were taken at Buckingham Palace to be published in the French magazine *L'Illustration*. Photographs like these were published across the globe to promote George V as a strong leader in the face of impending war with Germany, with the young Prince as his heir. During the war a black-and-white crop of the head and shoulders of the Prince was fashioned as a header on writing paper used by families when writing to their loved ones on the Front Line.

Queen Mary, c. 1920

**Lambert, Weston & Son
(active 1860s–1900s)**

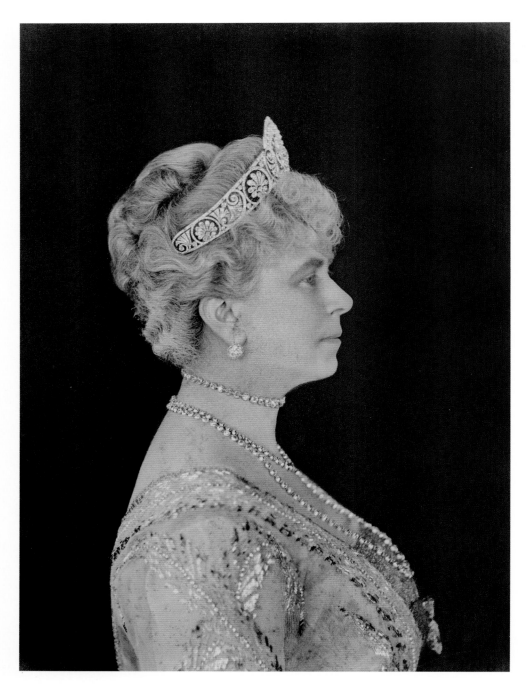

Throughout the reign of her husband, King George V, Queen Mary cultivated a solemn and majestic image of monarchy. She had a distinctly individual look that sat quite apart from the fashions of the day. Her dresses were cut almost identically and varied only in material and decoration. Along with her use of luxurious fabrics, extravagant furs and copious jewellery, intended in part to promote British design and textile manufacture, she embodied a truly timeless style and created an image of steadfast duty and stability during a period of war, economic depression and social change.

In this photograph, her regal appearance is accentuated by her stiff, upright posture. Her patronage of well-established royal photographers Lambert, Weston & Son, who had previously photographed Queen Victoria, helped to reinforce a sense of continuity, while her profile pose resembles traditional imagery of monarchs on coinage – perhaps one of the most widely circulated representations of royalty in Western history.

Christmas card with portrait of the Royal Family at Buckingham Palace, 20 December 1938

Marcus Adams (1875–1959)

The warmth and nobility of Marcus Adams's photographs led to his being commissioned to take the first of the newly proclaimed sovereign, George VI (known affectionately within the family as Bertie, short for his birth name of Albert; 1895–1952), and his family just four days after the accession on 11 December 1936. Over the following years, Adams's images of a close-knit family helped to re-establish an aura of monarchical duty and dependability after the crisis of Edward VIII's abdication. Photographs of the reigning family were injected with a new formality to reinforce their altered status, but the romantic whimsy of Adams's style softened the traditional severity of official royal portraits.

Two years later Adams was asked to photograph the Royal Family at Buckingham Palace (below), a task that presented considerable technical difficulties. First, Dookie the corgi had to be encouraged to cooperate using a biscuit hidden on the King's shoe. In order to ensure that both the family group and details of the palatial background were in focus, Adams photographed the family and the background separately and layered one negative on top of the other to achieve the final image.

Millions of copies of this picture were produced, and it was used for the family's Christmas card, shown here, the following year.

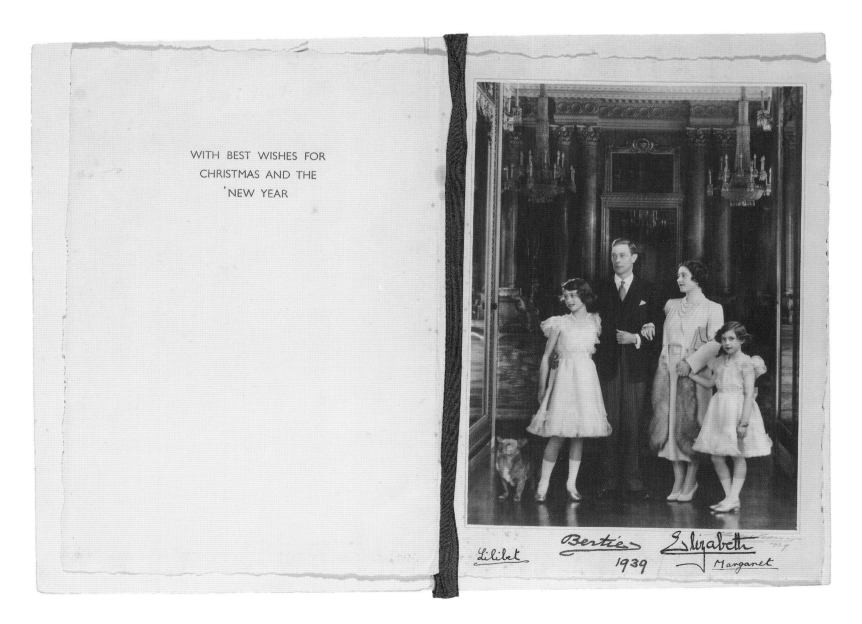

WITH BEST WISHES FOR CHRISTMAS AND THE 'NEW YEAR

**Princess Elizabeth (later Queen
Elizabeth II), 20 December 1938**

Marcus Adams (1875–1959)

The continuing patronage of children's photographer Marcus Adams after George VI's accession in 1936 suggests a decided softening in the image of monarchy. Adams wrote that children possessed 'a lovable spirit of pluck, determination and peaceful tranquillity', and it is perhaps his success in capturing these qualities that made him well suited to the task of re-presenting the new reigning family and re-establishing public support.

Her father's accession to the throne also led to a decided shift in the portrayal of Princess Elizabeth (born 1926), who was now heir presumptive. She had always been in the public eye – a likeness by Adams even appearing on the Canadian $20 banknote in 1935 – but from 1936 she became a focal point for popular attention. Photographic representations of the girl princess began to move away from the cosy domesticity of her childhood. Adams captured her at the age of twelve mimicking a pose adopted by her grandmother Queen Mary in 1920 (see page 72). In this extraordinary unretouched picture, Elizabeth carries herself with a poise and sophistication well beyond her years. The photograph inaugurated the young Princess into the traditional genre of portraiture widely seen on coinage and foreshadowed her future role.

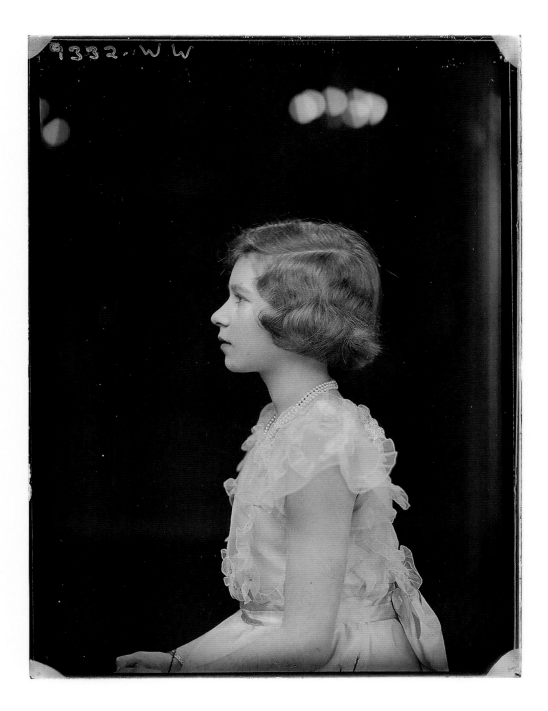

King George VI, Queen Elizabeth, Princess Elizabeth (later Queen Elizabeth II; centre) and Princess Margaret, 12 May 1937

Dorothy Wilding (1893–1976)

The scandalous abdication of Edward VIII provoked concern for the continuing viability of the British monarchy, and careful thought was undoubtedly given as to how it should be presented going forward. As Prince of Wales, Edward had been a much-loved but individual public figure. Lacking his brother's suave charisma, the newly proclaimed George VI cultivated a very different public image, reverting to the Victorian failsafe of a devoted, affectionate family at the heart of nation and empire.

Breaking with tradition, Dorothy Wilding's coronation portrait of 12 May 1937 placed the young princesses firmly at the heart of the image. The first official photographs of the Royal Family reasserted the traditional and reassuring notions of continuity, stability and longevity that underpinned the historic image of monarchy but the choice by Queen Elizabeth (1900–2002) of fashion photographer Dorothy Wilding demonstrated her desire to promote a sophisticated and contemporary approach. Wilding's strong tonal contrasts and modernist style, which was so fashionable at the time, seem slightly at odds here with a traditional court setting.

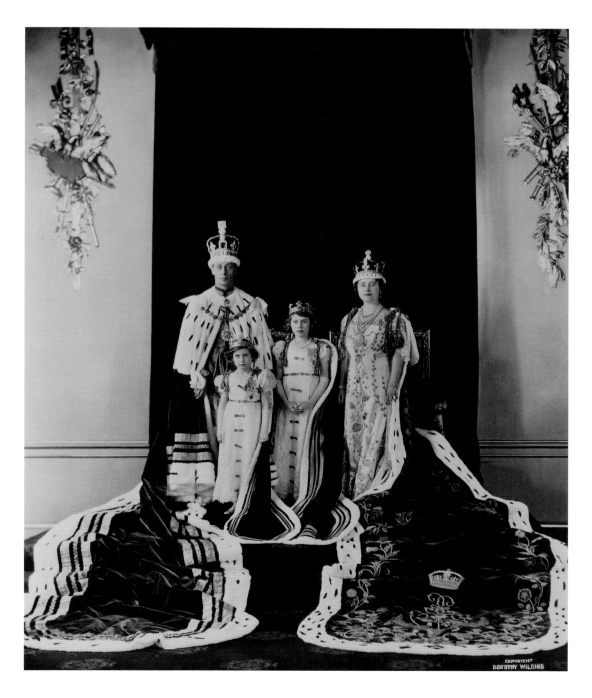

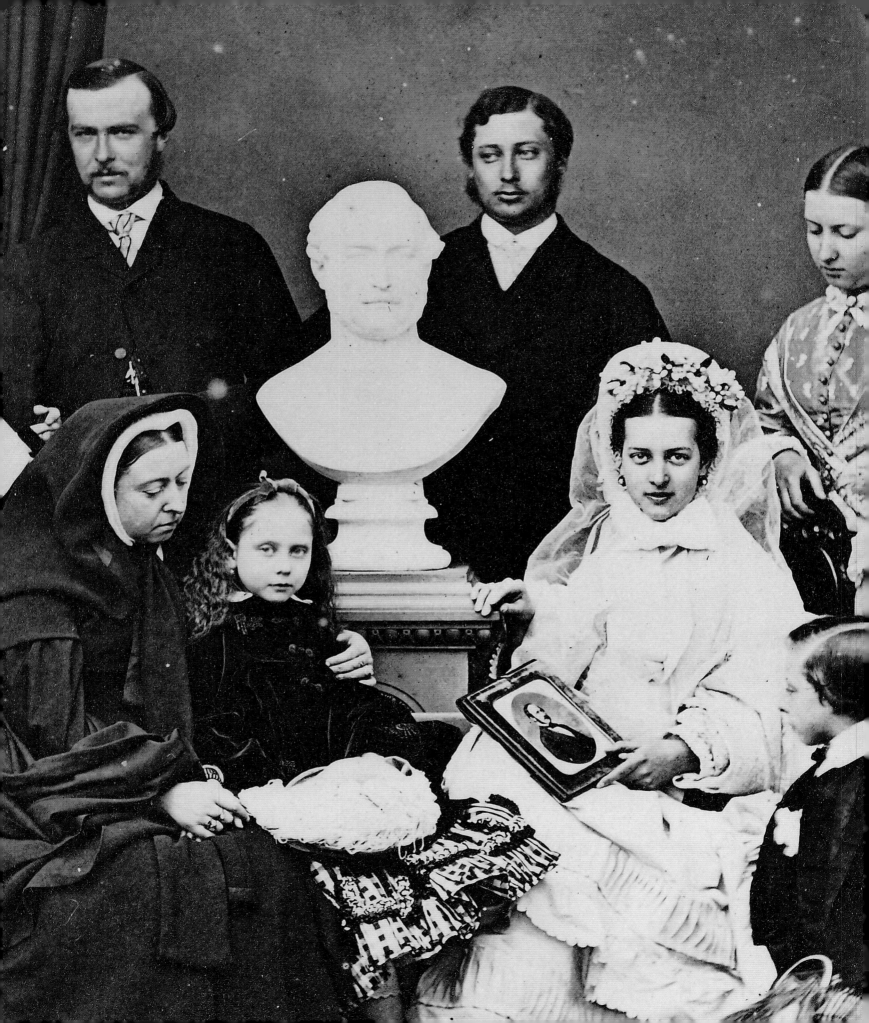

Sense and Sentiment

Group portrait with Queen Victoria and members of her family, with a bust of Prince Albert, April 1863; see page 81

John Jabez Edwin Mayall (1813–1901)

Photography has allowed the Royal Family, like its subjects, to record and share family milestones and personal moments of love and loss. Queen Victoria was an obsessive collector of significant objects, and photography allowed her to collect moments in time as well.

The Queen embraced successive advances in photographic technology to celebrate, commemorate and mourn people she loved. From their earliest experimentations, she and Albert were enchanted by photography's capacity to document their growing brood of children, so much so that a darkroom was installed at Windsor Castle. Together they began to compile a sequence of albums titled 'Portraits of Royal Children'. The Queen continued the project for the remainder of her life, and the collection eventually ran to forty-four volumes (see also page 84).

After the untimely death of Prince Albert in December 1861, photography became essential to Victoria's memorialization of her husband, both in public and in private. The publication of images of the vulnerable, grieving Queen created a new connection between Crown and subjects.

Later, Queens Alexandra and Mary continued the tradition, carefully documenting aspects of royal life, from domestic family scenes and private holidays to international state visits. Their albums could be those of any reasonably affluent young family, were it not for the grandiose portraits of ceremonial occasions mounted alongside the happy snapshots, transforming these family heirlooms into important historic documents.

**Princess Alexandra of Denmark
(later Queen Alexandra), 1860**

E. Lange (active 1854–69)

Determined to ensure that their playboy son, Albert Edward, Prince of Wales (later King Edward VII), did not stray into immorality, Victoria and Albert were keen that he married as early as possible. They enlisted the help of their eldest daughter, Vicky. Now settled in Germany with her husband, Vicky was well placed to identify a suitable royal bride. 'God knows! where the young lady we want is to be found!', the Queen wrote of her search. '[G]ood looks, health, education, character, intellect and a good disposition we want; great rank and riches we do not.'

Henry VIII (1491–1547) famously claimed that he had been deceived by the portrait of Anne of Cleves (1515–1557) on which he had based his fourth betrothal. For the first time, a photograph as well as a portrait of a potential bride could be sent to the monarch for consideration before any commitment was made. Both Victoria and Albert were immediately taken by this photograph of Alexandra sent to them from Denmark. On the reverse of the picture, written in Victoria's hand, are the words: 'So much admired by my beloved angel'.

Locket containing portraits of Queen Victoria and Prince Albert, 1861

John Jabez Edwin Mayall (1813–1901)

Camille Silvy (1834–1910)

The 1860s saw increasingly creative and widespread application of the sensational new technology that was photography. For Queen Victoria, jewellery had always been charged with emotion. She and Albert took great joy in sharing the deeply romantic pieces they had personally designed for each other, and a lifelong habit of including locks of a loved one's hair or a miniature portrait was now given new life with the potential for the incorporation of miniature photographic portraits. Evidently Prince Albert was pleased with John Mayall's commercial photograph of the Queen, in the new carte-de-visite form, because he chose it and his own image by Camille Silvy to face each other in this gold locket.

On the back of the locket is engraved 'Xmas 1861', but Prince Albert died on 14 December. The presents he had chosen for family and friends were already wrapped and labelled. This modest little locket must have been one of his posthumous gifts to the Queen, and it is difficult to imagine the intensity of her feelings when, quite alone, she opened it to find one of the last images of her beloved Albert within.

Mourning ring with a microphotograph of Prince Albert, 1862

John Jabez Edwin Mayall (1813–1901)

Prince Albert died on 14 December 1861 at the age of forty-two. His widow was inconsolable. The grieving Queen commissioned this memorial ring almost immediately after her husband's death. It contains a profile portrait of Albert taken by John Mayall earlier that year. The image is flanked by the letters 'V' and 'A', interlinked.

Determined to memorialize her husband, Queen Victoria commissioned elaborate frames for many of his photographs and organized others into albums. Two years earlier, the Queen had enthusiastically embraced the latest innovation for microphotography, which enabled images to be reduced to the size of a pinhead without any loss of detail and initiated a trend for incorporating photographs into jewellery.

The Queen seized on this new development as a way of ensuring that Albert remained indelibly as part of her own public image. Almost all depictions of her from this time on show that she wore Albert's image constantly in miniature photographic form, and she distributed it to family and acquaintances embedded in forms of jewellery for much of the remainder of her life.

**The Royal Family in mourning.
Queen Victoria (seated, right) with
(left to right) Victoria, Princess
Royal, Princess Alice and Prince
Alfred, 28 March 1862**

William Bambridge (1820–1879)

In the aftermath of Prince Albert's death,
Victoria used photography to document
the circumstances in which he had died
and to memorialize her husband. William
Bambridge was immediately summoned
to Windsor Castle to photograph
the Prince on his deathbed. Three
months later he was commissioned
to photograph the mourning family
alongside a newly commissioned bust
of the late prince, by William Theed
(1804–1891).

The resulting photograph was the
first to be released publicly after the
Prince's death. Never before had so
stark and vulnerable an image of a
sovereign been made public. The Queen,
in widows' weeds, sits at the centre of
the composition, surrounded by some
of her children. Albert's marble likeness
gazes serenely out of the scene and into
the light. Interestingly, Victoria's attention
is focused on a photograph of him that
she holds in her lap; a truer likeness
perhaps. Victoria mounted this picture in
an album. Underneath it she wrote, 'Day
turned into night'.

The nation shared Victoria's mourning
in the months after Albert's death.
The publication of this image and the
reproduction of numerous others of
the Prince kept William Bambridge
fully employed for months. By revealing
herself publicly at such an intensely
personal moment, the Queen brought
her subjects closer.

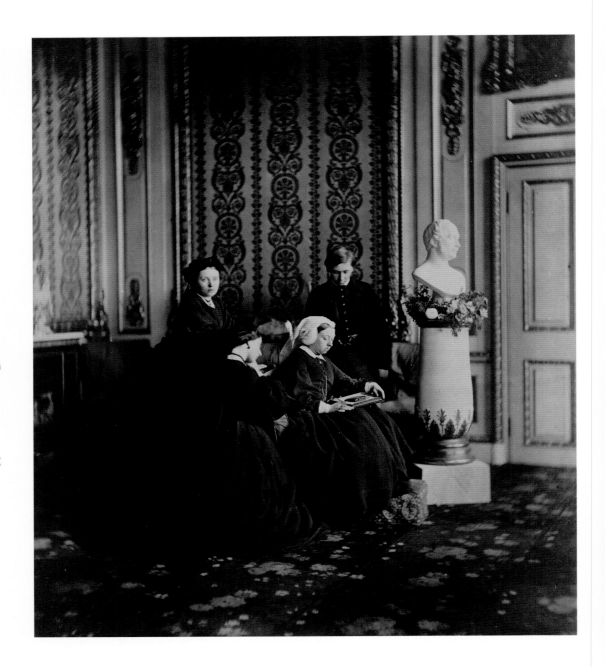

Group portrait with a bust of Prince Albert. Left to right: Princess Louise, Princess Alice of Hesse, Queen Victoria, Prince Louis of Hesse, Princess Beatrice, Albert Edward, Prince of Wales (later King Edward VII), Alexandra, Princess of Wales (later Queen Alexandra), Prince Leopold and Princess Helena, April 1863

John Jabez Edwin Mayall (1813–1901)

The Prince of Wales married Princess Alexandra of Denmark on 10 March 1863, but a shadow of continued mourning after Prince Albert's death was cast over the happy occasion. Photographs such as this group portrait by John Mayall served as a means by which the Queen could demonstrate her continuing and all-consuming grief, conveyed her desire to ensure that the memory of her husband remained central, and helped to sustain the impression that the model family unit remained complete.

William Theed's marble bust (see opposite) now usurps the bride as the focal point of the image. Alexandra holds a portrait of Albert in her hands, implying his approval of the union. In the years following his death, sales of photographs of the Prince Consort reached record levels; one distributor even reported selling 70,000 in one week. Their wide dissemination in carte-de-visite form meant that, as Alexandra did, the public too could hold their own portrait of the lost Prince and share in an intimate and collective experience of grief.

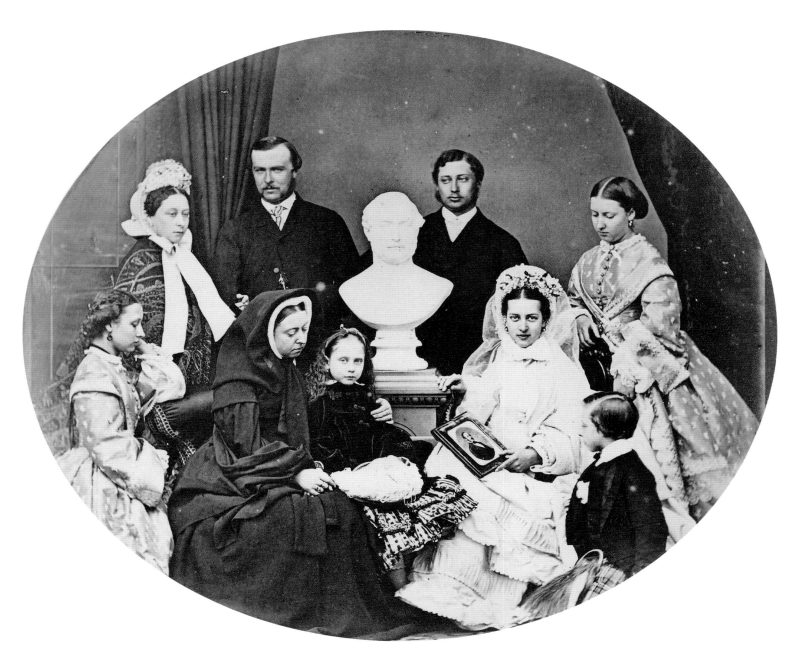

The marriage of Victoria, Princess Royal, 25 January 1858. Clockwise from top: Bridesmaids Princess Louise, Princess Alice and Princess Helena; Victoria, Princess Royal; Victoria, Princess Royal (right), Queen Victoria and Prince Albert

Thomas Richard Williams (1825–1871)

The first British royal wedding to be captured on camera took place on 25 January 1858 with the marriage of Victoria and Albert's eldest daughter, Princess Victoria, to Prince Friedrich Wilhelm of Prussia (later Frederick III; 1831–1888). These whimsical shots were taken before the wedding ceremony took place. Unlike modern royal wedding photos, invariably carefully orchestrated moments for public consumption, these intimate images show a deeply personal moment before the public spectacle began.

For Queen Victoria, her daughter's marriage was a political triumph but a personal loss. The Princess would soon be whisked away to Germany with her new husband and her absence would be keenly felt by the Queen. Victoria wrote of the occasion in her diary, 'Vicky was daguerreotyped in my room, & she & her dear father & I, together, but I trembled so that it has come out indistinct. Then, it was time to go. '

Once again, the preferred technology was the daguerreotype process. Wet-plate negatives had by now become the prevailing method. But although they allowed multiple copies, they tended to fade quickly. The marriage of their eldest daughter was an important political occasion, as well as a personal one, and Victoria and Albert were anxious to ensure the images' permanence. Photographer Thomas Richard Williams was chosen because of his well-known skill in copying daguerreotypes.

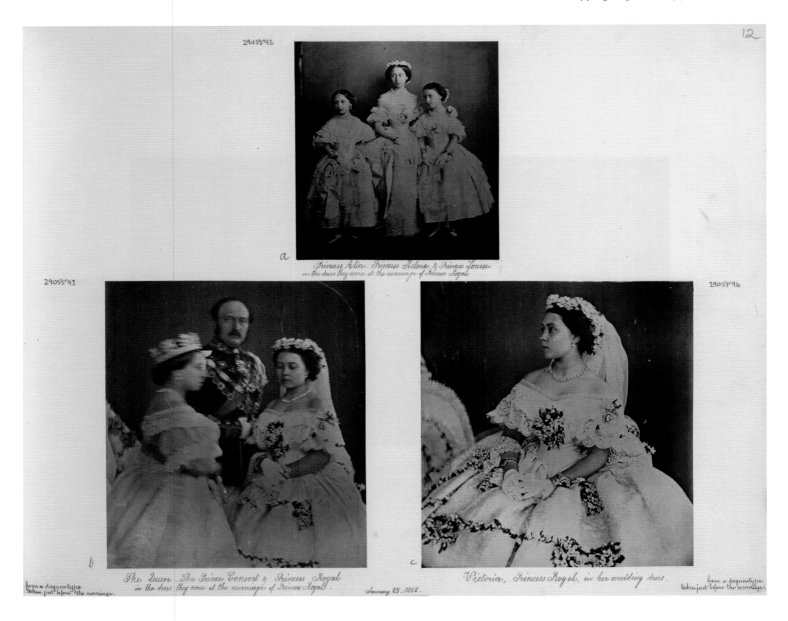

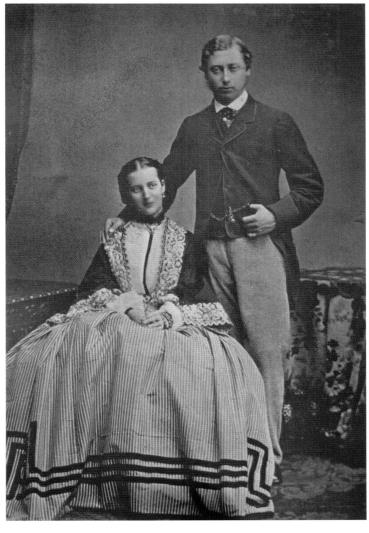

Albert Edward, Prince of Wales and Princess Alexandra of Denmark (later King Edward VII and Queen Alexandra), September 1862

Ghémar Frères (active 1859–94)

Since photography's inception its potential to open a window on to a private world has forced the monarchy to straddle a nebulous line between revealing just enough and revealing too much.

The newly engaged Prince of Wales and Princess Alexandra of Denmark provided a welcome dose of youth and glamour to the image of a monarchy that was grieving after the death of Prince Albert in December 1861. But the degree to which the public was prepared for the potential familiarity afforded by photography was yet to be defined.

These photographs by the Belgian royal photographers Ghémar Frères were published to mark the engagement of the Prince of Wales and Princess Alexandra. The couple's affection for each other is evidenced by the tenderness of their physical touch. Such demonstrations of intimacy were far removed from the restrained decorum of traditional images of royalty, however, and were met with surprise from a public that considered the photographs distinctly risqué. Perhaps unsurprisingly, they were both a sell-out and a debacle. Sales of these pictures, along with another of Victoria, exceeded 2 million copies by 1866 but criticism abounded that the couple had gone too far, had exposed too much of themselves, their private feelings and desires.

The *London Review* of 10 April 1863, in an article entitled 'Photography and Bad Taste' stated: 'That a young lady may have stood, in that attitude of tender watching at the chair of her future husband, is likely enough, – but she would never think of being photographed at so confiding a moment … can Paterfamilias possibly believe that the Prince and Princess allowed themselves to be shown after this fashion to the general gaze?'

The nine children of Queen Victoria and Prince Albert at The Rosenau, Coburg, Germany. Left to right: Princess Louise, Princess Beatrice, Princess Alice of Hesse, Prince Alfred, Albert Edward, Prince of Wales (later King Edward VII), Prince Arthur (seated), Princess Helena, Prince Leopold and Victoria, Princess Royal, 1865

Robert Jefferson Bingham (1825–1870)

Photographs depicting all nine of Victoria and Albert's children are rare. This one was taken during the summer of 1865 when the family congregated at Albert's childhood home of The Rosenau in Coburg, Germany, for the unveiling of a memorial statue to the Prince. By this time the Princess Royal, the Prince of Wales and Princess Alice were all married and Vicky and Alice living in Germany.

In 1848 Victoria had begun collecting and compiling the photographic portraits commissioned of her children in a series of albums known as 'Portraits of Royal Children'. Victoria's interest in photography had always centred on portraiture, and after Prince Albert's death her engagement with the medium as an art form waned. Instead, she used

photographs to help her deal with her grief, concentrating her collecting on their potential to help her to document, memorialize and remember the happy moments of family life.

By the end of her life, Victoria had compiled forty-four of these albums, spanning the years 1848 to 1899 and including photographs of three generations of royal children. Although intended for private use, many of the photographs were released to the public.

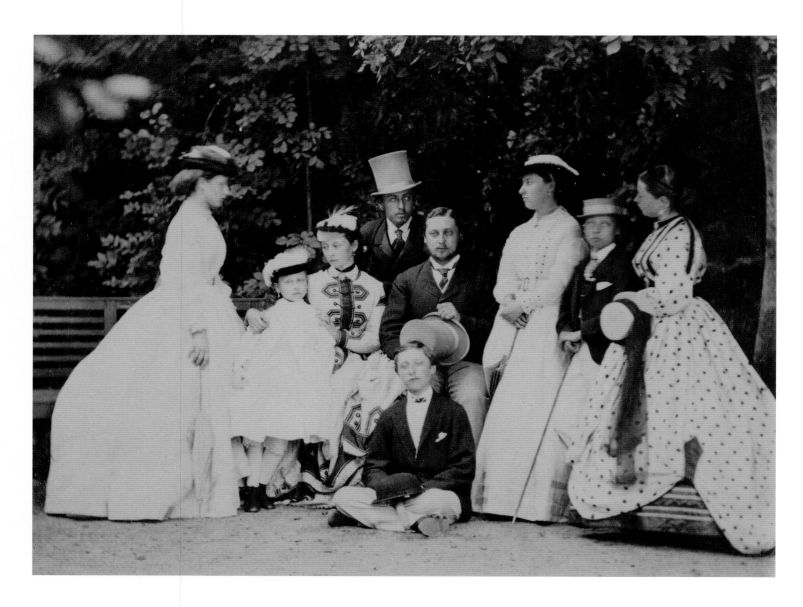

A page from a collage album belonging to Alexandra, Princess of Wales (later Queen Alexandra), c. 1866–69

Alexandra, Princess of Wales (1844–1925) and various photographers

The Princess of Wales (centre background) showed an early interest in photography and was an enthusiastic sitter. Her first creative engagement with the medium was through the imaginative presentation of professionally taken photographs in albums. The creation of richly decorated photocollage albums was a popular pastime for aristocratic Victorian ladies during the 1860s and 1870s.

Such albums provided a humorous and fanciful counter to the conventionality of mid-century studio portraiture. Considered to be 'society' rather than family albums, they straddled private and public worlds. They were intended to be pored over in drawing rooms and discussed with visitors, revealing their female creator's ingenuity and providing an opportunity to add coded messages in their making. Many of the photographs used in Alexandra's scrapbook were those released publicly, so their presentation is a colourful expression of her personality and insight into her relationship with the sitters. Imaginative vignettes establish the Danish princess as being at the centre of the royal court and fashionable society. Her compositions carefully flatter her new husband, Albert Edward, the Prince of Wales (seated front left), and show her affection for and integration into the British Royal Family.

Conversely, photographs of the Prince of Wales in the surviving album of one of his mistresses, Lady Filmer, suggest that for some makers the albums could also offer the opportunity to transmit more subversive messages.

Pages from Queen Mary's personal photograph album, 1905

Queen Mary (1867–1953) and various unknown photographers

Princess Mary (later Queen Mary) was an avid collector of family photographs. Thirty-three albums containing about 10,000 photographs record seventy years of Royal Family life from 1880 to 1952. Formal studio portraits are mounted alongside spontaneous family snapshots.

The development of portable handheld cameras in the final decades of the nineteenth century freed the medium from the constraints of the studio, allowing for a more relaxed and less exacting approach. All of a sudden, the camera was able to capture the energy of real life.

These two pages from 1905 are typical of many of Mary's albums. A stately professional portrait of the wedding of Mary's cousin, Princess Margaret of Connaught, to the Crown Prince of Sweden is mounted alongside a series of photographs of the young Princes Albert and Edward of York (later King George VI and King Edward VIII) with one of their cousins, paddling and swimming in the sea at Osborne House.

Mary took a close personal interest in creating these albums. Her careful documentation, the meticulous nature of her collecting and the flourish of her elaborate and changing signatures, with which she opens each album, suggest her appreciation of them as historic documents for posterity as well as family mementos.

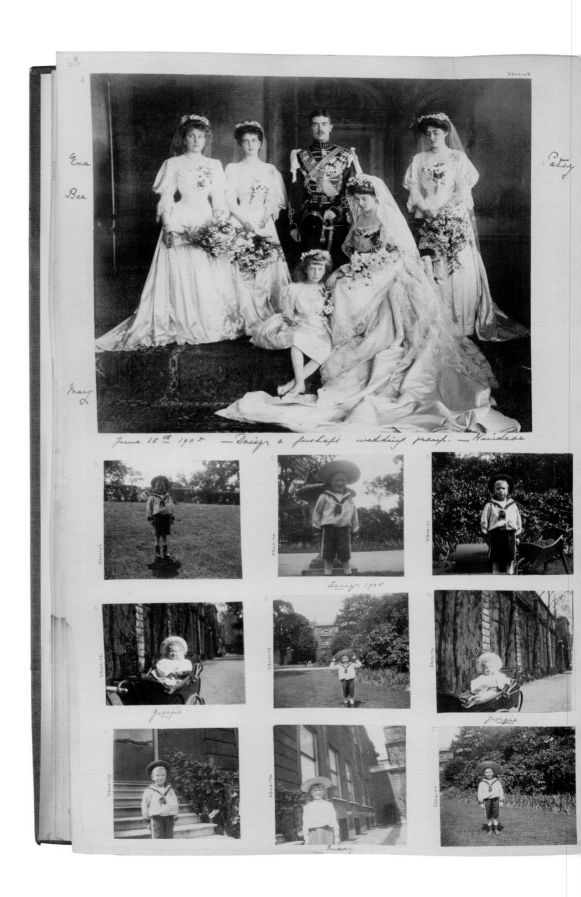

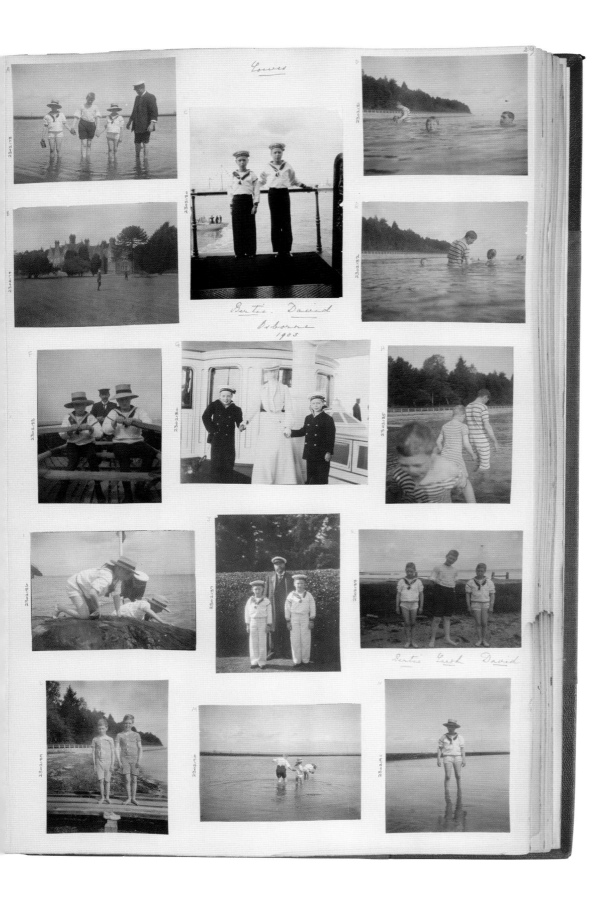

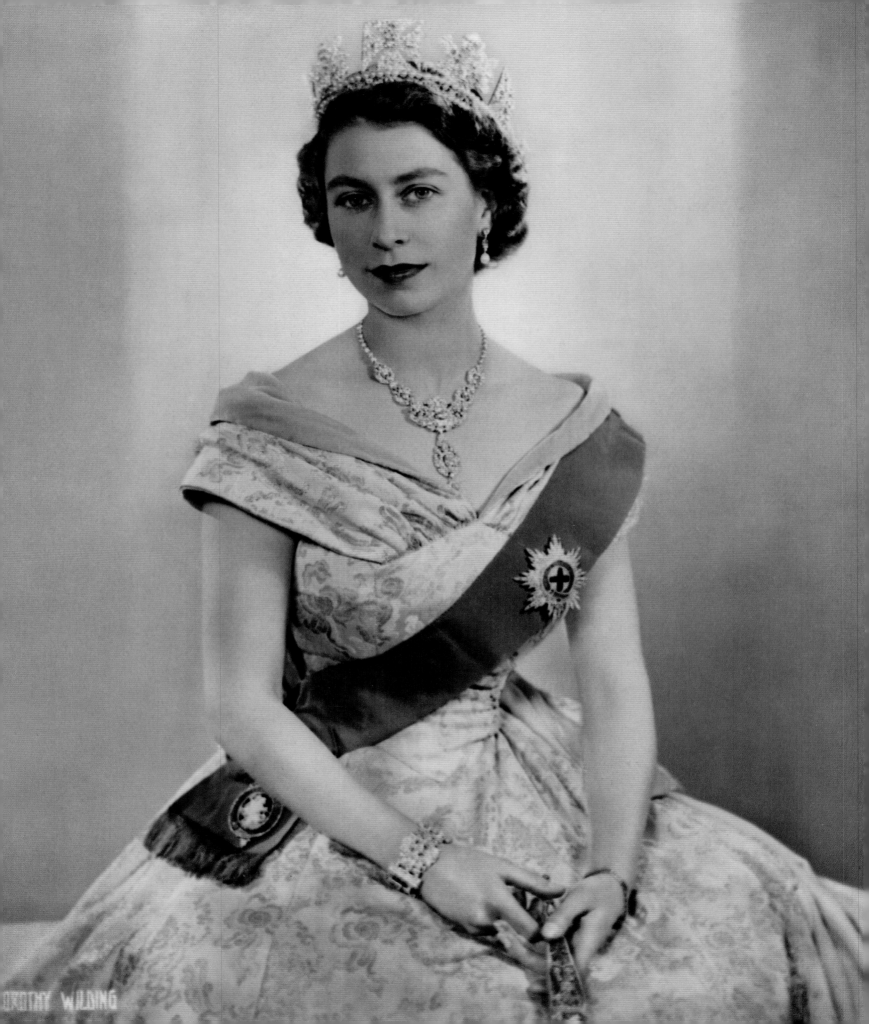

A New Elizabethan Age

When the young Queen Elizabeth II acceded to the throne in 1952, she quickly demonstrated her determination to maintain the style of monarchy established by her grandfather and her father.

In the decade before The Queen's birth and during her childhood, royal popularity was dented by both global and family crises that threatened the stability of monarchy. Vast social change precipitated by the First World War had necessitated the final decline of a Victorian style of monarchy and seen the birth of the House of Windsor in 1917. The abdication of Princess Elizabeth's uncle, King Edward VIII, after a reign of less than a year brought her father, King George VI, unexpectedly to the throne. Within three years of his accession, the country was at war once again and the British Empire in terminal decline. King George V and King George VI used their photographic commissions to project an image of steadfast duty and family values, combined with images of the splendour and power of monarchy in order to challenge Britain's diminishing role on the world stage, an approach that Queen Elizabeth II would emulate during the first decade of her reign.

The Queen favoured three photographers, with diverse yet complementary styles. Dorothy Wilding's striking studio portraits lent a contemporary edge to the fresh, young queen (see, for example, opposite and pages 120–121). In contrast, Cecil Beaton's opulent images captured the mystique and magic of monarchy (see page 125). Lisa Sheridan provided relaxed images of The Queen's young family, demonstrating her role as wife and mother as well as monarch (see page 122–23).

This careful balance between intimacy and splendour, light-heartedness and solemnity, and domestic and glamorous would carry The Queen through the first decade of her reign, until the Swinging Sixties demanded a renewal and reorientation of the royal image.

Queen Elizabeth II, 15 April 1952; see page 120

Dorothy Wilding (1893–1976)

Edward, Prince of Wales (later King Edward VIII) with Digger the wallaby, 1920

Probably T.P. Fisher (life dates unknown)

Following the end of the First World War Edward, Prince of Wales embarked on an extensive international tour, designed to demonstrate royal gratitude to the British overseas dominions for their vital support and to foster closer ties between Crown and Empire.

After visits to North America and the West Indies, in March 1920 the Prince arrived in Australia where his two-month stay was widely publicized. Edward visited 110 places across the country, and was invariably greeted by rapturous crowds. A diary kept by his staff recorded that in Melbourne, 'Confetti is appearing in great and unpleasant quantities, and the touching mania has started, only owing to the heartening disposition of the Australians the touches are more like blows and HRH arrived half blinded and black and blue.'

Crowds nicknamed the Prince of Wales 'Digger', a term used to describe the soldiers who dug trenches on the front line, in reference to his own widely publicized involvement (see page 187). When he was gifted a wallaby in Victoria the little marsupial was also named Digger. The press were invited to photograph the encounter and the resulting images showed a warm, affectionate and sincere side to the Prince, unusual in public depictions of royal men.

Elizabeth, Duchess of York (later Queen Elizabeth), 2 July 1924

Vandyk (active 1881–1947)

Lady Elizabeth Bowes-Lyon, with her lively personality and love of naughtiness, was a surprising addition to the Royal Family on her engagement to the Duke of York, the second son of King George V and Queen Mary, in 1923. The vivacious daughter of the Scottish Earl of Strathmore may have had her doubts too: it took three proposals from the Duke before she accepted.

As the second son of the monarch, the Duke of York was afforded slightly more privacy than his elder brother, the Prince of Wales, as was his family. During the early years of her marriage the Duchess delighted in private photography. She kept extensive albums of personal snapshots taken by her husband and friends, recording family milestones and lively gatherings both at Glamis Castle, owned by her family, in Scotland and Royal Lodge in Windsor Great Park. Being increasingly in the public eye, however, she found the endless demands for official portrait sittings and press photographs tiresome.

The Vandyk studio had a longstanding relationship with the Royal Family. It had photographed Queen Victoria in 1880 and was used often by George V and Queen Mary. In January 1923 it was employed to take the official engagement photographs of the Duke of York and his fiancée, and was used again in 1924 to depict the fashionable young newlyweds. Elizabeth's solemn reserve in these official portraits, however, hides a more playful side to her, rarely seen outside of her private family albums.

Elizabeth, Duchess of York (later Queen Elizabeth) and Princess Elizabeth (later Queen Elizabeth II), May 1926

Richard N. Speaight (1875–1938)

Acclaimed court photographers Speaight Ltd was commissioned to take the first professional photographs of five-week-old Princess Elizabeth in May 1926. Richard N. Speaight was frequently commissioned to photograph royals and aristocrats at weddings, christenings and coronations but had a particular passion for photographing children. Throughout the first decades of the twentieth century, he was popularly known as the 'Photographic Laureate of Children's Photographers'. Speaight's reputation as a photographer of mothers and their children had earned him many prestigious commissions, including requests to photograph both the Duke and Duchess of York when they were children. It was fitting, then, that his skills would be called upon to celebrate the arrival of their first child.

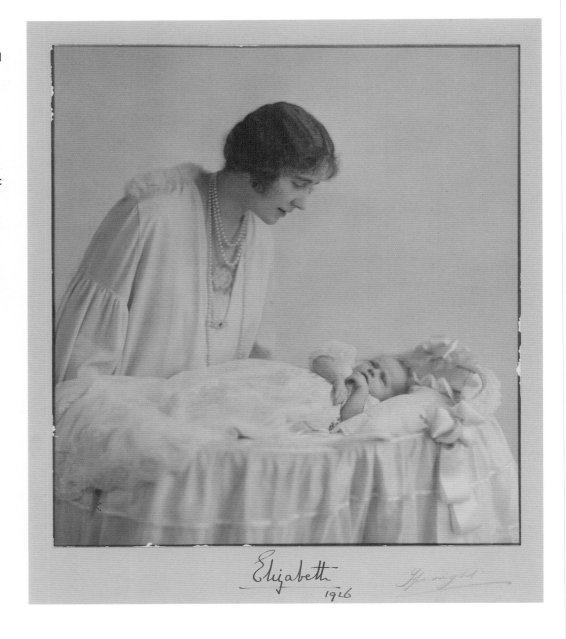

TOP
Princess Elizabeth (later Queen Elizabeth II), 20 January 1927

BOTTOM
Queen Mary and Princess Elizabeth (later Queen Elizabeth II), 31 March 1927

Marcus Adams (1875–1959)

The Duke and Duchess of York were dispatched on a six-month Commonwealth tour of Australia and New Zealand in 1927. At just a year old, Princess Elizabeth was considered to be too young to accompany her parents and she was cared for at her grandparents' home.

During Princess Elizabeth's stay with them, Queen Mary took her granddaughter to The Children's Studio in London's Mayfair for four sittings with the renowned children's photographer Marcus Adams. Adams was first commissioned to photograph Princess Elizabeth as a newborn in 1926 and went on to photograph two generations of royal children in what would become a thirty-year relationship with the Royal Family.

A photograph from the Princess's sitting on 20 January 1927 shows her gazing at a picture of her mother in a magazine, which was held up by an invisible hand. Another photograph from a sitting two months later shows Queen Mary holding her granddaughter on her lap. The resulting images were sent to the Yorks as monthly updates on their baby's progress and assurance of her well-being until their return in June. The photographs also served as a memento of this special time shared between grandmother and granddaughter.

Princess Elizabeth (later Queen Elizabeth II), 5 July 1928

Marcus Adams (1875–1959)

Marcus Adams documented much of Princess Elizabeth's childhood and eventually that of her own children, receiving two Royal Warrants – one from Queen Elizabeth (later Queen Elizabeth The Queen Mother) in 1938 and the other from The Queen in 1956.

Adams loved working with children, once stating: 'I'm glad I photograph children … I regard photographs of our children in the Press, and perhaps especially the Royal Children, as some of the best ambassadors of good will we can have.' He also alluded to the challenges, writing: 'Oh, the difficulty of portraying a child's expression.'

In one of his best-known sittings with Princess Elizabeth, in July 1928, Adams captured her in a pose reminiscent of that of Prince Arthur taken by Leonida Caldesi in 1857 (see page 37). Both reference the angels in Renaissance artist Raphael's painting *The Sistine Madonna*.

4423-MM.

Princess Elizabeth (later Queen Elizabeth II), 1929

Prince Albert, Duke of York (later King George VI) (1895–1952)

The Duke of York (later King George VI) was born into a world in which photography was the norm. His own childhood had been minutely documented on camera and he inherited the family passion, becoming an enthusiastic amateur photographer himself. The Duke and Duchess of York's private photo albums chart the familiar transition from courting couple gallivanting with friends at house parties across the country to newlyweds and soon, new parents.

In 1930 the Duke of York offered three of his own photographs for a charity exhibition of royal photography hosted by Kodak. This enchanting image of a three-year-old Princess Elizabeth against a backdrop of Madonna lilies (a reference to the Princess's nickname, Lilibet) was among those selected.

The photograph was taken at St Paul's Walden Bury, Hertfordshire, the Duchess of York's family home. As with many of the royal pictures later released publicly, it was probably taken as a snapshot for private enjoyment and as a result has the appearance of a relaxed family moment.

Kodak often hosted exhibitions and competitions for amateur photographers as a means to promote their 'easy-to-use' cameras and photography as a leisurely pursuit. Public interest in the private lives of the Royal Family drew large crowds and allowed the family to harness this curiosity to raise funds for causes they supported.

LILIBET. 1932

MARGARET.

ABOVE
**Princess Elizabeth (later
Queen Elizabeth II), 21 July 1931**

ABOVE RIGHT
**Princess Margaret, 13 December
1935**

Marcus Adams (1875–1959)

Marcus Adams continued to capture
Princess Elizabeth as well as her younger
sister, Princess Margaret (1930–2002), as
they grew up. The whimsical results of his
sittings appear to have been firm family
favourites and some were incorporated
into personal cards produced for the
Royal Family's private use.

A photograph from a sitting with
the six-year-old Princess Elizabeth in
July 1931 was subsequently used on
a card the following year. The image
is surmounted with her title 'HRH
Princess Elizabeth of York' and is signed
with a tentative hand, 'LILIBET, 1932'.
Another card shows a charming full-
length portrait of a five-year-old
Princess Margaret from 1935 and it,
too, is signed, with a confident child's
hand, 'MARGARET'.

Prince George, Duke of Kent (left) and Prince Albert (later King George VI), 1932

Marcus Adams (1875–1959)

Marcus Adams moved from Reading to London to open The Children's Studio in 1920. It was located at 43 Dover Street, an address shared with society photographer Bertram Park (1883–1972) and his wife, the photographer and miniature painter Yvonne Gregory (1889–1970). The photographers had their own individual studios and assistants, but shared the processing facilities. The idea had come from Park, who on 3 February 1919 wrote to Adams: 'If you ever make up your mind to come to London, I would be quite willing to consider a business

arrangement with you, myself. Ever since I have got thoroughly on my legs here I have constantly refused to do portraits of children, and I am being continually asked to.' Adams's decision to accept Park's offer would prove to be auspicious.

In 1932, after official sittings with Park, Prince Albert and his younger brother, the Duke of Kent, could not resist paying a visit to Adams. They are playfully pictured here having fun in The Children's Studio, their uniforms and orders creating a delightful and telling juxtaposition with the toys clutched in their hands.

Princess Alice, Duchess of Gloucester, 6 November 1935

Madame Yevonde (1893–1975)

Born Lady Alice Montagu Douglas Scott, the younger daughter of the Duke of Buccleuch and Queensbury, the Duchess of Gloucester (1901–2004) became the first royal bride to be photographed in the new colour process when she married the third son of King George V and Queen Mary, Prince Henry, Duke of Gloucester (1900–1974), on 6 November 1935. The choice of Madame Yevonde was a novel move and showed the Royal Family to be a modern institution. The famed court photographer had exhibited her ground-breaking 'goddesses' series in the summer of 1935 and was a pioneer in the art of colour photography. Yevonde mastered the new Vivex colour process to captivating effect and overturned widespread scepticism about the merits of colour photography. A 1932 review in the *British Journal of Photography* of her first exhibition to include colour photographs concluded that 'Mme Yevonde has most emphatically established her place among the leading and most up-to-date exponents of photographic portraiture.'

Princess Alice also gave designer Norman Hartnell (1901–1979) his first royal commission, to make her wedding dress and those of her bridesmaids – one of whom was her new niece-by-marriage, the future Queen Elizabeth II.

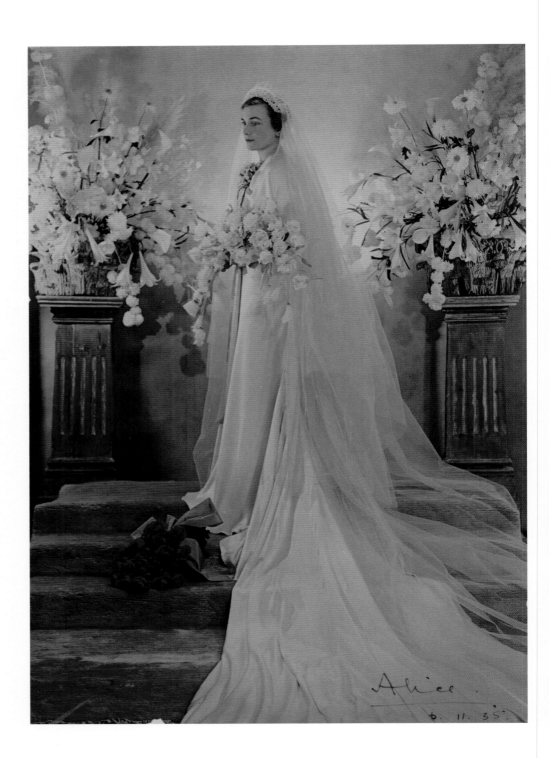

Princess Louise, c. 1936

Cecil Beaton (1904–1980)

The first royal commission by the renowned photographer Cecil Beaton was not a theatrical masterpiece but rather a glamorous vestige from another era: this little-known portrait of Princess Louise, Duchess of Argyll. Beaton had launched his career a decade earlier and quickly became an established fashion photographer, working for British and US *Vogue* and *Vanity Fair* as well as photographing high society and Hollywood celebrities.

Louise, the fourth daughter of Queen Victoria, had herself once been a trailblazer of considerable artistic prowess and had an excellent eye. As one of the first people in the world to have spent a lifetime in front of the camera, she had strong opinions on retouching, particularly regarding her own features. Following the sitting she and Beaton exchanged numerous letters, in which she advised in minute detail how to enhance or tone down various aspects of her likeness. Shortly after Beaton received Louise's final letter, an addendum from her lady-in-waiting arrived: 'Did I in the note ask you not to have too much light on the nose as it is inclined to make it too prominent H.R.H. thinks?'

The Duke and Duchess of York (later King George VI and Queen Elizabeth) with Princess Elizabeth (later Queen Elizabeth II) and Princess Margaret at Y Bwthyn Bach in the grounds of Windsor Castle, June 1936

Lisa Sheridan (1894–1966) for Studio Lisa

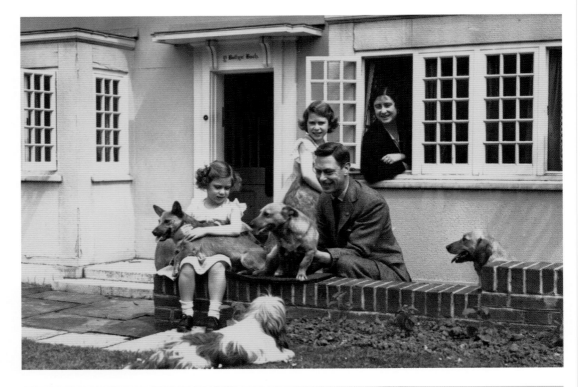

The married couple Lisa and Jimmy Sheridan had only recently started gaining recognition for their photographic venture, Studio Lisa, when fate struck. As Lisa was on her way to London one day, an acquaintance asked her, 'How would you like to photograph Princess Elizabeth?' To her amazement the proposal was a serious one, and the Sheridans were soon summoned to Royal Lodge at Windsor.

In June 1936 they arrived – albeit late – to the first of what would become many sittings with the Royal Family. Lisa wrote of that first encounter: 'Before I had time to knock, the door opened as if by itself … I found myself face to face with the Duke of York … Two little girls came running down the stairs jostling each other to be the first to shake hands.'

The resulting photographs show the family entirely at ease in relaxed domesticity, playing together with their dogs in the miniature thatched cottage Y Bwthyn Bach, or 'The Little Cottage', given to Princess Elizabeth for her sixth birthday by the people of Wales. Lisa Sheridan's photographs of the Yorks proved a strategically homely counter to the lavish lifestyle of the playboy King, and for the next three decades Studio Lisa would create some of the most intimate and revealing photographs of the Royal Family.

Princess Elizabeth (later Queen Elizabeth II), July 1936

Lisa Sheridan (1894–1966) for Studio Lisa

Edward VIII acceded the throne on 20 January 1936, unmarried and childless. As Princess Elizabeth was the eldest child of the next in line (Prince Albert, later King George VI), the possibility that she might eventually become queen was not unrealistic. The press followed her development with avid attention, and demand for photographs led to a regular timetable of professional commissions.

In common with generations of royals before her, Princess Elizabeth was frequently pictured with her dogs. Dogs have long occupied a privileged position within the royal household and played an important role in royal representation thanks to their association with loyalty, protection and unconditional love. Charles I popularized the King Charles spaniel in the seventeenth century, with their inclusion in court portraits. When Mary II and William III ascended the throne in 1689 they brought their pugs to Britain as symbols of the House of Orange, and the Duke and Duchess of Windsor were also admirers of the breed, including their pets in many of their photographs (see page 132).

Horses and dogs appeared frequently in the photographs of the young princesses chosen by the Duke and Duchess of York for public release, perhaps because of their photogenic quality and the informality they lent to a picture. This charming photograph shows a ten-year-old Elizabeth affectionately embracing a very contented Dookie, the first corgi to join the Royal Family. It was among the first of many photographs that would establish the breed as a renowned symbol of her reign.

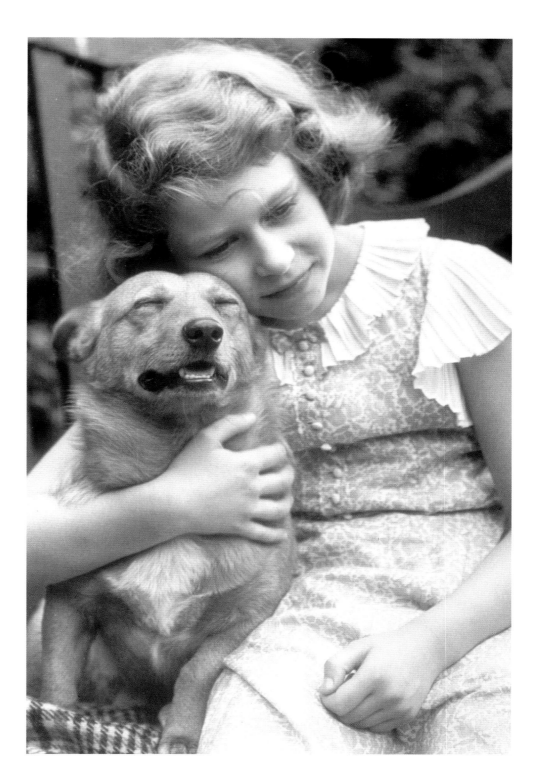

Wallis Simpson in the grounds of Château de Candé, France, 1937

Cecil Beaton (1904–1980)

In the immediate aftermath of Edward VIII's abdication in December 1936, the American socialite Wallis Simpson (1896–1986) was widely condemned by the British public. Prevented from marrying the Duke of Windsor until her divorce was finalized, she retreated to France. Mrs Simpson was keen to reshape her public image and commissioned Cecil Beaton to photograph her at Château de Candé, the home of Franco-American millionaire Charles Bedaux and his wife, Fern, with whom she was staying.

In contrast to the haughty severity of many of her previous photographs, Beaton suggested a softer approach to this commission, designed to ameliorate her standing her in the public eye. Inspired by Horst P. Horst's portraits of the Duchess of Kent in 1934 (see page 193), Beaton designed a romantic shoot in the chateau's garden with Wallis dressed in a gown from her trousseau.

Surprisingly, Wallis opted to wear a highly controversial garment: a white silk dress with a sheer panel around the ribcage and a large red lobster printed on the centre front of a semi-sheer skirt. Designed by Elsa Schiaparelli (1890–1973) in collaboration with Salvador Dalí (1904–1989) in 1937, the dress proved scandalous due to the sexual connotations of the lobster's placement. Beaton took more than one hundred photographs during the sitting, and a series was published in an eight-page spread in *Vogue*. Despite the success of the commission in fashion terms, the public-relations motive for the shoot was undermined by the controversy surrounding the dress, and Wallis's public image as a member of the Royal Family was little improved.

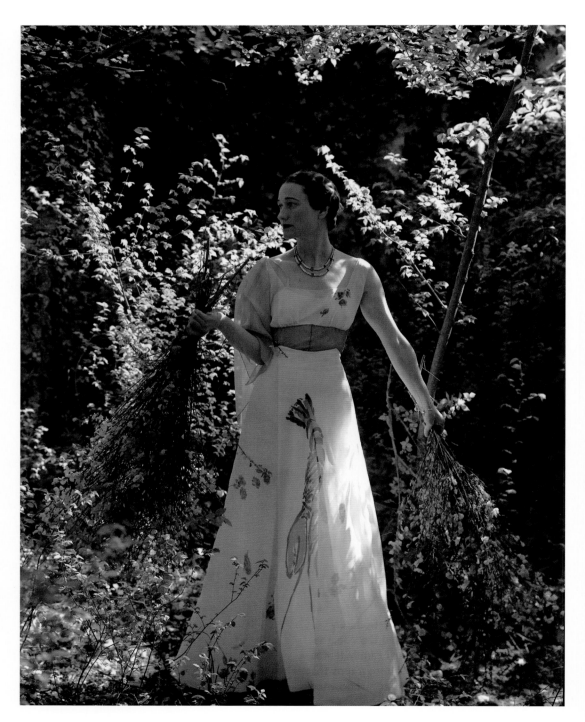

**The Duke and Duchess of Windsor
at Château de Candé on their
wedding day, 3 June 1937**

Cecil Beaton (1904–1980)

Six months after the abdication of
Edward VIII, the Royal Family and the
nation were still profoundly shaken by
the crisis. The wedding in France of the
Duke and Duchess of Windsor on 3 June
1937 was consequently a private affair
with only a few guests – none of them
royal – in attendance.

Despite the low-key nature of the
occasion, Cecil Beaton was commissioned
to document the fashion-forward pair
at Château de Candé. Beaton recorded:
'We started off by taking the Duke alone.
He was very pliable and easy to pose.'
However, as an experienced sitter, the
Duke evidently had strong opinions on
how he was portrayed: 'He will not allow
himself to be photographed on the right
side of his face and only likes his parting
to be shown.'

The resulting photographs of the
couple reflect the mixed emotions of
the day. Beaton recalled of the Duke, 'his
expression though intent was essentially
sad' but despite this the Duke was
satisfied with the results. The studied
nonchalance of the images is much
more akin to magazine fashion pictures
than it is to the romantic tradition of
royal wedding photographs. Beaton's
treatment of the pair as society figures
rather than royals shows a decisive
departure from the traditional approach
to royal image-making and reflects the
Duke's altered status.

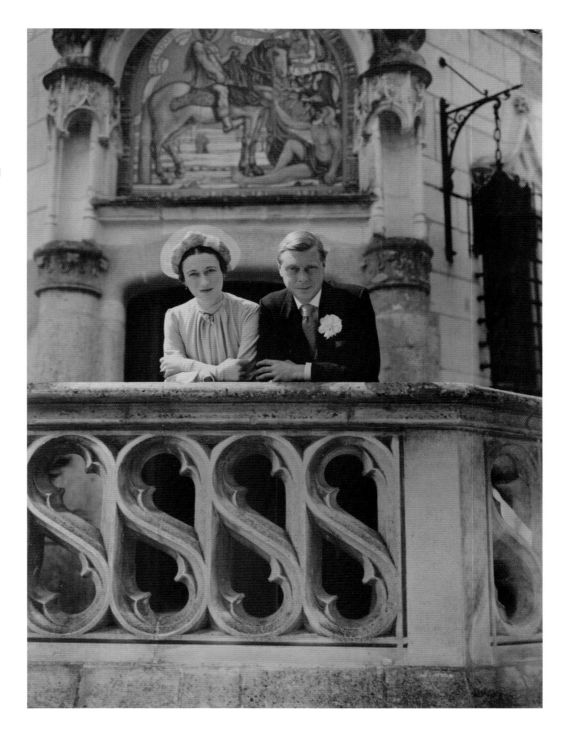

BELOW
Princess Alice, Duchess of Gloucester, 1961

BELOW RIGHT
Princess Marina, Duchess of Kent, 1939

OPPOSITE
Queen Elizabeth, 1939

Cecil Beaton (1904–1980)

Between 1938 and 1939 Cecil Beaton was commissioned to photograph the wives of the three royal brothers, Prince Henry, Duke of Gloucester, Prince George, Duke of Kent and King George VI. Princess Alice, Duchess of Gloucester, Princess Marina, Duchess of Kent (1906–1968) and Queen Elizabeth were all depicted in Beaton's characteristic fairy-tale style to magnificent effect.

Beaton's recollections of his first meeting with the relatively new Queen suggest her tentative desire to project a more majestic picture of herself than had previously been shown to the public. ' "I thought perhaps another evening dress of – tulle? – and a – tiara?" All this very wistfully said and rather apologetically with a smile.'

Queen Elizabeth would become the main focus of royal images in the following years. Beaton's photographs of her and her sisters-in-law imbued royalty with a new aura of youth and glamour that projected them to celebrity status in the 1930s. Each had a distinctly personal style: Queen Elizabeth (opposite) was feminine and staunchly nationalistic; Princess Marina (below) was fashionable and understatedly elegant; and Princess Alice (below left) epitomized the idea of a refined Englishness.

All three were framed by Beaton's hand-painted backdrops inspired by the works of the eighteenth-century artists Giovanni Piranesi and Jean-Honoré Fragonard. The flowers placed behind them were often picked from Beaton's own garden. The original photograph of Princess Alice from 1938 has been lost, but like her sisters-in-law she continued to commission Beaton for decades. This photograph, taken in 1961, shows her in front of an elegant Chinese lacquer screen. The effect of Beaton's photographs was to create a homogeneous image of royalty, while still capturing the uniqueness of each sitter.

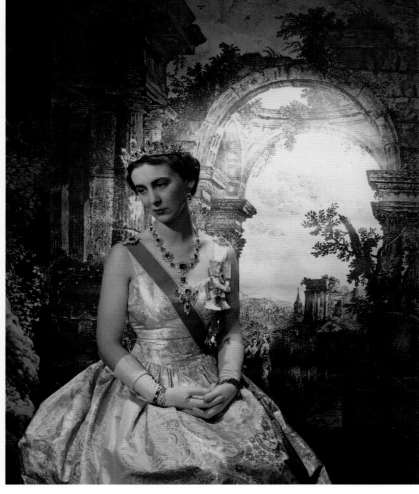

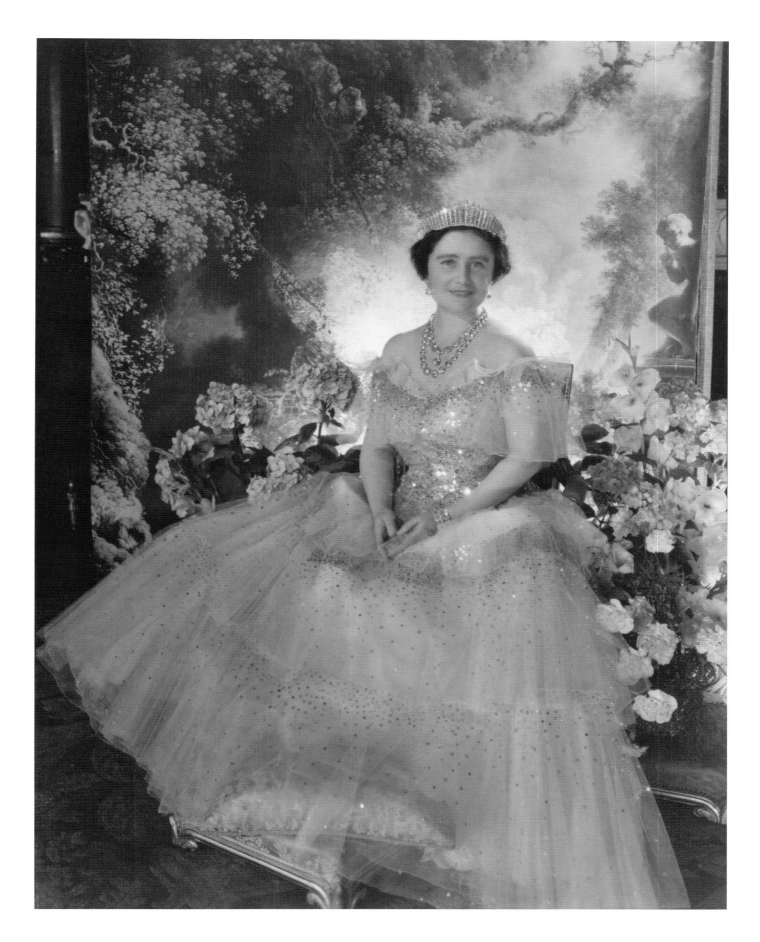

BELOW
Queen Elizabeth in the gardens of Buckingham Palace, 1939

BELOW RIGHT
Queen Elizabeth in the Blue Drawing Room, Buckingham Palace, 1939

Cecil Beaton (1904–1980)

In 1939 an iconic photoshoot at Buckingham Palace established a new romantic image for monarchy in Britain, recasting the Queen as the focal point of the new reigning family and celebrating her success in taking on an unexpected role.

The magic encapsulated in the photographs was thanks to the creative ingenuity of two men whose whimsical and historically informed vision would shape the image of monarchy in Britain for much of the twentieth century: couturier Norman Hartnell and photographer Cecil Beaton.

Hartnell had been entrusted to create Queen Elizabeth's wardrobe for a state visit to Paris in 1938 but the death of her mother, the Countess of Strathmore, just five days prior to departure necessitated the speedy production of a new mourning wardrobe. At Hartnell's ingenious suggestion, it was to be entirely white.

Beaton was deeply inspired by eighteenth- and nineteenth-century portraiture, and his approach served to reinforce the uplifting, dreamlike majesty of Hartnell's gowns. Combined, their work served to create an image of what Beaton called 'the Fairy Queen in her ponderous Palace'. His photographs situated Queen Elizabeth firmly within the palatial surroundings of Buckingham Palace's Blue Drawing Room and in its gardens. He encouraged her to pile on the jewellery and, by photographing her against the light, enveloped her in a mystical, other-worldly glow. The photographs would prove an enduring success, with images from the shoot appearing on the covers of magazines across the empire.

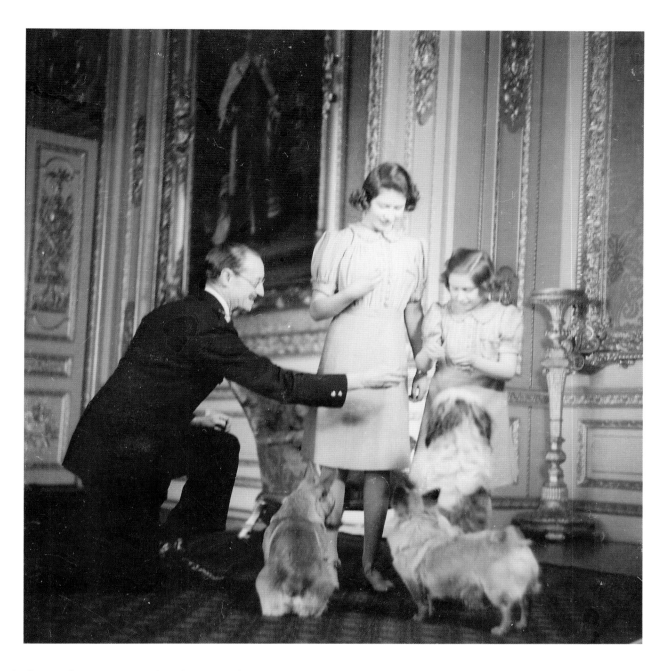

Princess Elizabeth (later Queen Elizabeth II; centre) and Princess Margaret with dogs, being posed for a photograph in Windsor Castle by Marcus Adams's associate, Bertram Park, 18 March 1941

Marcus Adams (1875–1959)

On 18 March 1941 Princesses Elizabeth and Margaret held their last sitting with Marcus Adams. The children's photographer had a strict age limit of sixteen unless the sitter was accompanying his or her own children. Princess Elizabeth was by now almost fifteen years old and gradually evolving her public image from royal child to heir apparent.

Their final sitting took place at Windsor Castle, instead of The Children's Studio at 43 Dover Street, London. The warm domesticity of the results included photographs of the adolescent royals working on a jigsaw, with their mother, Queen Elizabeth, and with the family's corgis. This image shows Adams's associate and business partner, the photographer Bertram Park, kneeling on the left trying to position the dogs. Park may have been there just to assist Adams or to hold his own sitting with the King and Queen, whom he had photographed on a number of occasions. The Princesses seem to be holding something in their hands, perhaps biscuits with which to coax their pets. It is one of the last images in which Elizabeth looks more like a child than a young woman.

Princess Margaret (left) and Princess Elizabeth (later Queen Elizabeth II), April 1940

Lisa Sheridan (1894–1966) for Studio Lisa

OPPOSITE

King George VI and Princess Elizabeth (later Queen Elizabeth II), April 1942

Lisa Sheridan (1894–1966) for Studio Lisa

War was declared on 1 September 1939, and for perhaps the first time in the twentieth century the Royal Family deliberately cultivated a public image that emphasized their similarity to their subjects and communicated to them that 'we are all in this together'.

Lisa Sheridan's relaxed, informal style was frequently employed to show the family off-duty, at home in Windsor, the rural idyll providing respite from the pomp and ceremony of life in the capital. Here they could be shown doing normal things such as tending their vegetable patch in the gardens, doing their schoolwork or, as the Queen termed it, having 'natural good fun' (right).

From 1940, Elizabeth and Margaret were increasingly photographed as young women in their own right, and their depictions reflected the gradually evolving seriousness of their future roles. On Easter Day in 1942 the photographer captured an intimate moment between the sovereign and his heir (opposite). Sheridan recalled that the 'dispatch-cases arrived from town for the King's inspection – the famous scarlet leather boxes. I noticed that once he drew Princess Elizabeth's attention to a document and explained certain matters to her very earnestly.'

**Contact sheet depicting portraits
of King George VI, Queen Elizabeth,
Princess Elizabeth (later Queen
Elizabeth II) and Princess Margaret,
October 1942**

Cecil Beaton (1904–1980)

King George VI and Queen Elizabeth with Princess Elizabeth (later Queen Elizabeth II; far left) and Princess Margaret, November 1943

Cecil Beaton (1904–1980)

The characteristic opulence of Cecil Beaton's photographs provided a much-needed boost to public morale during the Second World War, masterfully projecting an image of a united, seemingly unshakeable family.

Beaton was invited to Buckingham Palace to photograph the Royal Family in 1942 and 1943, and the resulting images were a celebration of the building and, by extension, the institution of monarchy, as much as of the individual sitters themselves. Beaton's photographs situated the family firmly among the grandeur of Buckingham Palace's State Apartments, making use of the architecture of the building to frame his sitters or placing them in front of elaborate and whimsical backdrops that referenced historic portraiture.

The contact sheet of photographs approved by the Royal Family for public release (opposite) shows the variety of compositions, outfits and associated meanings that were captured during Beaton's shoots. On the bottom two rows, three photographs show Princess Elizabeth wearing a cap of the Grenadier Guards, of which she was Colonel-in-Chief: the first time in history that a woman had been awarded such a senior position. The following February one photograph appeared on the cover of *Life* magazine (bottom row, second from the left).

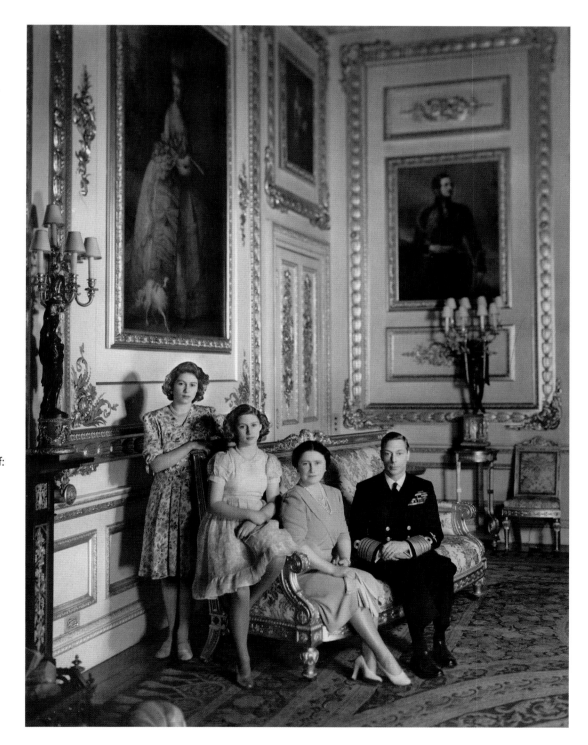

Princess Margaret (left) and Princess Elizabeth (later Queen Elizabeth II) dressed for a pantomime, 23 December 1944

Lisa Sheridan (1894–1966) for Studio Lisa

During the Princesses' teens, the Royal Family held annual Christmas pantomimes. These productions grew out of Elizabeth and Margaret's love for dressing up and dancing, and were organized by the Princesses themselves. Weeks were spent preparing scripts and helping to assemble the stage and scenery out of scraps from the castle's junk and salvage.

In 1944 they hosted a production of *Old Mother Red Riding Boots* – the last and reportedly the most accomplished of these performances. The highlight of the spectacle was the Victorian Bathing Ballet, comprising dance and mime choreographed by dancing-mistress Madame Vacani.

Lisa Sheridan was commissioned to record the evening. 'At one point in the ballet', she recalled, 'bathing-booths were wheeled on to the stage from which players emerged for a careful dip in the ocean.' The photographer found Princess Margaret as the 'Victorian Miss' (left), on the beach with her nurse and little sailor-suited boyfriend, 'particularly comic', but it is the uncharacteristically playful snaps of Princess Elizabeth that seem most surprising, revealing a different side to a young woman whose public image at the time was one of increasing solemnity and duty. Some of the images were published and provided a dose of humour and fun for a war-weary public.

From left to right: Queen Elizabeth, Princess Margaret, Princess Elizabeth (later Queen Elizabeth II) and King George VI, 27 May 1946

Maryon Parham (1904–1983)

Dorothy Wilding's refined simplicity was the ideal aesthetic for depicting the Royal Family during the years of post-war austerity. In 1946 she was commissioned to photograph the family at Buckingham Palace but the invitation clashed with work at her New York studio and the shoot was delegated instead to her highly competent assistant, Maryon Parham. The resulting images were still characteristic of Wilding's distinctive style.

A series of elaborate conversation-piece portraits pictured the family gathered around the fireplace. The family style is elegant but modest, reflecting their scrupulous observance of clothes rationing. The younger generation is the central focus of the composition, flanked on either side by their parents. The family appears to be discreetly divided into two groupings: Queen Elizabeth and Margaret sit close to each other on the left; to the right, in a subtle nod to their respective status, the King and his heir are afforded greater space and prominence within the frame of the portrait. This pairing was seen increasingly often in images of the Royal Family throughout the 1940s, helping to affirm Princess Elizabeth's position as her father's heir.

King George VI with Princess Elizabeth (later Queen Elizabeth II; left) and Princess Margaret, in the grounds of the Royal Lodge, Windsor, 8 July 1946

Lisa Sheridan (1894–1966) for Studio Lisa

Lisa Sheridan's down-to-earth approach continued to serve the Royal Family well after the war on both a personal and a public basis, offering a privileged window on to the private world of the monarch, his wife and his daughters. From this point on, however, Sheridan appears to have begun experimenting with a marginally more formal approach to depicting the family, perhaps reflecting the fact that the Princesses were growing up.

This pair of photographs of the Princesses and their father demonstrate how radically different effects could be achieved through small adjustments to expression or pose. Shown next to each other, the images perfectly sum up the two photographic faces of monarchy. In the top photograph, father and elder daughter perhaps share a joke, holding each other's gaze while Margaret smiles contentedly into the camera. The corgi at the Princesses' feet and the sunloungers suggest laid-back approachability.

The bottom photograph achieves an entirely different effect with the same elements. King George VI stares directly into the lens; his expression, and those of his daughters, is now kindly but authoritative. The King is literally and metaphorically at the centre of the photograph, framed by his progeny. The corgi now can be read as a totem of monarchy – a traditional motif of formal royal portraiture.

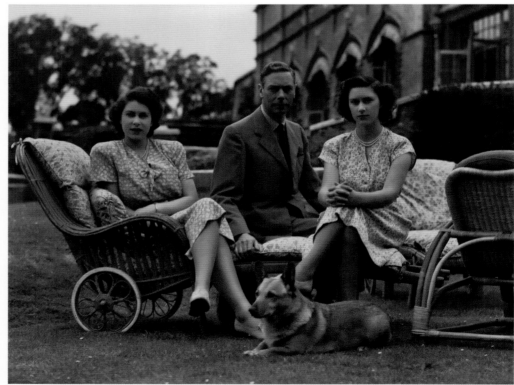

Princess Elizabeth (later Queen Elizabeth II) and Prince Philip of Greece and Denmark, 1947

Dorothy Wilding (1893–1976)

It was the minimalist glamour of Wilding's style that was selected for the official photographs to mark the engagement of Princess Elizabeth and Prince Philip of Greece and Denmark (born 1921), announced to the public on 10 July 1947.

The pair were introduced to each other when the Princess and her parents visited the Royal Naval College in Dartmouth in 1939. During the summer of 1946 Philip asked George VI for the Princess's hand in marriage and the King agreed on condition that they delay the engagement until her twenty-first birthday. Prior to the engagement, the groom abandoned his Greek and Danish royal titles and adopted his British maternal surname of Mountbatten.

The decision to use Wilding as photographer for this particular sitting was probably made on the recommendation of Elizabeth's parents. Wilding was their photographer of choice for important royal milestones and she was well acquainted with Princess Elizabeth, who had sat for her many times before. The 'royal romance' was celebrated in the press, and this photograph, along with individual portraits of the couple, were widely circulated, hailing the promise of the first major royal wedding since the war, in November that year.

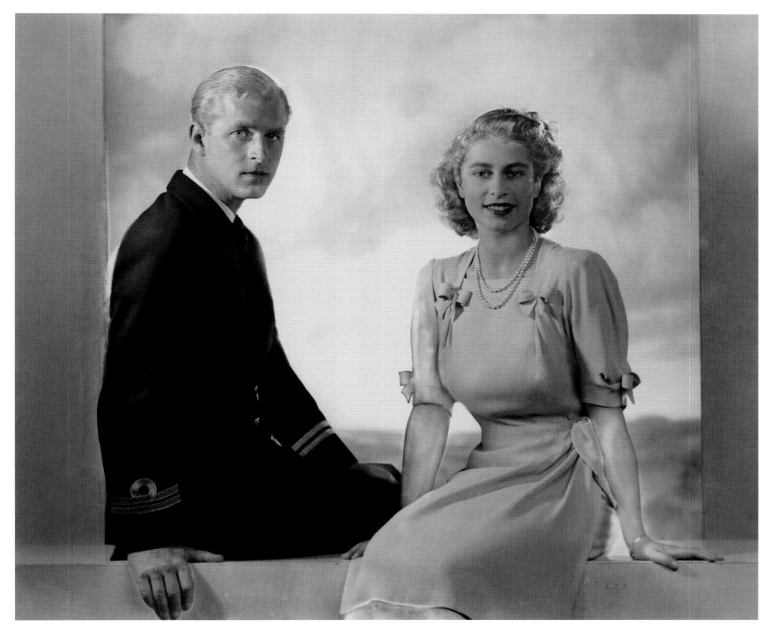

Princess Margaret, 1949
Cecil Beaton (1904–1980)

In the years following the return of peace, the Royal Family released a regular flow of photographs that provided much-needed pageantry and spectacle amid the continuing stringency of austerity. Unlike other surviving monarchies in Europe, which were now scaling back on public displays of grandeur, the British Royal Family once again invoked the captivating marriage of Norman Hartnell's dress designs and Cecil Beaton's photography (see page 106) to harness a renewed feeling of public hope and enthusiasm.

Beaton's photographs of Princess Margaret, taken to celebrate her nineteenth birthday, show an enchanting revival of the photographer's pre-war glamour. They also mark a transformational shift in the Princess's public image, from child to glamorous young woman: 'I was interested to see the change the last four years has brought about', Beaton wrote in his journal. 'The last time I photographed Princess Margaret she … wore homemade dresses – had lank hair – now she attempted a high degree of sophistication.' The appearance of the demure Princess in her tulle dress reminded Beaton a great deal of his sitting with her mother before the war. This time, his photograph also caught his own reflection in the mirror, perhaps a playful nod to his role in the creation of such iconic images of the Queen.

Princess Elizabeth (later Queen Elizabeth II) and Prince Charles, September 1950

Prince Charles and Princess Anne, 1950

Cecil Beaton (1904–1980)

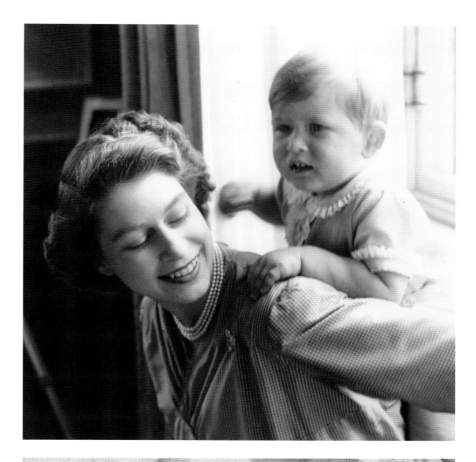

Cecil Beaton's romantic treatment and his ability to craft an iconic photograph made him a particular favourite with the Queen and her two daughters. After the birth of her first child, Prince Charles, in 1948, Princess Elizabeth frequently commissioned Beaton to provide official portraits of her own growing family. These photos from 1950 show the Princess with an eighteen-month-old Prince and the young Prince with his new-born sister, Princess Anne.

Beaton recalled that the occasion was chaotic, as he made a desperate attempt to capture the little Princess before she fell asleep. Princess Elizabeth 'seemed very amused by the spectacle confronting her of so many grown-up people doing … everything in their power to keep the baby's eyes open'. Later, Beaton remembered, 'Prince Charles was rushing about the lawns wearing a policeman's helmet … corgi dogs were barking and running round in circles … '. The resulting images capture something of the energy of the day and, for Beaton's photographs, have an uncharacteristic spontaneity.

Beaton appears to have attempted his own contemporary take on the nineteenth-century's most popular photograph, that of Princess Alexandra carrying her daughter on her back (see pages 52–53).

Princess Margaret, 1951
Cecil Beaton (1904–1980)

Princess Margaret was photographed by Beaton six times between 1949 and her marriage in 1960. Her second sitting with the photographer, to mark her twenty-first birthday, took place at Buckingham Palace against an opulent tapestry backdrop. The Princess was pictured in a billowing, off-shoulder gown by the French couturier Christian Dior (1905–1957), created for her birthday ball. The choice of a French designer was controversial and the dress itself very modern, blending synthetic and natural materials. Like Beaton, Dior bucked the trend for austerity with his sensational 'New Look', but despite their shared sense of irreverence Beaton was disapproving of the choice of couturier: 'The Dior dress was a disappointment – colourless and indistinctive … but her complexion wonderful – and she had put on a wonderful array of make-up with vivid lips, rosy cheeks and black mascara.'

The arresting results depicted a thoroughly modern young woman occupying the space between tradition and innovation. Dior's feminine cinched waists and voluminous skirts, combined with Beaton's characteristic flamboyance, encapsulated the nation's gradual emergence from a period of austerity.

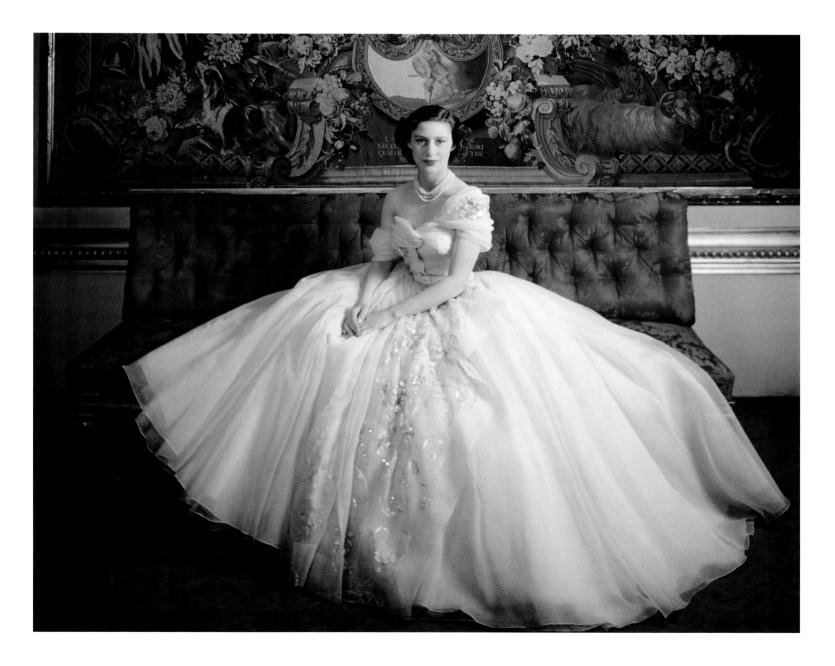

Queen Elizabeth II, 15 April 1952

Dorothy Wilding (1893–1976)

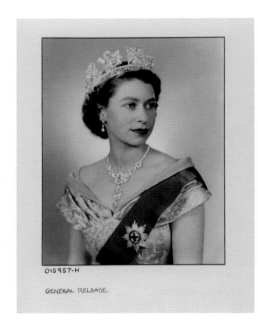

015957-H

GENERAL RELEASE.

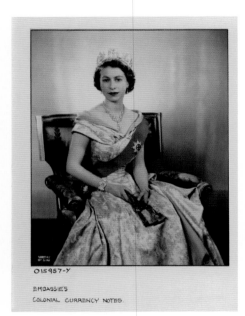

015957-Y

EMBASSIES

COLONIAL CURRENCY NOTES.

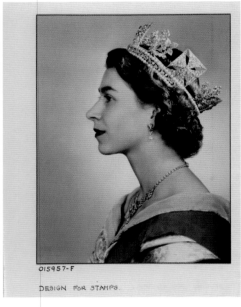

015957-F

DESIGN FOR STAMPS.

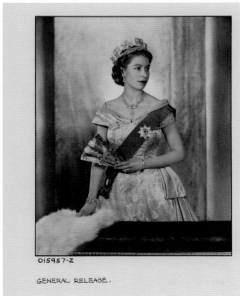

015957-Z

GENERAL RELEASE.

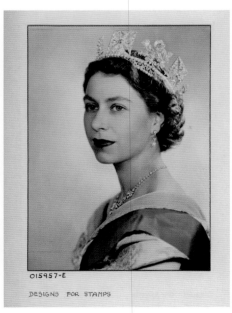

015957-E

DESIGNS FOR STAMPS

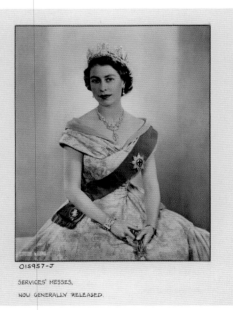

015957-J

SERVICES' MESSES.

NOW GENERALLY RELEASED.

The Queen employed the tried and tested methods of Dorothy Wilding for her official portraits to mark the accession. By commissioning the same photographer and aesthetic used to document her father's coronation fifteen years earlier, Elizabeth emphasized the continuity and endurance of the monarchy.

The sitting produced fifty-nine photographs, in which The Queen mixes and matches dresses, jewellery and insignia: gowns by Norman Hartnell, the riband and star of the Order of the Garter, Queen Mary's Girls of Great Britain and Ireland Tiara (shown below) and George IV's Diamond Diadem

(opposite). Each ensemble was designed for a different publication purpose. Wilding employed her characteristic simple backdrops and strong tonal contrasts focusing attention on the face, to mesmerizing effect.

The sittings were commissioned by the Post Office and the Royal Mint. Copies of the photographs were distributed among embassies around the world, were used as the basis for images on banknotes and appeared on millions of postage stamps between 1953 and 1971. This series of proofs held in the Royal Collection indicates the intended use of each image, as shown here.

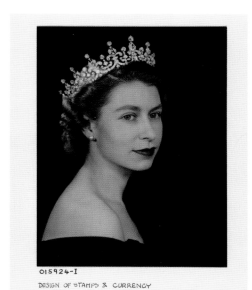

015924-I
DESIGN OF STAMPS & CURRENCY
DESIGNS FOR CORONATION SOUVENIRS.

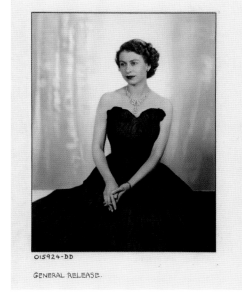

015924-DD
GENERAL RELEASE.

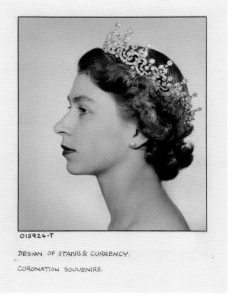

015924-T
DESIGN OF STAMPS & CURRENCY.
CORONATION SOUVENIRS.

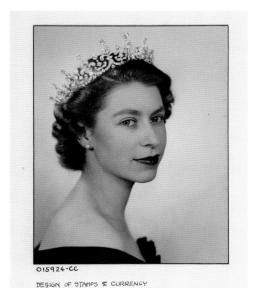

015924-CC
DESIGN OF STAMPS & CURRENCY
DESIGNS FOR CORONATION SOUVENIRS.

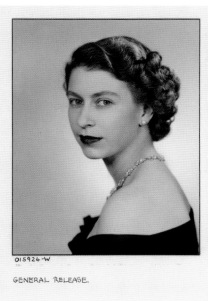

015924-W
GENERAL RELEASE.

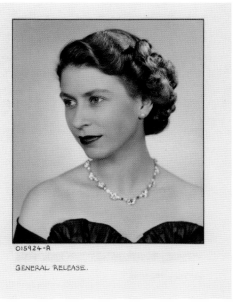

015924-A
GENERAL RELEASE.

Queen Elizabeth II, Prince Charles and Princess Anne at Balmoral Castle (with added image of Prince Philip, Duke of Edinburgh, opposite), 28 September 1952

Lisa Sheridan (1894–1966) for Studio Lisa

In September 1952 The Queen made her first commission as a mother in her own right from family favourite Studio Lisa, at Balmoral Castle. It was the studio's first royal commission in some years.

Lisa Sheridan described a moment during the sitting when, 'as the Queen leant from her sitting-room window to speak to the children in the garden, I suggested a photograph of them together in the window and, at that moment, Prince Charles's eyes fell upon the wire-netting which had supported plants newly removed. He chose a short cut into his mother's sitting-room, and it was in that way that we succeeded in obtaining the enchanting series of photographs of the royal children climbing into their

mother's window at Balmoral Castle.' The image of the trio in the window was considered to be so successful that back in the studio during the editing process, Sheridan attempted to add the Duke of Edinburgh (opposite). In another photograph from the day, The Queen is shown familiarizing the children with the camera (below right), perhaps to ensure their ease around what would be an ever-present object in their lives.

The resulting photographs established The Queen's desire to continue the balance that had been successfully championed by her parents between an image of majestic figurehead and an approachable, relatable family.

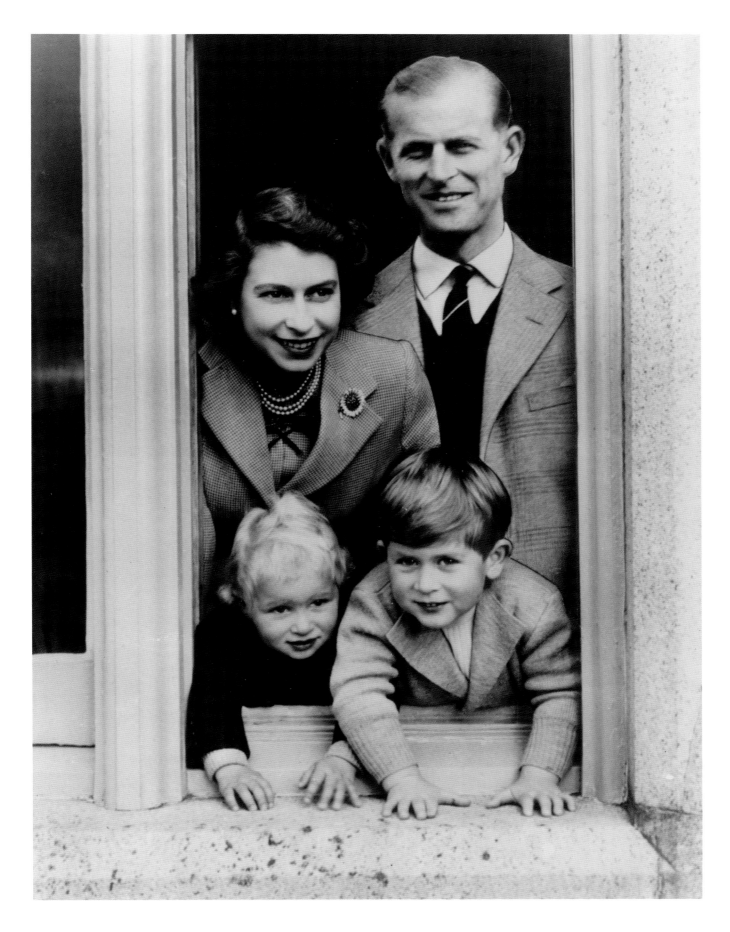

TOP
Queen Elizabeth II with two of her maids of honour on her Coronation Day, 2 June 1953

Cecil Beaton (1904–1980)

BOTTOM
Queen Elizabeth II, Cecil Beaton and two assistants (John Drysdale and Ray Harwood) on The Queen's Coronation Day, 2 June 1953

Patrick Matthews (1914–1996)

OPPOSITE
Queen Elizabeth II on her Coronation Day, 2 June 1953

Cecil Beaton (1904–1980)

Cecil Beaton's magnificent photographs of Queen Elizabeth II after her coronation on 2 June 1953 are perhaps the most iconic and enduring images of British monarchy in the twentieth century.

Extensive preparation went into the design and lighting of the sitting. Beaton sought inspiration in a wide range of coronation portraits from royal history but made particular reference in his images to the coronation of Queen Victoria, whose portrait by court artist Sir George Hayter (1792–1871) had signalled a new beginning for the nation. In the aftermath of the Second World War and the shocking passing of King George VI at just fifty-six years old, Beaton's spectacular portraits of another young, female sovereign would similarly usher in a 'new Elizabethan age' for monarchy in Britain.

Photography allowed for documentation not just of the moment but also of the making of the moment. Two different backdrops were used: the first a view of Westminster Abbey from the River Thames, used for a range of sitters, and the second, an interior view of the Abbey reserved for portraits of The Queen. Beaton captured The Queen's maids of honour arranging her trains (top) and organizing themselves into position, at Beaton's instructions, strictly that in which they had stood in Westminster Abbey, where the coronation had taken place. The studio manager of *Vogue* magazine, Patrick Matthews, captured the photographer at work, still in his tails and among a forest of his studio equipment (bottom).

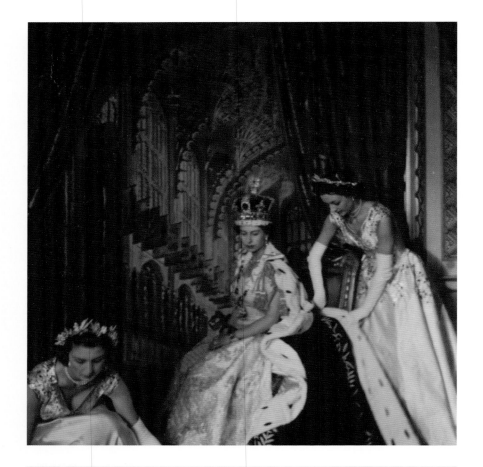

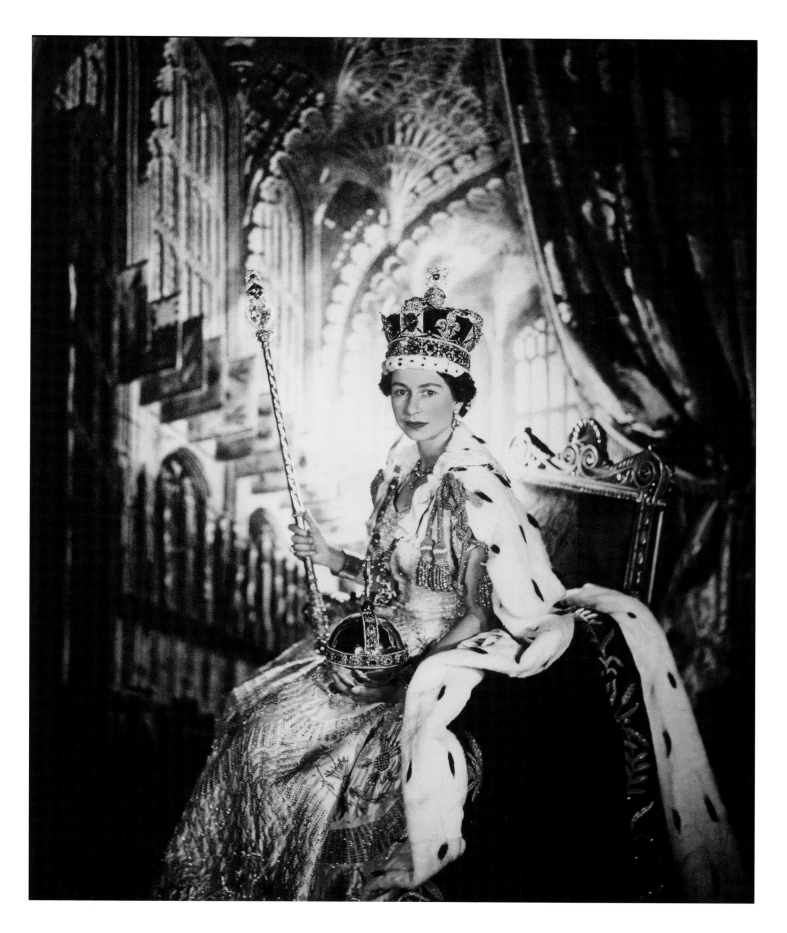

**Prince Philip, Duke of Edinburgh,
2 June 1953**

Cecil Beaton (1904–1980)

Despite the short time slot that Cecil Beaton was allocated to photograph the Royal Family at Queen Elizabeth II's coronation, he took a sequence of pictures in different poses and compositions. Throughout history, the monarch has traditionally been depicted with the Crown placed on a table beside him or her. In common with Charles II, Queen Victoria and most of her predecessors, The Queen (opposite) wore the Imperial State Crown and held the Orb and Sceptre. Her gown, designed by Norman Hartnell, was exquisitely embroidered with flowers symbolizing Britain and the Commonwealth, and Prince Philip was pictured as Admiral of the Fleet.

The camera films were processed overnight. The best photographs were sent to Buckingham Palace for official approval, and by noon the following day a selection had been chosen for publication in the press. Careful instructions were given as to which photographs should be used for what purpose: a double portrait of The Queen and the Duke of Edinburgh was to be shared among family; a group composition of The Queen and her maids of honour was to be sent to them as thank-yous; and an individual portrait of The Queen holding the Orb and Sceptre (opposite, top row, second from left) was to be given to distinguished guests and distributed throughout the Commonwealth.

**Contact sheet depicting portraits
of Queen Elizabeth II and
Prince Philip, Duke of Edinburgh,
2 June 1953**

Cecil Beaton (1904–1980)

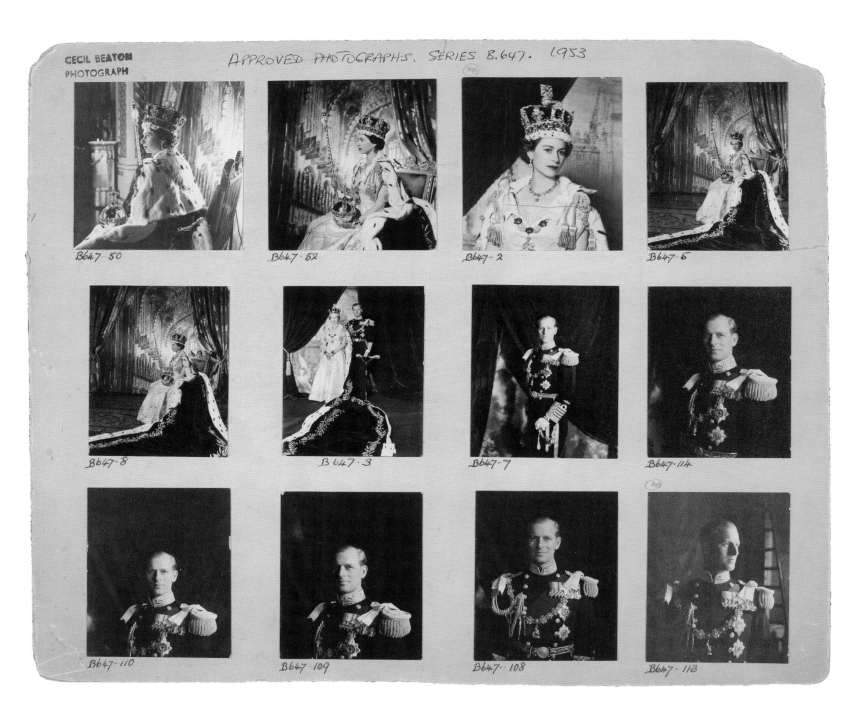

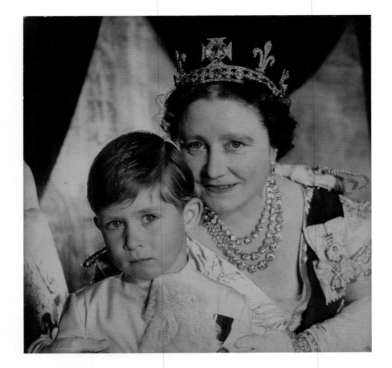

TOP
Queen Elizabeth The Queen Mother with Prince Charles, 2 June 1953

BOTTOM
Princess Anne, 2 June 1953

Cecil Beaton (1904–1980)

While The Queen was being photographed in the Throne Room for *The Times* after the coronation, Cecil Beaton captured other senior members of the Royal Family. It was not until he photographed the Queen Mother, however, that the apprehensive photographer relaxed into his work: 'All at once, and because of her, I was enjoying my work. Prince Charles and Princess Anne were buzzing about in the wildest excitement and would not keep still for a moment. The Queen Mother anchored them in her arms, put her head down to kiss Prince Charles' hair, and made a terrific picture.'

In striking contrast to the stately portraits of The Queen, the charming spontaneity of Beaton's portraits of the children and their grandmother offer an intimate view of proceedings as the Queen Mother attempts to calm her excitable grandchildren. Beaton attributed his selection as official coronation photographer to the Queen Mother, and their mutual regard is evident in these relaxed, unguarded images. Not long before the coronation Beaton encountered her at a reception: 'I also had a short opportunity to thank Queen Mother for what I am sure must have been her help in bringing about this "coup" for me. She laughed knowingly with one finger high in the air.'

Marcus Adams is among a select group of photographers to have enjoyed a long career photographing successive generations of royal children. Beginning with his first sitting with the infant Princess Elizabeth in 1926, Adams's royal commissions continued at regular intervals until his final sitting, in which he photographed Princess Anne in 1957.

At the time of Queen Elizabeth II's coronation in 1952, Adams reflected on the privilege of witnessing the child of less than a year old that he first photographed, grow up to become a queen of nations.

The strong professional relationship and trust between Adams and The Queen, established over decades of working together, is plain to see in this charmingly candid sitting of 1954. The unbridled joy of childhood and affection between parent and child is encapsulated in the relaxed informality of Prince Charles and Princess Anne's laughter. Adams's crop marks show his eye for capturing intimate moments that challenged the established conventions of Royal Family photographs and the traditional visual identity of portraits of the monarch and their heirs.

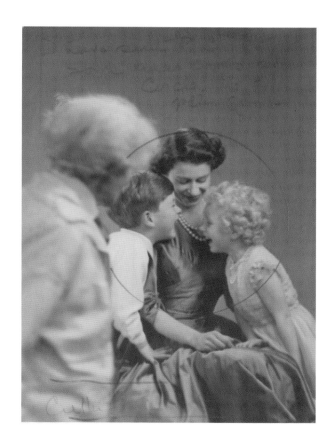

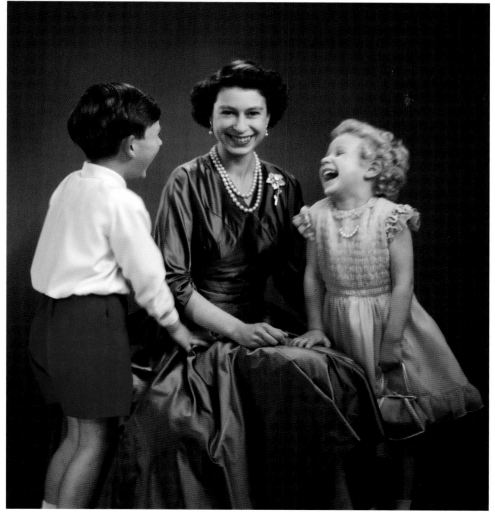

Queen Elizabeth II being photographed by Cecil Beaton, 1955

Photographer unknown

On her accession to the throne in 1952, Queen Elizabeth II was required to form her own visual identity as sovereign. Her father, King George VI, had successfully struck the balance between intimacy, splendour and ceremony required of the monarch in the middle of the twentieth century. At the beginning of Queen Elizabeth II's reign, she relied on the photographic prowess of tried and tested photographers to create a visual continuity with what had come before. In so doing, The Queen's early photographic commissions re-established a sense of stability after her father's untimely death and promoted her intention to adopt a similar style of reign.

Cecil Beaton continued to be a fundamental component of The Queen's royal image-making. His compositions contextualized the young Queen within a long royal tradition by situating her within the opulence of the palaces rather than in a studio, while the romance of his aesthetic celebrated her youth and femininity as well as her position of authority. By the time this photograph was taken, in 1955, Beaton had been capturing the royal image for twenty-five years over four reigns and was considered to be a safe pair of hands. Monarch and photographer are pictured here together in the Music Room of Buckingham Palace, The Queen wearing an evening gown and George IV's Diamond Diadem, and the composition is archetypical of Beaton's royal photographs.

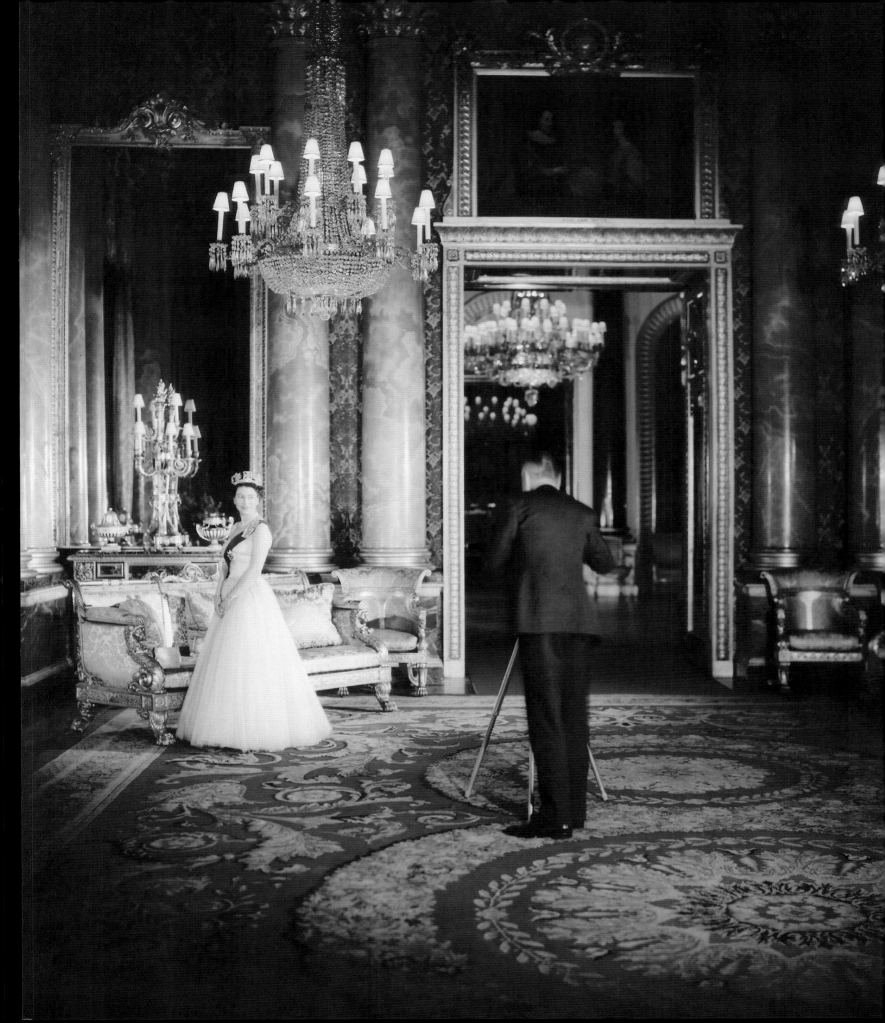

The Duke and Duchess of Windsor, 6 April 1955

Dorothy Wilding (1893–1976)

Following the controversy of Edward VIII's abdication, the image of the Duke and Duchess of Windsor, as he and his wife, Wallis Simpson, were subsequently titled, was marred in Britain. The Duchess in particular became the target of great antagonism from both the British public and the Duke's family. Her divorcée status was the main point of contention, but at times even her fashion sense was criticized in the press.

To counter these negative views and possibly to justify his decision to abdicate the throne, the Duke and Duchess began to commission playful images that portrayed them as a loving and happy couple. Their beloved pugs were often a central feature of their compositions, as seen in this photograph by Dorothy Wilding from 1955; they added a comical element and paralleled the corgis in the royal household.

The decision to commission Wilding is a poignant one, as she had previously photographed popular royal couples, such as the Duke and Duchess of Kent (see page 194), George VI and Queen Elizabeth (see page 75), and Princess Elizabeth and Prince Philip (see page 115). This photograph hints towards the Duke's desire to have his own marriage accepted and celebrated among a broader visual representation of royal couples of the time.

The Duke and Duchess of Windsor, 1958

Philippe Halsman (1906–1979)

Throughout their marriage, the Duke and Duchess of Windsor continued to project an image of a jovial and loving couple free from the formality required of the reigning family. To achieve this they worked with several prominent photographers of the period. In 1958 they featured in Philippe Halsman's 'Jump', a series of photographs featuring celebrities as they jumped. The photographer explained: 'In a jump, the subject, in a sudden burst of energy, overcomes gravity. He cannot simultaneously control his expressions, his facial and limb muscles. The mask falls. The real self becomes visible.'

Halsman was a celebrated portrait photographer responsible for 101 covers for *Life* magazine. His request to include the Duke and Duchess of Windsor in his 'Jump' project attests to the celebrity status the royal couple had gained internationally, and the Duke's acceptance was perhaps symbolic of his freedom both literally and metaphorically to 'let the mask fall' after his abdication in 1936.

Capturing a Modern Monarchy

[My] relatively informal pictures were received by the press as 'off-beat' and 'unconventional studies'. 'The end of the old stuffy era of princely portraiture', said the Daily Express.

LORD SNOWDON, 1979

The onset of the Swinging Sixties saw a concerted effort to modernize the royal image, precipitated by renewed public debate about the relevance of the monarchy itself in a rapidly changing world.

Cecil Beaton's grandiose displays of royal splendour were replaced from the late 1950s by a new and thoroughly modern image of monarchy born out of a shifting photographic trend away from the constraints of the studio towards a more relaxed, spontaneous and dynamic aesthetic.

Technological advances, the influence of reportage photography and the growing association between royalty and celebrity during the 1960s and 1970s contrived to create demand for a more informal documentary style and provoked renewed interest in the individuals behind the crown.

The introduction to the Royal Family of photographers Anthony Armstrong-Jones (later Lord Snowdon) and The Queen's cousin, Patrick Lichfield, helped to ease the monarchy towards this newly fashionable and intimate public approach. Their proximity and inclusion lent their photographs an air of authenticity hitherto unseen and helped to engender a far-reaching impact, prompting novel commissions from such fashion photographers as Norman Parkinson and imbuing the royal image with a new sense of informality that would become the hallmark of subsequent generations.

Royal photographs became startlingly simple or candid and often pertained to show the family 'behind-the-scenes' as relatable figures, going about their daily lives or at private occasions. The royal image was invested with a sense of fun and spontaneity that effectively contrasted with the standard ceremonial and regal photographic portraits of The Queen and the Duke of Edinburgh that were widely distributed throughout the Commonwealth.

Prince Charles, Prince of Wales and Lady Sarah Armstrong-Jones, September 1971; see page 152

Lord Lichfield (1939–2005)

Prince Charles and Princess Anne playing on an improvised see-saw, watched by Queen Elizabeth II and Prince Philip, Duke of Edinburgh at Balmoral Castle, 15 September 1957

Photographer unknown

In an attempt to dispel concerns that they remained out of touch with a democratized Britain no longer dominated by the aristocratic elite, the Royal Family increasingly began to lift the lid on their private world. In September 1957, The Queen invited a photographer representing the national press to photograph the family on holiday at Balmoral Castle. Until then, all informal photographs at their Scottish retreat had been taken only by privately commissioned court or local photographers.

This picture was published in a double-page spread across the front and back pages of the *Daily Mirror* on 16 September 1957 under the emboldened heading: 'The Picture The Queen Asked For'. She, her husband, Prince Philip, and one of the family's corgis are pictured watching Prince Charles and Princess Anne as they play on a makeshift see-saw at a sawmill on the castle's estate. The Duke of Edinburgh lends a helpful nudge to his children, both of whom are dressed in kilts.

The relaxed, surprisingly humble picture of Royal Family life and the decision to invite the national press to Balmoral Castle, traditionally considered to be a place of refuge and privacy, represented a decisive shift in royal representation as the monarchy attempted to show themselves letting the public in.

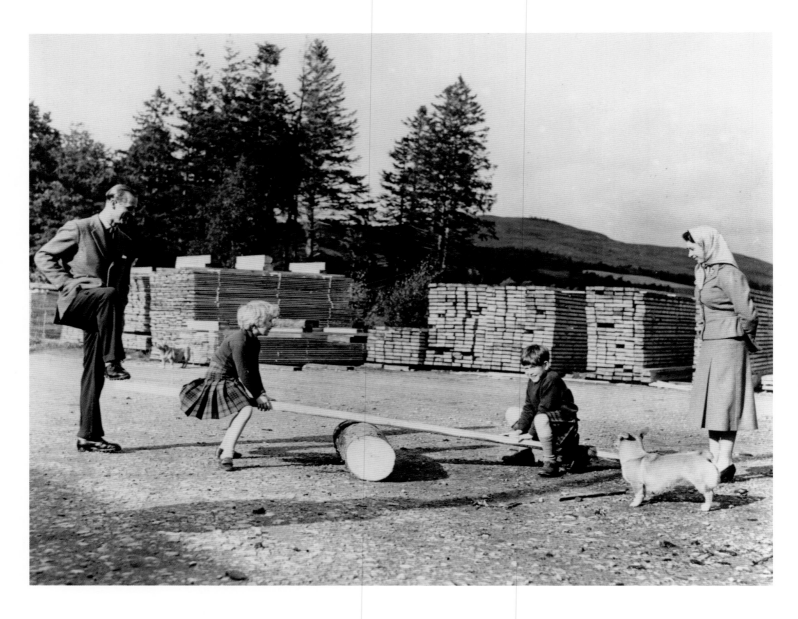

Prince Charles and Princess Anne with broadcaster David Attenborough, 4 January 1958

Photographer unknown

The 1950s were the decade of television. The broadcasting of the Coronation in 1953 propelled sales of television sets across Britain, and the monarchy, keen to remain at the forefront of technological change, anchored itself within the new visual medium and maintained a strong relationship with the British Broadcasting Corporation (BBC).

Ahead of the launch of the children's programme *Blue Peter* in October 1958, Prince Charles and Princess Anne were photographed on a tour of the BBC Studios at Lime Grove in London. During the visit they encountered the young presenter of the nature documentary series *Zoo Quest*, David Attenborough (born 1926), and his cockatoo, 'Cocky'. Attenborough would become one of Britain's most renowned environmentalists and natural history broadcasters and would develop a longstanding relationship with the Royal Family, with whom he shared his passion for animals and nature.

Technological improvements meant that press photography was producing ever more sophisticated results, and the clean, natural approach lent itself to growing calls for modernization of the royal image. The Royal Family were increasingly represented by press photographers as well as portrait takers, and their documentary style showed the family going about their duties or daily lives and helped to create a sense of openness and familiarity with the younger generation of royals.

Princess Margaret and Antony Armstrong-Jones (later Lord Snowdon) on their wedding day, 6 May 1960

Cecil Beaton (1904–1980)

OPPOSITE
Princess Margaret and Lord Snowdon with Cecil Beaton in the garden at Kensington Palace, 1965

Unknown Cecil Beaton assistant

On 6 May 1960, Princess Margaret married the photographer Antony Armstrong-Jones (later Lord Snowdon; 1930–2017). To record the day, Armstrong-Jones relinquished the camera to the renowned Cecil Beaton. It was, after all, Beaton's skill that had transformed the bride into an extraordinarily popular and romantic figure in the public imagination (see pages 116 and 118-19). However, the young Snowdon often could not resist lending a helping hand. Particularly adept at lighting his subjects, he insisted on angling reflectors to illuminate the Princess, as shown here. Beaton was happy to relegate him to the supporting role of photographic technician, resentful as he was of Snowdon's gradual encroachment on his position as royal favourite. Although Beaton's disparaging diary entries make plain his contempt at the notion that someone of Armstrong-Jones's social standing might have the impertinence to marry into the Royal Family, he could not help but be charmed by the young couple.

These out-takes from royal sittings demonstrate a mutual respect and sense of collaboration between the two men as one, somewhat unwilling, passed the baton for defining the royal image, to the next.

**Princess Margaret at a ball,
1 July 1964**

Photographer unknown

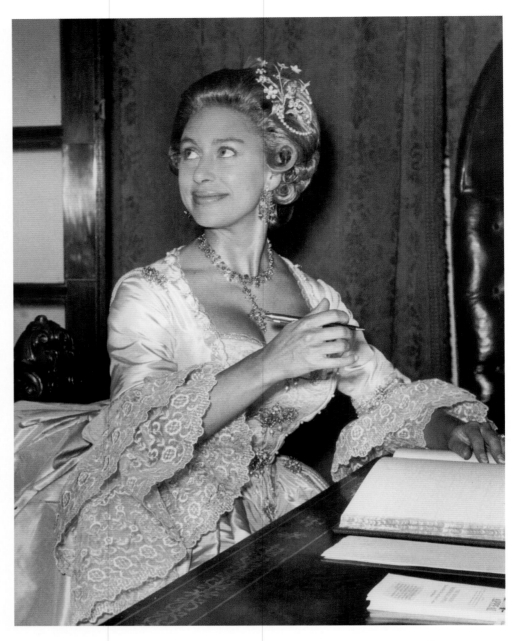

This playful photograph of Princess Margaret at a Georgian ball shows the sense of decadence and fun that became synonymous with the Snowdons during the 1960s.

Just two months after giving birth to her second child, Princess Margaret attended a charity ball held at Mansion House in London to raise funds for the restoration of St John's Church, Westminster. The following day, photographs of the Princess and Lord Snowdon in full fancy dress and wigs, reportedly dancing to the tunes of pop singer Cilla Black, were released in the national press.

Charitable patronage was an important part of royal duty and royal support earned causes widespread attention. Princess Margaret was a dedicated philanthropist, but she and Snowdon engaged with the public with a greater degree of humour and flamboyance than would have been appropriate for her sister, The Queen.

Snowdon's reputation as a fashion photographer and Margaret's as a fashionable icon earned them a place among celebrity society, and photographs of the pair meeting musicians and holidaying on the yachts of famous friends provided the press with a playful and glamorous counter to The Queen's more conservative image as a dutiful mother and stateswoman.

Lord Snowdon, 1969

Norman Parkinson (1913–1990)

While Norman Parkinson's official photographs to mark the investiture of the Prince of Wales were contrived to adhere to the strict conventions of ceremonial portraiture (see page 147), his photographs of the event's mastermind, Lord Snowdon, were characteristic of Parkinson's flamboyant and narrative style.

In a sense of contrived spontaneity, Snowdon, himself the son of Welsh gentry, is depicted rather theatrically against the medieval backdrop of Caernarfon Castle, where the ceremony took place. Focused and assertive, plans laid out in front of him, he appears as the dynamic conductor of proceedings. Lord Snowdon, widely considered to be the modern face of monarchy at the time, was behind much of the choreography of the event, which was carefully devised to democratize royal pageantry. The spectacle was to

be broadcast to a global audience of an estimated 500 million people, and Snowdon designed the staging to maximize visibility for the cameras. A clear Perspex canopy surmounted the simple slate dais upon which the Prince of Wales was invested by his mother, The Queen, with a royal title dating back to the thirteenth century.

Snowdon had followed in Parkinson's footsteps as a fashion photographer for *Vogue*, *Harper's Bazaar* and *Queen* magazines. Both sought to take portrait photography beyond the stiff formality of its origins and inject it with verve and vitality. As one of the early pioneers of fashion photography who bridged the gap between Beaton's class-conscious society portraits and the realism of the Swinging Sixties, Parkinson was an apt choice to depict an event intended as a seamless marriage of tradition and modernity.

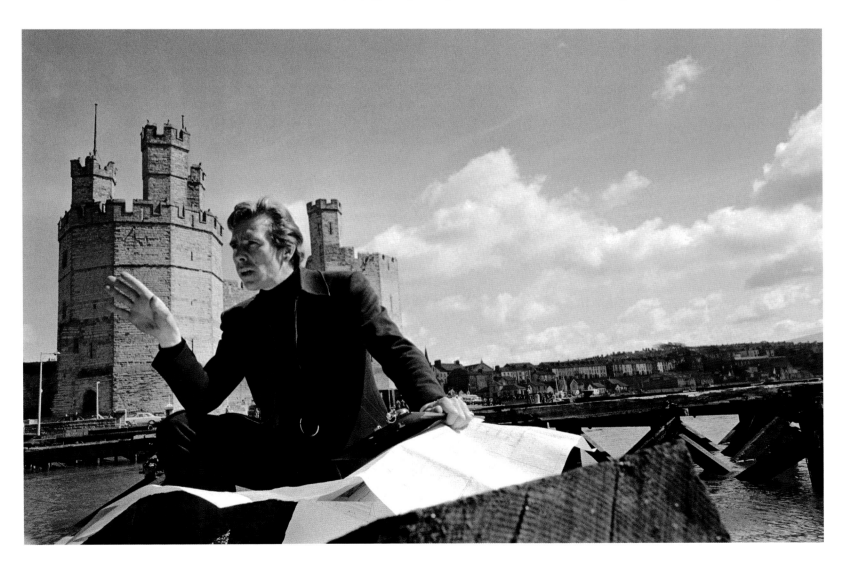

Queen Elizabeth II with Prince Andrew (right in main photograph) and Prince Edward, and contact sheets from the shoot, 20 May 1964

Cecil Beaton (1904–1980)

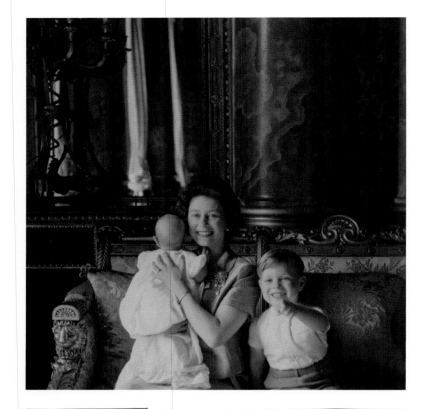

The Queen continued to patronize photographer Cecil Beaton well into the 1960s, and a sitting was arranged to celebrate the birth of her fourth child, Prince Edward, in 1964. The variety of compositions seen in the contact sheets demonstrates the gradual evolution of Beaton's approach to his royal photographs.

Throughout the 1960s photographic fashions, and with them Beaton's style, changed dramatically from sumptuous set pieces to stark backdrops that focused attention on the sitter. During this sitting Beaton produced a series of slightly more formal photographs set within the recognizable surroundings of Buckingham Palace's Music Room, but he also brought with him a white backdrop against which he shot a series of uncharacteristically tender portraits to which any parent could relate. 'From the moment the family group assembled themselves in our white oasis in front of the camera the pattern seemed to form and the lighting proved as luminous as we had hoped', he wrote of the sitting.

These photographs, in contrast to the opulent splendour of his earlier royal commissions (see, for example, page 131), show a more intimate and informal side of royal life, reflecting a reorientation of the British Royal Family's image-making towards a more approachable picture of monarchy that was aligned with popular values, and emphasizing The Queen's role as a wife and mother.

Princess Margaret, Lord Snowdon and their children, Lady Sarah Armstrong-Jones and Viscount Linley, 1967

Norman Parkinson (1913–1990)

During the 1960s the Snowdons brought a dose of modernity and fun to the royal image, transcending social barriers to embody the spirit of the Swinging Sixties while remaining firmly rooted in the British Establishment.

As a sense of liberation imbued the cultural climate, the stiff formality of the 1950s gave way to a more realistic, lively and documentary approach to photography. Unsurprisingly, Lord Snowdon's family photographs, whether taken by him or commissioned from his colleagues in fashion photography, were right on trend.

The casual elegance of this photograph by the renowned fashion photographer Norman Parkinson exemplifies the thin line the couple straddled between tradition and modernity: Princess Margaret's expertly coiffed hair and immaculate attire are juxtaposed against the playful dynamism of her family; Snowdon's flushed appearance and his children's joyful expressions give a sense of movement, which creates the impression that the viewer is sharing in the moment. The success of Parkinson's photographs earned him the position of an official royal photographer from 1969.

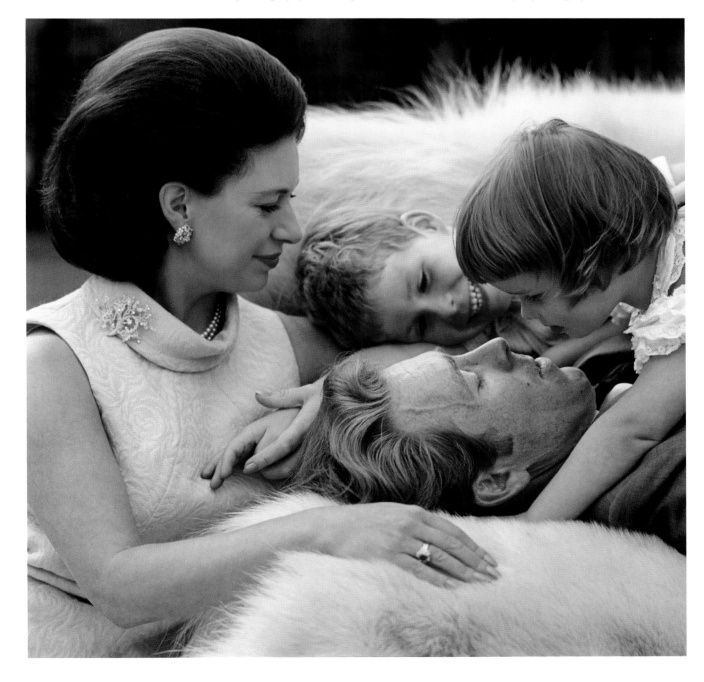

Queen Elizabeth II, 1968

Cecil Beaton (1904–1980)

Cecil Beaton's last photoshoot with The Queen, in 1968 to mark her forty-third birthday, consolidated his gradual transition away from the frothy Fragonard-inspired painted backdrops of the 1930s (see, for example, pages 104–105) towards his 'stark and clear and bold' rendition of The Queen seen here.

The photograph still refers to painted portraiture, this time inspired by a painting of The Queen by Pietro Annigoni (1910–1988) made in 1954. Yet even without the crutch provided by palatial surroundings and the usual trappings of monarchy, the sovereign's embodiment of regal authority withstands. Like Annigoni before him, Beaton chose a sparse depiction that conveys a dignified presence but it is also suggestive of the solitude occupied by those in positions of leadership.

Beaton's penchant for couture gowns and lashings of jewellery and insignia is replaced here with the pared-back elegance of an admiral's cloak, emphasizing duty over luxury. Perhaps as a result, Beaton struggled with the composition until 'suddenly she turned to the L. [left] and the head tilted – and this was the clue to the whole sitting – the Tilt'. His recollection highlights the nuance involved in creating even seemingly the simplest of photographs, and the power of pose to transform an image.

Prince Charles, Prince of Wales, 1969

Norman Parkinson (1913–1990)

Prince Charles's investiture as Prince of Wales took place at Caernarfon Castle on 1 July 1969. Although the Royal Family had come under criticism in the changing political and social climate of the 1960s, the investiture ceremony proved surprisingly popular with the public.

Despite its apparent anachronism, the pageantry was very much an invention of the twentieth century. It was based on the 1911 investiture of the future King Edward VIII (see page 69), part of a resurgence of royal ceremony in response to the rise of press photography. Like that of 1911, it included newly created costume, regalia and traditions, including the Prince addressing the crowds in Welsh. Now, however, it was also designed with television audiences in mind (see page 141).

The official investiture photographs were taken on a separate occasion by the fashion photographer Norman Parkinson, assisted by his mentee, the then junior fashion editor for British *Vogue* Grace Coddington. The shoot was deliberately designed to depict the Prince within the stiffly composed conventions of royal portraiture. He arrived for the sitting red-faced, fresh from the polo field. Coddington was asked to apply make-up to his cheeks to calm his florid complexion and as she did so, Parkinson snapped a quick Polaroid. 'If you stole that picture, I bet you'd make a fortune', the Prince joked.

Queen Elizabeth II, Prince Philip, Duke of Edinburgh (with his back to the camera), Prince Charles, Prince of Wales and Princess Anne, 1969

Photographer unknown

Perhaps the most radical attempt to modernize the royal image came in 1969 when The Queen made the unprecedented move of allowing a film crew to record a year in the life of the Royal Family. Richard Cawston's fly-on-the-wall documentary *Royal Family* aired to television audiences of more than 30 million and gave a startlingly honest account of royal life behind the scenes; the monarch could be seen choosing a dress to wear to the opera and sharing breakfast with her family.

Designed to present The Queen as a relatable figure, the documentary highlighted the fundamental paradox in the relationship between Crown and subjects; criticism abounded that it had also destroyed monarchy's allure by 'letting light in upon the magic'. By clearly exploiting their private life to improve their public image, the documentary also inadvertently opened monarchy up to a new virulence of media scrutiny and removed any remaining deferential immunity they held to public intrusion. Perhaps unsurprisingly, the film was retracted from public view in 1972 and has not been seen in full since.

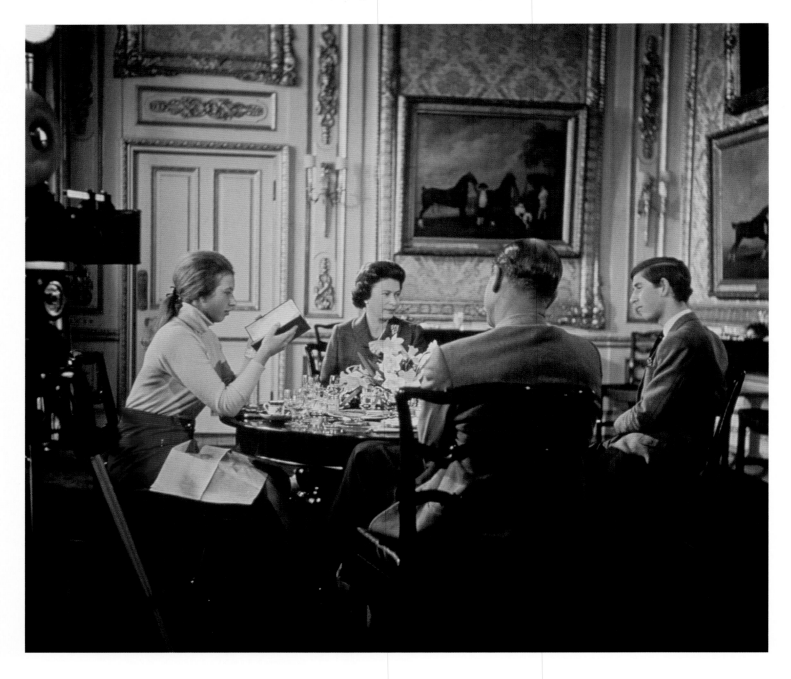

Princess Anne, 1973

**Norman Parkinson
(1913–1990)**

After finishing school, Princess Anne chose not to go to university but instead to become a working member of the Royal Family. During the 1970s a series of commissions from notable photographers helped to acquaint the British public with their new royal representative and transformed the Princess's image from gauche teen to royal professional.

International tours to the USA and Africa as president of the charity Save the Children launched the Princess's royal work, and a series of magazine shoots established her as a modern style icon.

In 1970 she was photographed by her uncle Lord Snowdon for British *Vogue,* and in September 1971 she appeared as the magazine's cover girl in a shoot by Norman Parkinson to mark her twenty-first birthday on 15 August.

Anne was pictured in the gardens of Frogmore House on the Windsor Castle estate. A series of photographs showing her in flowing gowns and royal jewels against the gothic arches of a Frogmore outbuilding offered the archetypal picture of a princess, but it is perhaps the image shown here that best typifies Princess

Anne as the public knew her: unstuffy, energetic and a little wry. Sat in the driver's seat of her Reliant Scimitar GTE sports car and dressed casually in 'double denim', she presented a fresh image for a modern monarchy. Her reputation for sporting prowess over royal glamour was cemented less than a week after the issue was published when she became European Eventing champion at Burghley. She subsequently became the first royal to be named BBC Sports Personality of the Year, for 1971.

Queen Elizabeth II (centre), Prince Philip, Duke of Edinburgh (top) and Queen Elizabeth The Queen Mother (right) dancing a Scottish reel, September 1971

Lord Lichfield (1939–2005)

By the 1970s emerging photographer Patrick Lichfield was making a name for himself among artistic and aristocratic circles, thanks in part to his links with the Royal Family. His mother, Anne Bowes-Lyon (1917–1980), was a niece of Queen Elizabeth The Queen Mother and Lichfield a first cousin once removed of Queen Elizabeth II.

Lichfield's unusual proximity to the Royal Family, and his ability to capture what appeared to be spontaneous and informal moments, made his photographs some of the most relaxed and authentic to be released to the public during The Queen's reign.

In 1971 Lichfield was invited to photograph the family at Balmoral Castle for The Queen and the Duke of Edinburgh's silver wedding anniversary. '[T]he secret of candid photography', he said, 'is to Be Prepared.' Lichfield established 'which doors, which rooms, which lochs and woods and burns were particular favourites, reconnoitred the terrain for hidden obstacles and opportunities, and kept an eye firmly open to every changing nuance of the light'. His technical dexterity is demonstrated in this photograph, in which he uses a long exposure to capture the dancers in a split-second moment of stillness amid the lively frenzy of the Ghillies Ball.

TOP
Prince Philip, Duke of Edinburgh and Princess Anne, 1971

BOTTOM
Prince Charles, Prince of Wales and Lady Sarah Armstrong-Jones, September 1971

Lord Lichfield (1939–2005)

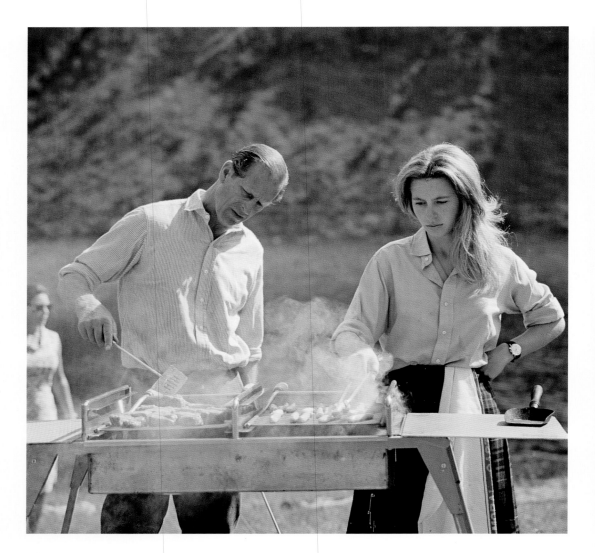

Lord Lichfield's close connection to the Royal Family meant that he was able to photograph even the most private of family occasions. The impression made by these images is almost that of an advertisement: glamorous, yet unstuffy and natural. Lichfield plays with light and shutter speed in order to photograph in the bright northern summer light of the Scottish Highlands.

In the top image, Prince Philip and Princess Anne are shown together at a barbecue, a favourite family pastime during their annual summer holidays. In the image to the right, Lichfield captures a touchingly intimate moment in which the Prince of Wales greets his young cousin Lady Sarah, whom he had not seen for some time. Lichfield called this shot 'an interesting example of reportage photography, in that the frame before and the frame immediately after were useless. In one she had not got close enough and [in] the other they had their arms around each other.'

The Royal Family at Balmoral Castle, 1971

Lord Lichfield (1939–2005)

During his stay at Balmoral, Lord Lichfield was asked to take the photograph for the following year's Christmas card. Since Henry Cole's invention of the Christmas card in 1843, the Royal Family have sent their own to family, friends and charitable or military colleagues and from the 1920s these have usually shown a relaxed family photograph, signed by the sitters.

Throughout history, the possession of a depiction of the sovereign has long denoted a loyalty to or friendship with the monarchy. In the twentieth and twenty-first centuries, the gesture of sharing a photograph perhaps not widely published elsewhere continues to reinforce a bond of friendship with the recipient and demonstrates the power of offering a seemingly privileged glimpse of the reigning family.

Despite the casual Scottish countryside clothing of Queen Elizabeth II and her family here, Lichfield used the Castle as a backdrop, subtly underpinning the modern informality of the sitters with a long-standing symbol of the British monarchy. 'Probably because it was all done so informally', he wrote, 'the result looks, I think, pleasantly relaxed and casual.'

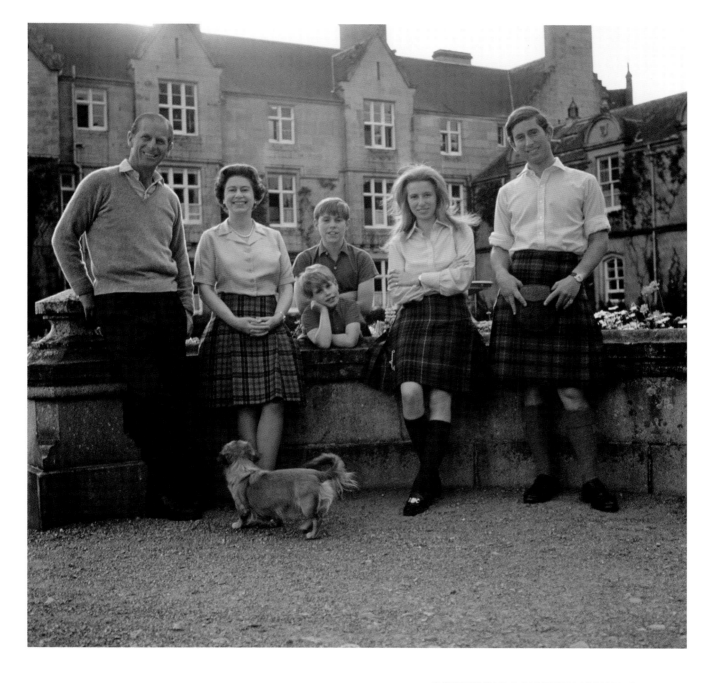

Lady Diana Spencer (later Princess of Wales) on her wedding day, with Queen Elizabeth II and bridesmaids, 29 July 1981

Lord Lichfield (1939–2005)

Lord Lichfield's relaxed style of photography was perhaps a surprising choice for the official photographs to mark the wedding in July 1981 of the Prince of Wales to Lady Diana Spencer (1961–1997), a highly choreographed royal spectacle. While the traditional wedding portraits were taken in the Throne Room at Buckingham Palace, Lichfield also captured many informal shots of the day. These included photographs of Princess Margaret and the Duchess of Gloucester returning from St Paul's Cathedral, and a view of the thronged Mall taken from behind the royal couple as they greeted the crowds from Buckingham Palace's balcony.

Perhaps one of the most compelling images of the day was this enchanting shot of the bride with her new mother-in-law and bridesmaids. Lichfield captured a fleeting moment in which Lady Diana comforted one of her bridesmaids before the bridal party's departure for St Paul's Cathedral. The photograph masterfully combines a sense of royal opulence, in the clouds of ivory taffeta and lace, and the cascades of flowers, with an informality and warmth rarely seen in royal wedding photographs. The photograph establishes the Princess's love of children and the charm of her informality, which so endeared her to the public.

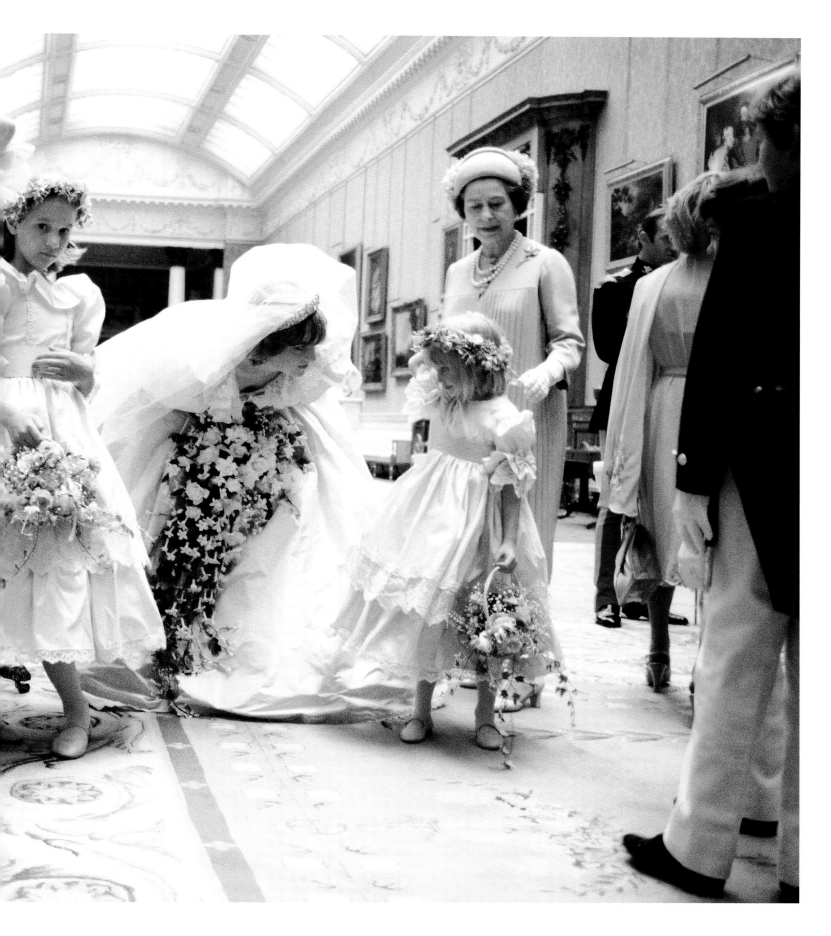

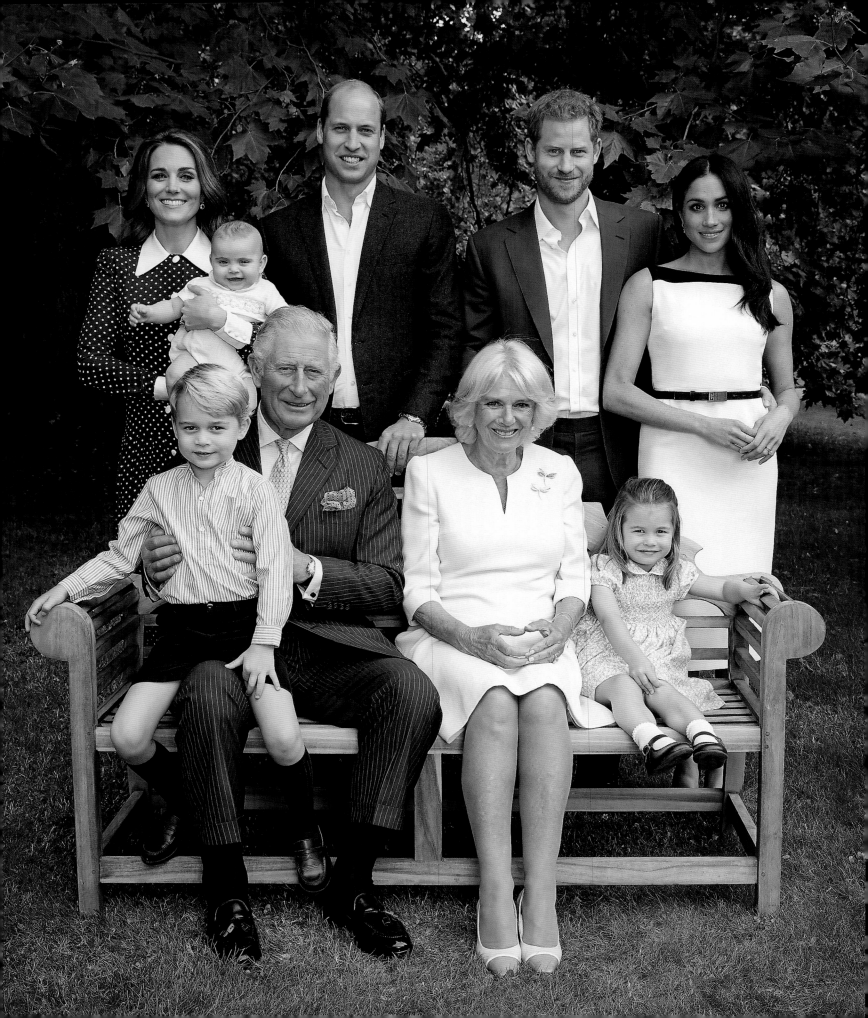

Tradition and Innovation

As a photographer documenting an historical family you are creating a record. You only need to look back at images of the Royal Family over the last hundred years to realize that the images we take today will be looked at in twenty years, thirty years, one hundred years; you are part of the process of creating historical record, and the imagery will live on.

CHRIS JACKSON, 18 FEBRUARY 2020

During the final decades of the twentieth century, the image of a relatable *family* presided over by an iconic matriarch has cemented its position as the central, winning dichotomy of the visual representation of monarchy in Britain. Photographs that celebrate the most important and universal family milestones have shown themselves to be the most popular and sought-after images of the Royal Family.

The proliferation of digital photography in the final decade of the previous century, and most notably since the first mass-market camera phones were released in 2000, has inaugurated a culture of sharing our everyday lives. The technology has provided the younger generation of the Royal Family with a promotional tool so powerful and so immediate that Victoria and Albert could not have imagined it in their wildest dreams, or possibly, nightmares. Royal embrace of the photo-sharing social media platform Instagram has in turn allowed them to recoup a degree of control over the selection and messaging around their image dissemination.

The Queen has now handed the mantle for promoting family values to younger generations whose prevailing aesthetic is one designed for mass consumption. The authenticity and spontaneity of photographs of Diana, Princess of Wales and her children, and the colourful and relaxed images the family continue to commission – often created by press photographers, such as Tim Graham and Chris Jackson – mark a break with the past.

It has been left to The Queen and her heir, Prince Charles, to concentrate on the commissioning of formal photographic portraits for posterity, and these have not been without flair and experimentation. Such cutting-edge photographers as Rankin, Chris Levine, Annie Leibovitz and Nadav Kander have created new and surprising images of a monarch sure of herself, her role and her popularity (see pages 165, 169, 170 and 171).

Prince Charles, Prince of Wales and his family, 5 September 2018; see page 182

Chris Jackson (b. 1980)

Diana, Princess of Wales, Prince William (centre) and Prince Harry at Kensington Palace, 4 October 1985

Tim Graham (b. 1948)

The marriage of the Prince and Princess of Wales in 1981 was quickly followed by the birth of two sons: Prince William the following year and Prince Harry in 1984. However, the couple could not escape persistent rumours of marital discord. In October 1985, the Prince and Princess agreed to their first televised interview since their engagement. This was widely reported as Buckingham Palace's attempt to end such rumours.

For forty-five minutes the couple were probed by ITN's Alastair Burnet on matters ranging from their wardrobe and diet to their relationship with each other and with members of the Royal Family. To accompany the programme, press photographer Tim Graham was invited to photograph the couple and their children over a series of months. Graham said of this shoot at Kensington Palace, 'I was struck … [by] how easy-going the Princess was about this intrusion into her privacy. To be photographed on public occasions is one thing but to have a camera follow you into your garden, your house, your sitting room … is quite another.'

Behind the camera, Charles played peek-a-boo in an attempt to capture his sons' amused attention. The photographs helped to dampen rumours, presenting to the public a young and seemingly contented couple, both clearly enthralled by their children.

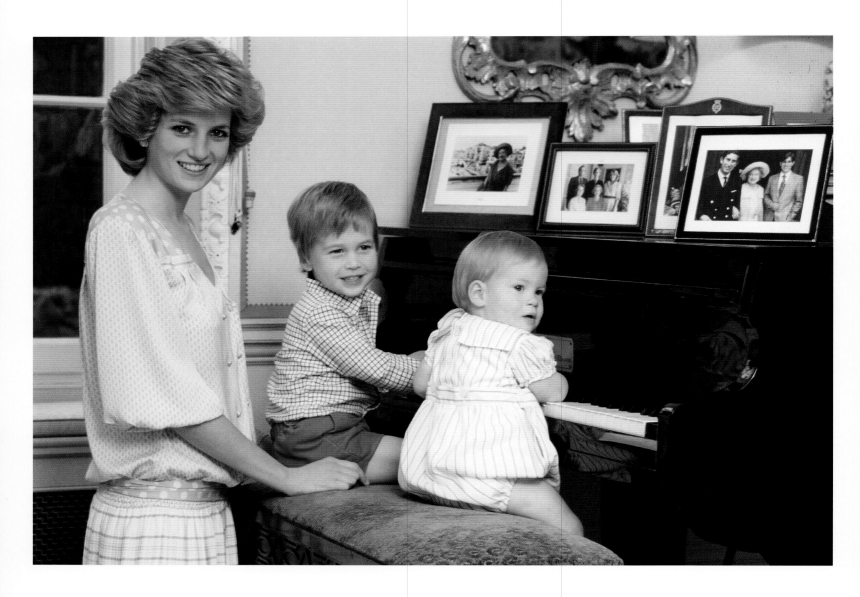

Prince Charles, Prince of Wales holding Prince Harry in his arms, and Diana, Princess of Wales with Prince William, Highgrove House, 1986

Tim Graham (b. 1948)

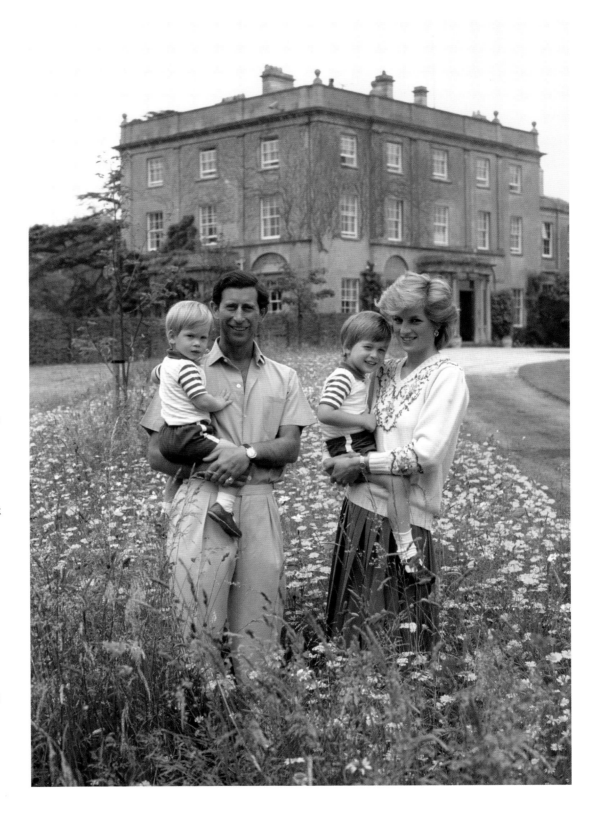

The Prince of Wales purchased Highgrove House in Gloucestershire in 1980, as a private family residence. The Georgian villa and its grounds would become a familiar backdrop for photographs of Charles, Diana and their sons throughout the 1980s as the younger generation took on the mantle for maintaining continuity and promoting the now well-established image of a 'family monarchy'.

Press photographer Tim Graham was commissioned to photograph the Wales family at Highgrove in July 1986. Having worked with Diana since she was nineteen, Graham had become a familiar and trusted figure and was increasingly commissioned for private as well as public sittings. His recollections of photoshoots at Highgrove suggest that the royal pair were at their most natural when photographed in their country retreat. This picture, taken in the wild flower meadow, was used on the family's Christmas card for that year. Graham remarked that 'The Princess understands the requirements of photography well … She was easy to work with.' The couple's relaxed informality when pictured with their young sons conveyed a new and refreshing sense of authenticity and warmth.

Diana, Princess of Wales with Prince Harry (left) and Prince William, 1994

John Swannell (b. 1946)

In 1994 British *Vogue*'s deputy fashion editor, Anna Harvey, a friend and fashion adviser to Princess Diana, asked the photographer John Swannell to photograph a friend who wanted a portrait of herself and her two sons for her Christmas cards. Fashion and portrait photographer Swannell, well known for his striking portraits of actors, musicians and politicians, was surprised, and presumably delighted, to discover that the friend was the Princess of Wales.

The atmosphere surrounding the sitting at the photographer's London studio was distinctly relaxed. While Diana was having make-up applied, Swannell occupied the Princes with a game of table tennis. The resulting photographs encapsulate the carefree feeling of the day and became some of the most recognizable of Diana as a mother, entirely at ease with her two sons.

Few images portraying such a genuine sense of informality and fun had been released since Marcus Adams's portrait of The Queen with a young Prince Charles and Princess Anne (see page 129). A more formal image was eventually chosen for the Princess's Christmas card, but the joyful out-takes were framed and hung in the dressing room of her Kensington Palace apartment.

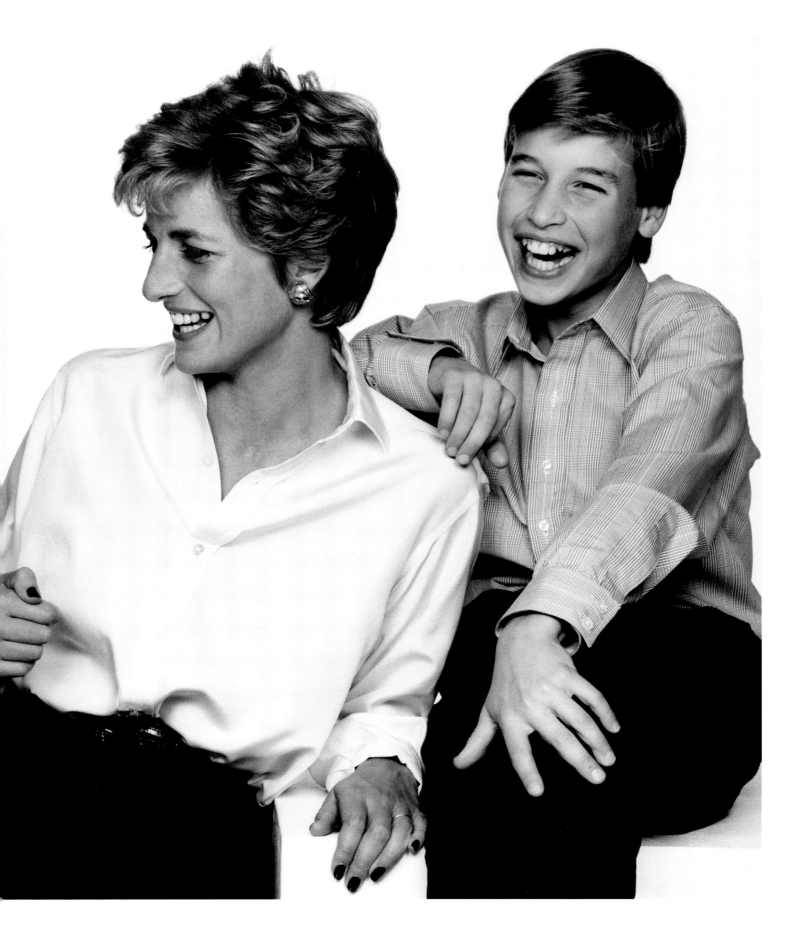

Diana, Princess of Wales, 1997
Mario Testino (b. 1954)

In 1997 Diana was photographed at Kensington Palace by the renowned Peruvian fashion and portrait photographer Mario Testino. The sitting was a commission for *Vanity Fair* magazine, and designed to publicize a charity auction of seventy-nine of the Princess of Wales's most iconic gowns. Diana modelled nine of the dresses for the shoot and is depicted here in a white silk crêpe gown by British-based designer and Diana's long-time collaborator, Catherine Walker (1945–2010).

After her divorce from the Prince of Wales in 1996, Diana was no longer required to carry out state visits. Acutely aware of the currency of her image and purportedly at the suggestion of her son Prince William, Diana decided to sell off part of her working wardrobe to raise money for charity. The auction, which took place at Christie's in New York on 25 June 1997, raised more than $3 million to support HIV/Aids and cancer charities. The sale was widely reported in the international press as a symbolic closing of the chapter on Diana's royal life, as she prepared to concentrate instead on her humanitarian work.

Testino's effortlessly stylish photographs were intended to show Diana in a new light. She wore little make-up and no jewellery. Instead, her natural beauty and charisma shone through, eclipsing even the couture gowns the photographs were commissioned to promote. Held five months before her death on 31 August, the sitting would be Diana's last official fashion shoot and the photographs would become the most iconic images of a woman who, at the time of their taking, Testino said, was 'happy, fresh and sure of herself'.

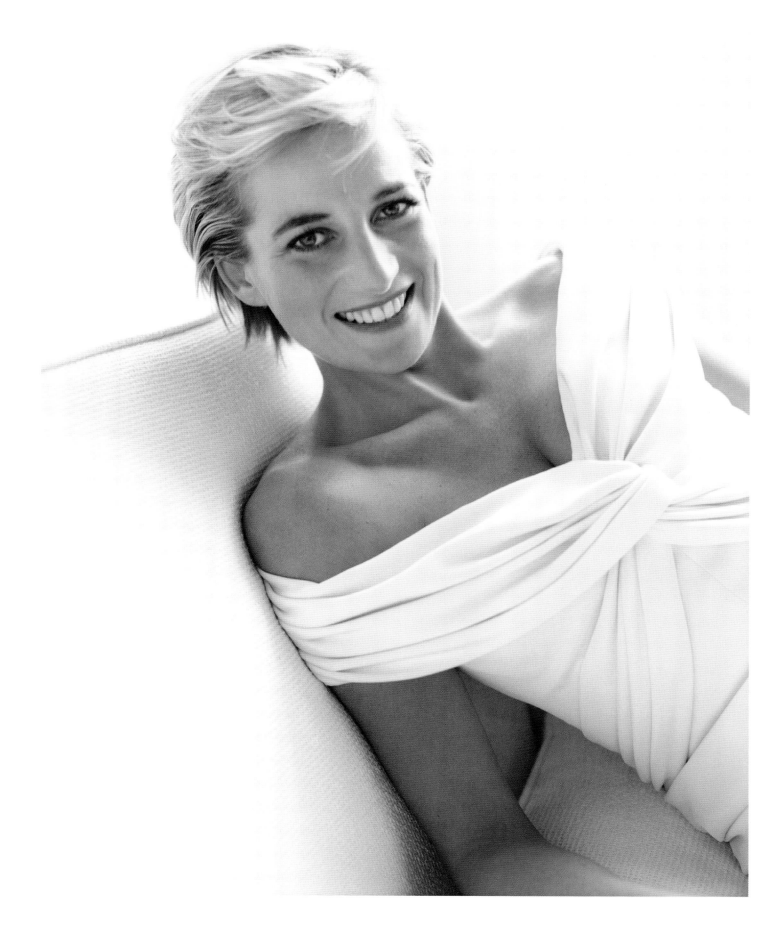

Queen Elizabeth II, 2001
Prince Andrew, Duke of York
(b. 1960)

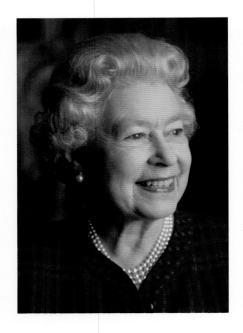

Like many members of the Royal Family past and present, Prince Andrew, Duke of York is a skilled amateur photographer. He took this series of candid portraits of his mother at Sandringham House, The Queen's private home in Norfolk, as part of a portfolio of photographs that was published in 2002 to mark the fiftieth anniversary of her accession.

The Golden Jubilee was a celebration of royal photography. The Duke of York featured among a stellar line-up of professional photographers from Britain and the Commonwealth, commissioned to photograph The Queen and the Duke of Edinburgh. Bryan Adams (born 1959), Polly Borland (born 1959), Julian Calder (born 1945), Anthony Crickmay (born 1937), Fiona Hanson (born 1959), Lord Lichfield, Rankin (see opposite), David Secombe (born 1962) and John Swannell all contributed photographs capturing different aspects of the monarch's public life.

The Duke of York's photographs, however, offer a privileged glimpse of a softer side to The Queen that only a trusted family member could capture. Also interested in the history and science of photography, the Duke has written that a photograph 'is one person's view at one instant in time', noting that 'It is the eye of the individual which makes art out of a simple record.'

Accompanying the portfolio was a series of previously unseen photographs of the Royal Family taken by Lord Snowdon during the 1950s, and for the first time Buckingham Palace gave permission for official photographs of The Queen to be made available online royalty-free for non-commercial use.

Queen Elizabeth II, December 2001
Rankin (b. 1966)

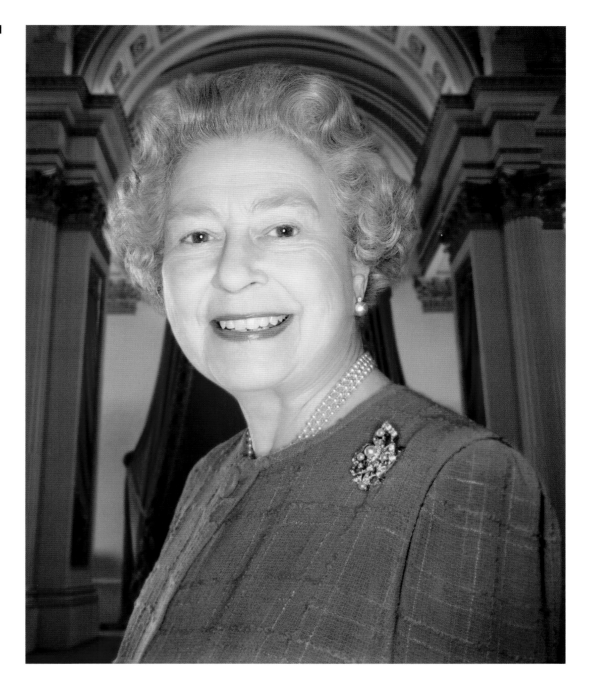

Perhaps the most surprising photograph produced for the Golden Jubilee portfolio in 2002 (see opposite) was Rankin's portrait of The Queen at Buckingham Palace. The British photographer and co-founder of pop culture magazine *Dazed & Confused* was an unexpected choice, which reflects both The Queen's ongoing patronage of British photography and continuing efforts to expand the Royal Collection with work by notable artists of the day.

Despite his initial reservations, Rankin found himself charmed by the monarch's profound sense of duty: 'Most people I photograph want to be famous and successful', he said. 'She had no choice. She was born into it.' He was equally surprised at her sense of humour: 'I saw her walking down this really long hallway with a footman who must have been two feet taller than her. They were both … chatting and laughing, and I was like, "Oh my god, she's human." ' It was this sentiment that Rankin wanted to capture in his photographs.

In this shot, The Queen is framed against a backdrop of the dais in the Buckingham Palace ballroom. The image is strong, modern and almost intrusively irreverent – a perfect example of Rankin's style, softened only slightly by a touch of deference afforded by the fact that the viewer looks up at the sovereign.

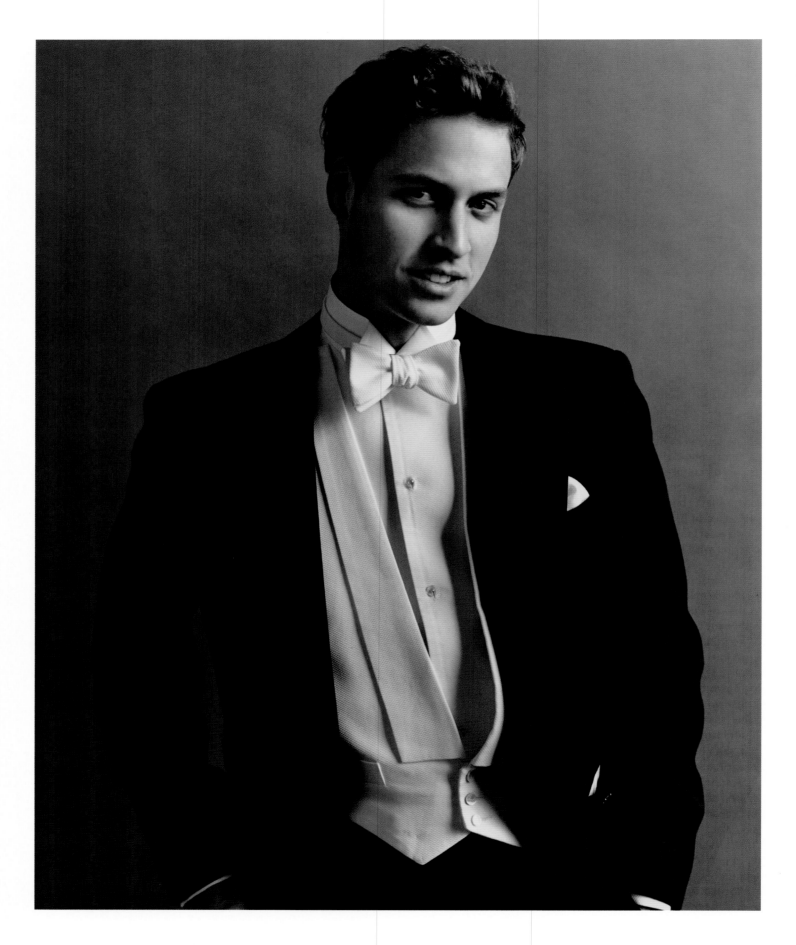

OPPOSITE
Prince William, 2003

BELOW
Prince Charles, Prince of Wales with Prince Harry (left) and Prince William, 2004

Mario Testino (b. 1954)

Since first photographing Diana, Princess of Wales in 1997 to great acclaim (see pages 162–63), Mario Testino has received frequent commissions from the Royal Household. In 2003 he was commissioned to photograph Prince William to mark his twenty-first birthday (opposite). This black-and-white portrait, striking in its simplicity and unashamedly suave, presented the second in line to the throne with all the glamour of a Hollywood movie star. The Prince is dressed in white tie but displays a relaxed nonchalance, and the portrait beautifully straddles the line between formality and informality.

The later image of the Prince of Wales and his sons (below) presents an openness and intimacy that is characteristic of Testino's work. Although similar photographs had been captured of the boys and their mother (see pages 160–61), this was among the first to show Prince Charles as a relaxed and hands-on father. Testino's skill for capturing energy and movement in his photographs imbues the royal sitters with an immediacy that has frequently served to invite the viewer into the action of a royal occasion, and has continued to evoke a subtle sense of inclusion and of the opening up of royal life. It is testament to the esteem in which he is held by the Royal Family that Testino has been commissioned to take official photographs of many royal occasions since.

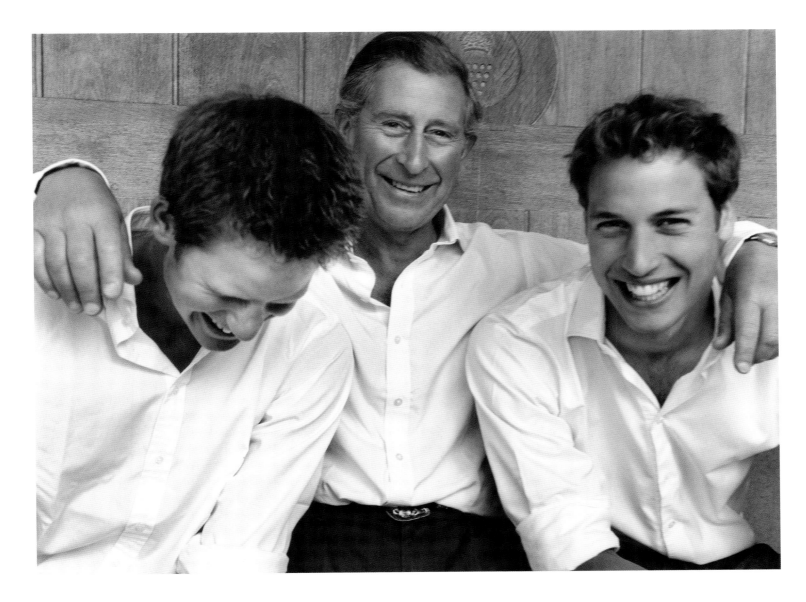

Queen Elizabeth II, 2004

Chris Levine (b. 1960)

In 2004 The Queen's likeness was portrayed in a holographic portrait for the first time, to mark 800 years since the island of Jersey pledged allegiance to the Crown. In order to create the three-dimensional image, light artist Chris Levine filled Windsor Castle's Yellow Drawing Room with three separate camera and laser set-ups to capture more than 10,000 images, across two sittings. One camera moved around the monarch on a circular track and each lengthy exposure lasted up to eight seconds.

Levine said of the sitting, 'I wanted to create something that had a certain power to it, that was iconic.' He had asked that she wear something 'really simple, beautifully elegant and regal but understated. I wanted one line of pearls not three, [and] simple diamond earrings; I chose a diadem that just had a simple cross on it.'

The effect created by a hologram cannot be replicated on paper, but the sitting also produced this unplanned image of The Queen resting her eyes between shots. The extraordinary portrait was released some years later. 'I wanted The Queen to feel peaceful', Levine said. 'This was a moment of stillness that just happened.'

As was the case with Victoria and Albert before her, The Queen's bold embrace of new photographic technologies has ensured that while monarchy remains a symbol of tradition and continuity, its image does not become outdated. Levine's mesmerizing portrait masterfully marries the endlessly competing dichotomies of royal image-making: between public figure and private individual, splendour and intimacy, tradition and innovation. Levine said, 'the technology, the medium itself was speaking. This was The Queen in the twenty-first century. Regardless of the content the language was modern.'

A version of the holographic portrait, known as 'Equanimity', was used on the cover of *Time* magazine in 2012 to mark The Queen's Diamond Jubilee but on its release the same year, this discovery from the same sitting, 'The Lightness of Being', became a global sensation.

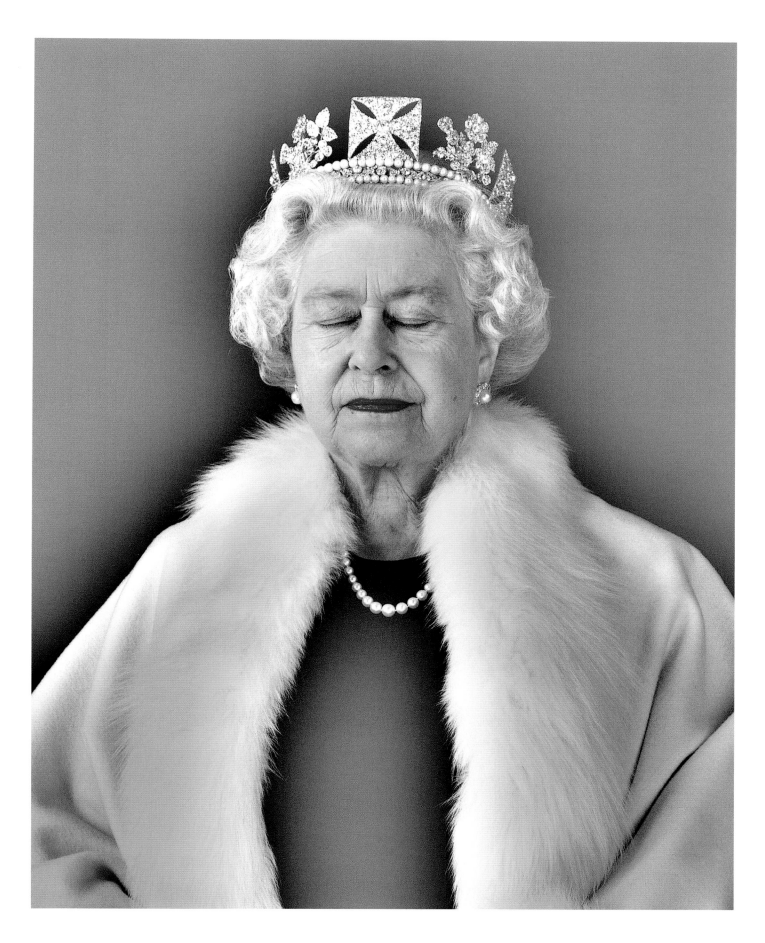

Queen Elizabeth II, 2007

Annie Leibovitz (b. 1949)

To celebrate The Queen's state visit to the United States of America in 2007, internationally renowned photographer Annie Leibovitz was invited to take a series of official portraits of The Queen. The commission was a considered diplomatic gesture, marking the first time an American photographer had taken an official state portrait of the monarch. Since the 1980s, The Queen has made increasingly interesting and varied choices in her formal photographic commissions, drawing on many of the leading photographers of the day to record her likeness for perpetuity and contributing innovative new pieces to the Royal Collection.

Leibovitz's return to a more traditional and stately portrayal of monarchy was greatly inspired by the opulent photographs of Cecil Beaton. Half a century on, however, her photographs felt fresh and 'new' against the context of the informal, documentary or starkly minimal photographs that characterized the intervening years. The photographer said of her approach, '[I] felt that because I was an American I had an advantage over every other photographer or painter who had made a portrait of [The Queen]. It was OK for me to be reverent.' Pictured in the White Drawing Room at Buckingham Palace, The Queen is resplendent in her Garter robes, orders and royal jewels. Leibovitz's masterful rendering of tradition with a contemporary edge proved so popular that she was commissioned for a second sitting with The Queen in 2016 (see pages 174–75 and 210).

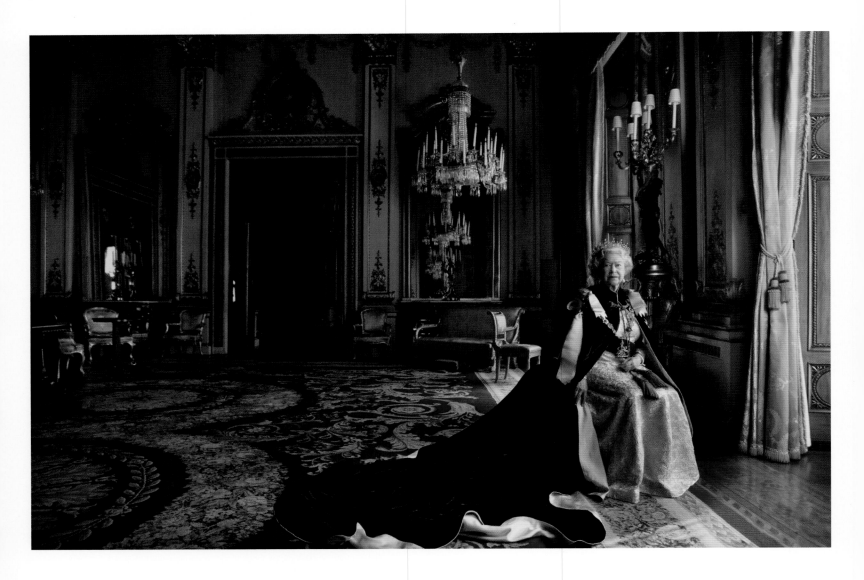

Prince Charles, Prince of Wales, 20 August 2013

Nadav Kander (b. 1961)

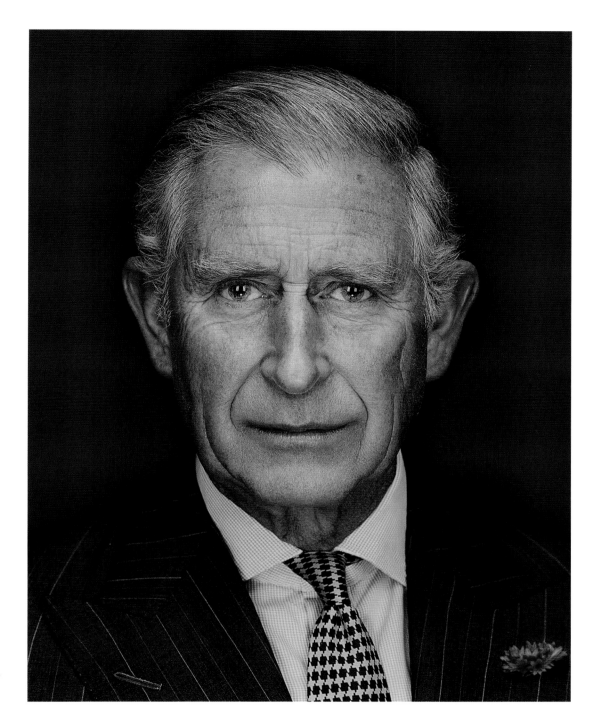

This arresting photograph was taken by Nadav Kander at the Prince of Wales's Scottish home, Birkhall on the Balmoral Estate. The bold, tightly cropped portrait appeared on the cover of *Time* magazine in November 2013 with the strapline 'The Forgotten Prince'.

Landscape and portrait photographer Kander's high-definition character studies have a striking rawness that is unusual in royal photographs. His work strives to reveal the individual behind the public persona, and he was aptly chosen to illustrate *Time*'s article aiming to show a new side to the Prince of Wales. At the age of eighty-seven, The Queen was beginning to scale back her work and her son was taking up the slack. Kander's astonishingly nuanced cover image served to invest a new solemnity and gravitas to Prince Charles's image, repositioning him in the public eye as a king-in-waiting.

Kander has said: 'I usually remove people from context so that the viewer can really become author'. Here, an almost intrusive sense of proximity is created by the Prince's expansive occupation of the frame, and the intensity of his gaze reveals both a dignified composure and a human vulnerability. Kander said of the shoot, 'I came into the shoot really respecting Prince Charles … I found [him] very generous with his emotions, very open.' Of his approach to photography he has said, 'I'm interested in the human condition … all that which lies behind our stereotypes, like an ever-present reminder that we are mere mortals.' His photograph of Charles is remarkable in its ability to evoke both a sense of pathos and the stoic majesty of a medieval or Tudor royal portraiture.

Prince William, Duke of Cambridge and Catherine, Duchess of Cambridge with Prince George of Cambridge and the family dogs, August 2013

Michael Middleton (b. 1949)

The Duke and Duchess of Cambridge broke with royal tradition when they chose not to commission a professional photographer to introduce the third in line to the throne to the public, instead releasing a photograph taken by the Duchess's father, Michael Middleton. The proud grandfather photographed the young family while they were staying at the Middleton family home, Bucklebury Manor in Berkshire, following the birth. Not since Lord Snowdon's photographs of a new-born David Linley in 1961 had a 'first photograph' for public release been taken by a family member.

Taken against the light, the photographs were criticized by some as lacking technical sophistication and widely praised by others for being uniquely relatable, family snapshots that could be of any young family. Although the composition was relatively formal, the pair's relaxed clothing, the dogs lounging in the dappled sunshine beside them and the knowledge that the Duchess's father is behind the lens offered the public a fresh and unusual glimpse of royal life 'behind the scenes'.

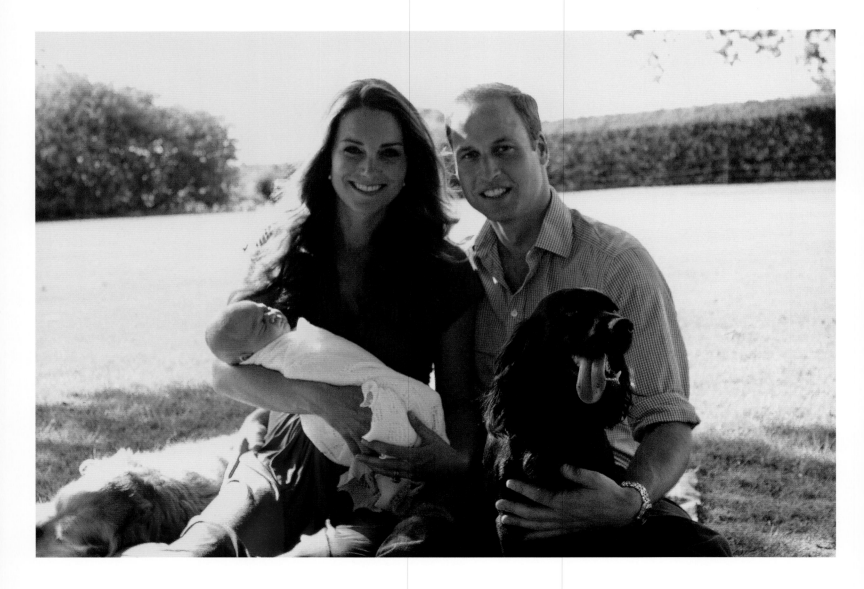

BELOW

Prince George of Cambridge and Princess Charlotte of Cambridge, May 2015

BELOW RIGHT

Princess Charlotte of Cambridge, May 2019

Catherine, Duchess of Cambridge (b. 1982)

The Duchess of Cambridge is a keen amateur photographer and has frequently dispensed with official photographs, choosing instead to mark important family occasions by releasing photographs she has taken herself. Such a personal approach has served as an effective means of satisfying public demand to share in royal milestones while allowing the family to retain a degree of privacy and control over the images' construction. Consequently, the photographs the Duchess has chosen for public release are imbued with a special charm thanks to their uniquely personal perspective: here, a mother's-eye-view of the heir to the throne and his new-born sister, the first of the Duchess's own to be released, and a daughter's comfort with her mother behind the lens, released to mark Charlotte's fourth birthday.

As well as being a keen practitioner, the Duchess is also an enthusiastic patron. Her patronage of the National Portrait Gallery was among the first she took on after her marriage in 2011, and she has since been involved in planning a touring exhibition of their Victorian image collection. Her photographs have been widely reproduced, and in 2017 her technical skills and role in encouraging amateur photography were acknowledged with a lifetime honorary membership of the Royal Photographic Society. Two years later, she also became the society's royal patron, taking up the mantle from The Queen.

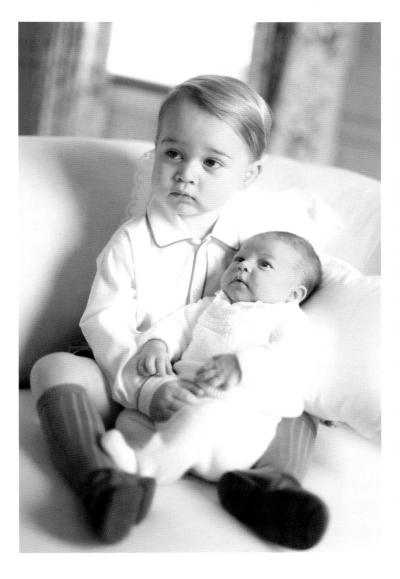

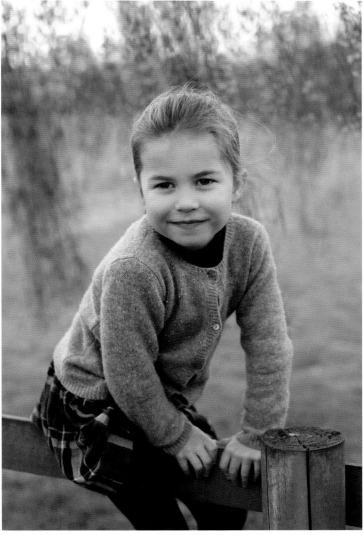

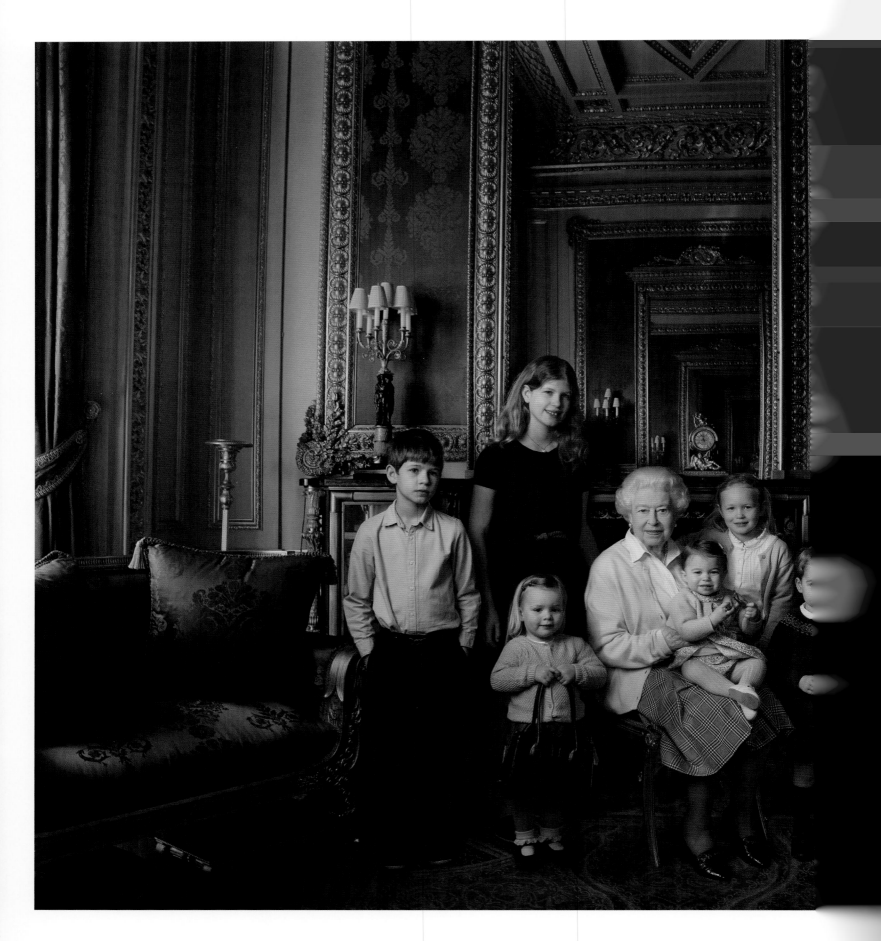

Queen Elizabeth II with some of her grandchildren and great-grandchildren: (left to right) James, Viscount Severn, Lady Louise Windsor, Mia Tindall, Princess Charlotte of Cambridge, Savannah Phillips, Prince George of Cambridge and Isla Phillips, 2016

Annie Leibovitz (b. 1949)

Annie Leibovitz's second sitting with The Queen in 2016 emphasized the monarch's role as royal, and by extension, national matriarch. This striking photograph of Queen Elizabeth II in the Green Drawing Room at Windsor Castle, surrounded by some of her grandchildren and great-grandchildren, expertly combines the winning formula of intimacy and splendour required of a modern monarchy.

As with Leibovitz's first portrait of The Queen (see page 170), the composition is rooted in tradition, in this case referencing a grand dynastic portrait by Laurits Regner Tuxen (1853–1927), *The Family of Queen Victoria in 1887*. Rather than being regal and imposing as her predecessor was, however, The Queen wears informal clothing, and appears warm and relaxed; only her surroundings denote her sovereign status. Although this is a contemporary rendering of the monarch, the choice of backdrop – a room often employed in royal portraiture – makes a visual reference to the reassuring continuity of monarchy. Similarly, the multi-generational grouping reinforces the stability of the family line, and in a lovely touch, two-year-old Mia Tindall, the eldest daughter of Zara Tindall (the daughter of Princess Anne and Mark Phillips; born 1981) holds her grandmother's iconic handbag.

Prince William, Duke of Cambridge and Catherine, Duchess of Cambridge with their children, Prince George of Cambridge (left), Princess Charlotte of Cambridge and Prince Louis of Cambridge, July 2018

Matthew Richard Holyoak (b. 1975)

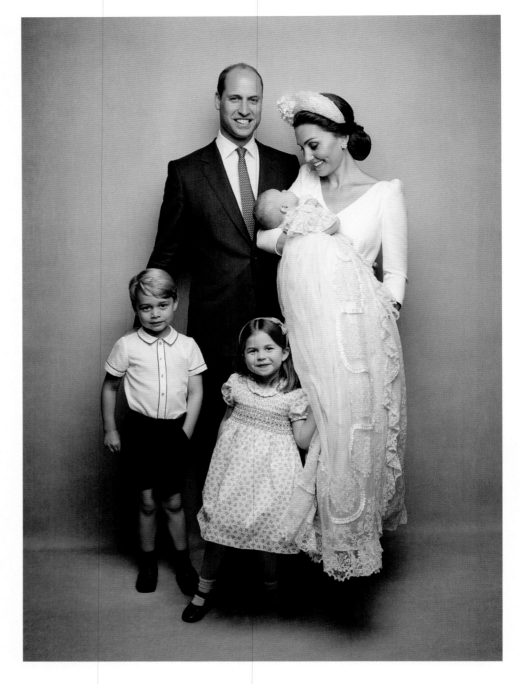

The christening of Prince Louis of Cambridge took place at the Chapel Royal, St James's Palace in London on 9 July 2018. To mark the first time the family of five were pictured together, the Duke and Duchess of Cambridge released four differently composed official portraits blending duty and modernity. Two followed the established formal conventions: the extended family group against a palatial backdrop, in this instance the Morning Room at Clarence House, the official London residence of the Prince of Wales

and Duchess of Cornwall. But the couple also decided to release a number of a decidedly more modern composition. A candid snapshot captures Prince Louis cradled in his mother's arms in the dappled sunshine of Clarence House's garden. The other, shown here, shows the Cambridge family, brightly lit against a plain backdrop.

Photographer Matthew Holyoak had photographed The Queen and the Duke of Edinburgh the previous year in a similarly minimalist composition to mark

their seventieth wedding anniversary. The choice of a grey backdrop for the christening shoot replicated that used the previous year, creating a subtle continuity in the visual representation of the monarch and her heirs. Although the photograph is contemporary in feel, a signifier of royal tradition remains in Prince Louis's christening gown, a precise replica of the Honiton lace gown originally commissioned by Queen Victoria for the christening of her first child in 1841 and worn by royal babies ever since.

Prince William, Duke of Cambridge and Catherine, Duchess of Cambridge with their children, Prince George of Cambridge (second from right), Princess Charlotte of Cambridge and Prince Louis of Cambridge, 2019

Matt Porteous (b. 1978)

Documentary photographer Matt Porteous has become a firm favourite in the Cambridge household. In 2018 he was commissioned to capture the family enjoying a garden created by the Duchess for the RHS Chelsea Flower Show to promote outdoor play, and the the christening of their third child, Prince Louis, alonside Matt Holyoak. Of the latter Porteous has said that, 'as with every photoshoot, I get to know my clients. I build trust and document what I'm observing. Nothing is staged, I just love to capture what's happening around me.'

Porteous's natural but elegant aesthetic was employed once again in 2019 to capture the family for their official Christmas card. Taken in the grounds of Anmer Hall, their Norfolk home, it reinforces the long-standing visual association between the countryside and informality – as seen across the generations in photographs of the Royal Family at Osborne House and Balmoral Castle (see, for example, pages 86–87 and 152–53).

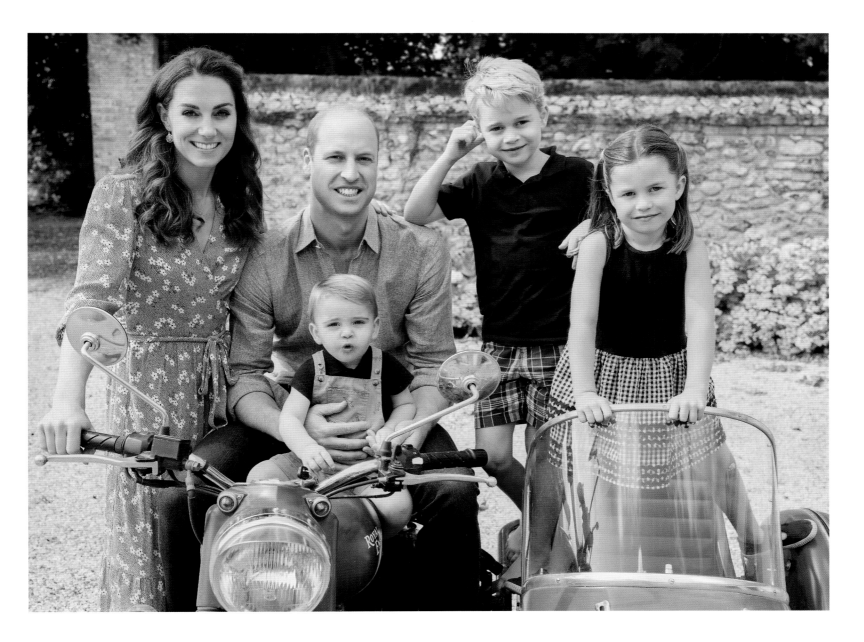

Prince Charles, Prince of Wales at Highgrove House, 19 July 2018
Chris Jackson (b. 1980)

To mark the Prince of Wales's seventieth birthday on 14 November 2018, royal photographer Chris Jackson was commissioned to record a year in the life of the heir apparent. The photographs released by the Prince of Wales's press office were designed to give a 'behind-the-scenes' look at his public and private life. Intimate family snapshots and photographs of the Prince performing his public duties were part of a year of festivities that placed Charles at the forefront of the Royal Family. He is seen here in a rare moment of quiet solitude in the gardens of his private residence, Highgrove House in Gloucestershire, surrounded by dispatch boxes and at work on his official papers.

The commission was one of a growing number by Jackson, whose fluid photo-documentary style has become the modern-day go-to for such informal royal portraits. The close working relationship between the press and portrait photographer and the Royal Family is a defining element of the modern relationship between monarchy, media and photography, and underpins the outward-looking approach of the British monarchy in the twenty-first century.

Prince Charles, Prince of Wales
and his family: (seated, from left)
Prince George of Cambridge,
Prince Charles, Prince of Wales,
Camilla, Duchess of Cornwall and
Princess Charlotte of Cambridge;
(back row, from left) Catherine,
Duchess of Cambridge, Prince
Louis of Cambridge, Prince William,
Duke of Cambridge, Prince Harry,
Duke of Sussex and Meghan, Duchess
of Sussex, 5 September 2018

Chris Jackson (b. 1980)

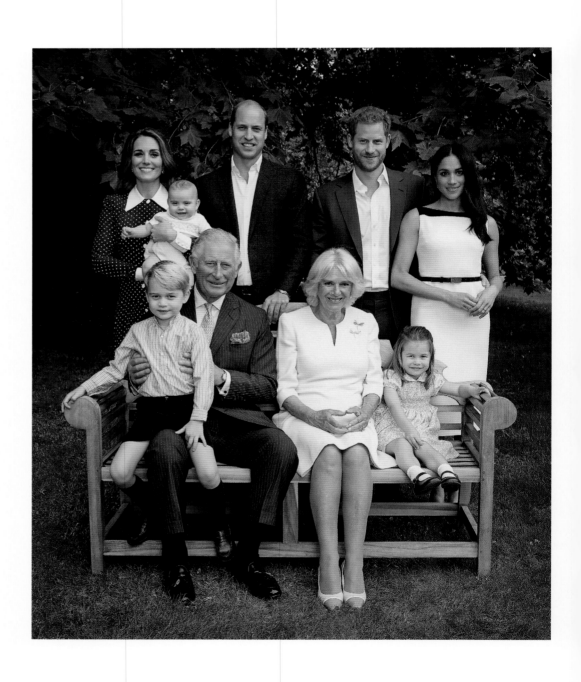

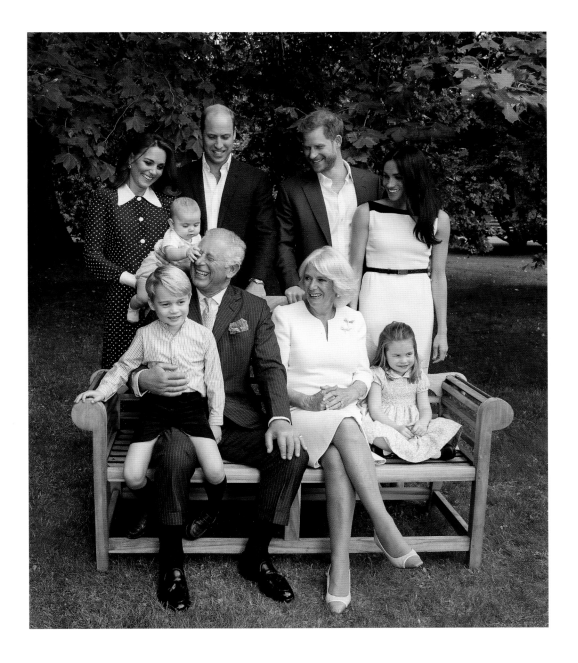

Here the Prince of Wales is pictured alongside his wife, the Duchess of Cornwall (born 1947), his sons and their families. The pairing of photographs, released for Charles's seventieth birthday, reflects a growing trend in royal image-making for publishing candid out-takes of official portraits; perhaps the earliest example of which was Lisa Sheridan's twin portraits of The Queen when Princess Elizabeth with her father and her sister, in the grounds of the Royal Lodge, Windsor, in 1946 (see page 114).

Although composed and somewhat formal, the photograph on the page opposite is a relaxed and happy composition showing the heir to the throne, so often seen in a more formal guise, as a tender and loving husband, father and grandfather at the centre of his family. This impression is greatly enhanced by the decision to release the light-hearted 'out-take' (left) alongside the more formal portrait.

Such an approach is in many respects a very straightforward response to the demands made on the modern royal image; it is required to be both dutiful and majestic, and at the same time warm and relatable. What underpins the two shots and has come to define royal image-making in the age of photography, is the vision of a multi-generational family and all the implications of virtue, stability and longevity encompassed within it.

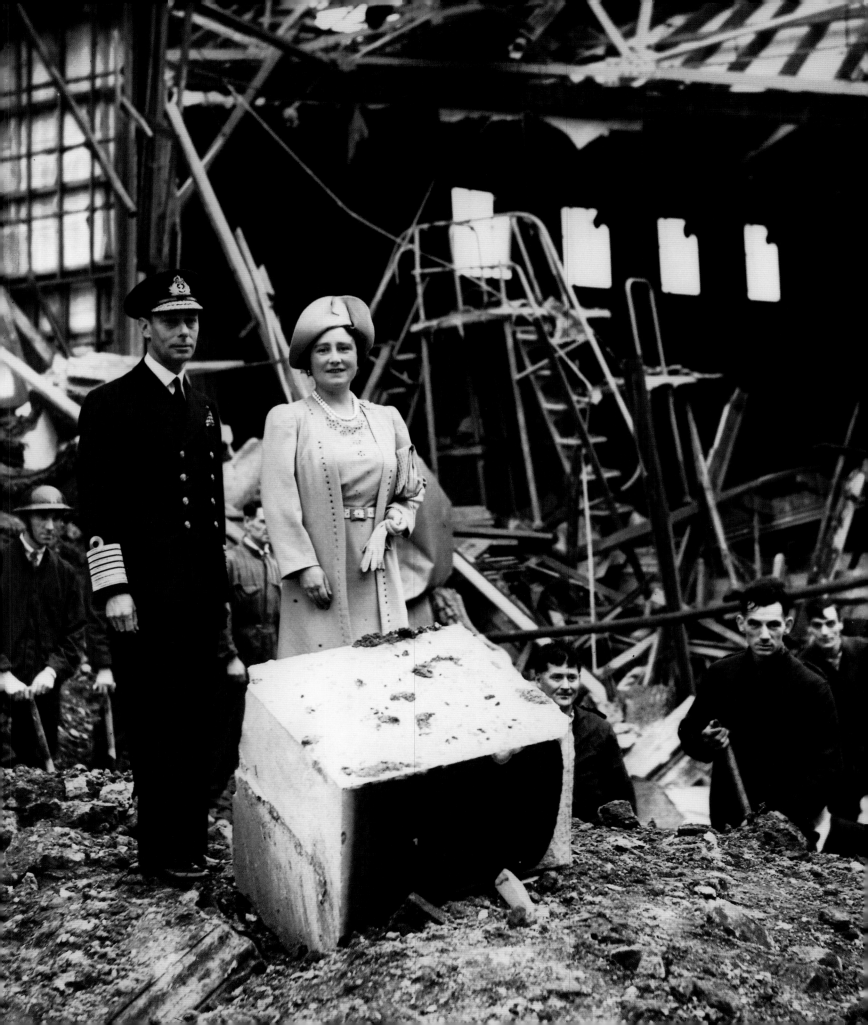

Monarchy and the Media

The flourishing of mass media over the course of the twentieth century has been both a blessing and a curse for the monarchy. Each successive reign has had to contend with a tide of new technological developments that have, on the one hand, created vital new avenues for public communication and, on the other, encroached on their private lives.

In the early twentieth century, photography became the main conduit for news. The flourishing of photojournalism during the interwar years, the proliferation of television from the 1950s and the tabloid and paparazzi revolution of the 1970s each initiated a new era of photographic surveillance, blurring the lines between public and private to satisfy popular demand.

In recent years, tighter legal controls around press photography and the growing popularity of social media channels, which enable the Royal Family to communicate directly with the public, have, to an extent, allowed the current generation to draw a line between public and private life. Instead, in an era of 360-degree surveillance in which much of the public is armed with a camera phone, focus has shifted to the creation of media 'moments', carefully planned into royal engagements so as to satisfy demand for visibility yet control the context and, as far as possible, the messaging.

Such media interest has without doubt underpinned the monarchy's continuation and popularity in Britain. The exposure of royal private lives has revealed them to be likeably human, but therefore, fallible. The media now has the capacity to enhance or diminish a royal reputation, but its speed and reach has also enabled the Royal Family to quickly adapt and recalibrate in the face of social change.

King George VI and Queen Elizabeth inspecting bomb damage at Buckingham Palace, 11 September 1940; see page 197

Photographer unknown

Queen Victoria, 1887
Charles Knight (active 1887–1909)

Until the end of the nineteenth century, when the development of halftone printing enabled low-cost mass reproduction of photographs in newspapers and magazines, royal spectacles were recorded by freelance commercial and documentary photographers who went to extraordinary lengths to capture candid shots of the Queen. These photographs could be sold for vast sums and were published in carte-de-visite or postcard form for widespread public consumption.

In 1887 evidence of the Queen's elusive smile reached the public with Charles Knight's shot of a beaming Victoria, published with the title 'Her Majesty's Gracious Smile'. The scarcity of such photographs has led to a widely held misconception that she was bad-tempered or depressive. But despite her undoubted grief after the death of Prince Albert in 1861, this was not always the case. Until the development of snapshot photography in the late 1880s, long exposure times led to straight-faced portraits. It was not until the final decades of Victoria's reign that more natural photographs were made possible, and they increasingly showed a joyful Queen during her public engagements. Her Golden Jubilee was met with rapturous enthusiasm by the British public, who by now had widely self-identified as the 'Victorians'. Knight's photograph was a reminder to the public that behind the increasingly haughty grandeur of Queen Victoria's formal photographic portraits, was an affable and affectionate woman who was, in fact, very often amused.

King George V and Queen Mary in India, at the Red Fort during the Delhi Durbar, 13 December 1911

Photographer unknown

By 1911, technical advances and the emergence of the press photographer meant that photographs were becoming an increasingly important conduit for news. The introduction of roll film freed photographers from the tripod, and increased shutter speeds produced more natural and spontaneous imagery, which was published alongside traditional photographic portraits.

In December 1911, despite a distinct dislike for being in the public eye, King George V became the only King-Emperor to attend the Delhi Durbar (or Delhi Court), a grand ceremony to mark the accession of a new Emperor or Empress of India. He and Queen Mary were accompanied by press photographers commissioned to record the spectacular festivities. This candid photograph capturing the couple in ceremonial dress, accompanied by local courtiers on the balcony of the Red Fort, shows the privileged vantage point granted to the photographer. The image gives an unusually intimate insight into the moment from the point of view of the monarch while also showing the vast spectacle taking place around him. The King's backward glance at the photographer suggests a comfort and perhaps a complicity in the creation of the image.

OPPOSITE
**Edward, Prince of Wales (later
King Edward VIII), 1917**

Speaight Ltd (active 1904–1940)

RIGHT
**Edward, Prince of Wales (later
King Edward VIII; right) with
the Grenadier Guards, 1914**

Photographer unknown

Edward, Prince of Wales, had just turned
twenty years old – the minimum age for
active service – when the First World
War took hold of Europe. He joined
the Grenadier Guards in June 1914 and
although he was keen to serve on the
front line, was initially forbidden from
going overseas by the Secretary of State
for War, Lord Kitchener (1850–1916).
Prevented from fighting, he was later
dispatched to the British Expeditionary
Forces General Headquarters in France
where he frequently visited the front
line, and then as a Staff Officer to the
XIVth Corps at the Somme where he
experienced trench warfare at first hand.

Edward's engagement with the war
was widely publicized in the international
press, particularly in France where
illustrated newspapers were increasingly
employing photographers to report on
the conflict. These photographs helped to
reinforce the monarchy's role as head of
the armed forces, clearly demonstrating
the Royal Family's support for and active
involvement in the British war effort,
and they situated the Prince among the
painfully young faces of the troops on
the ground. During a period in which
the position of monarchy in Europe was
fragile and the British monarchy was
striving to distance itself from its German
ties, they served an important role in
ensuring the young Prince's widespread
popularity as a patriotic figure.

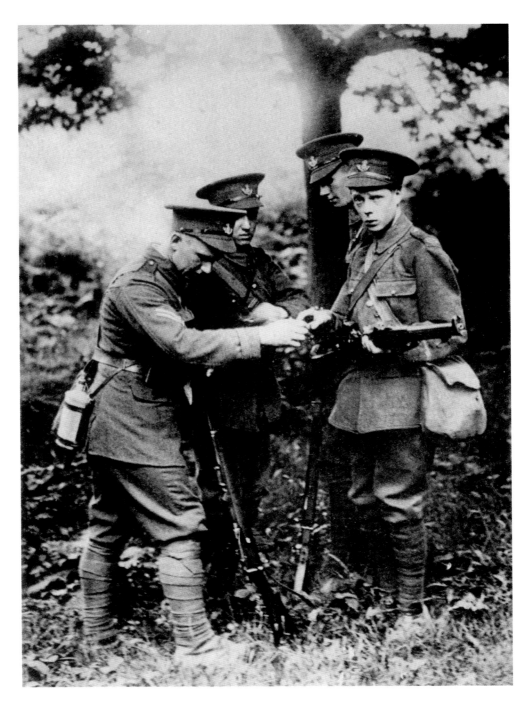

Queen Mary presenting a pipe and tobacco to an injured British soldier at the Royal Pavilion, Brighton, which had been converted into a hospital for wounded servicemen, 1918

Photographer unknown

BOTTOM

Queen Mary at a day nursery in Deptford, London, with children on a rocking horse, 1919

Photographer unknown

George V and Queen Mary made careful use of advancing photographic technology and a burgeoning photographic press to propagate an image of a modern working monarchy, which came into its own during the First World War.

Images of Queen Mary visiting hospitals, nurseries and other charities were widely circulated. These were not new additions to her schedule: she had been carrying out a variety of public duties since her marriage to Prince George in 1893. But war and the disintegration of the Russian and German monarchies ignited a renewed need for a demonstration of monarchy as a source of strength and stability. The increasing use of photographs in news reporting provided ample opportunities to ensure the King and Queen's work was widely circulated, and encouraged a surge of public engagements designed to be photographed.

Tender moments such as those depicted here could now be captured and distributed across the country. Such images served to reinforce the nurturing role of monarchy established by Queen Victoria and showed a warmer side to Queen Mary, helping to soften her sometimes rather cold public image.

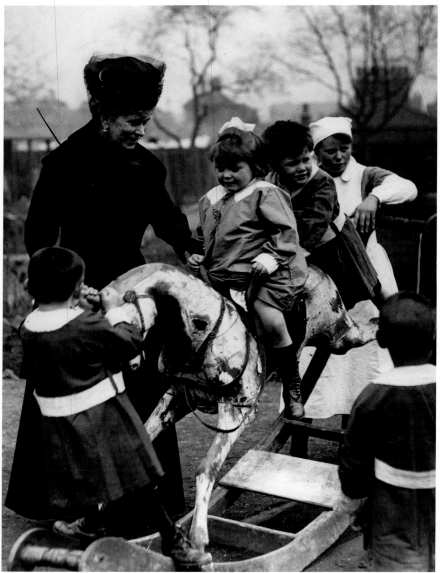

Edward, Prince of Wales (later King Edward VIII; second from the right) attending a British Legion Rally at the Crystal Palace, October 1922

Photographer unknown

The burgeoning public profile of the Prince of Wales earned Edward a reputation as one of the most popular members of the Royal Family during the 1920s. His busy apprenticeship of official engagements as heir to the throne, combined with his youth, good looks and controversial romances, gained him a position among the world of celebrity, which was flourishing thanks to a growing mass media.

In common with his parents, Edward embraced press photography, allowing the wide circulation and consumption of his image. But he proved a refreshing counter to his conservative parents and developed a bold and provocative sense of style inspired by a penchant for fine tailoring and exposure to American fashions. Thanks to widespread proliferation of his image, Edward was credited with popularizing monarchy among a younger generation, presenting a more relaxed image of the Royal Family and introducing new menswear trends in Britain, including the radical introduction of sportswear-to-city dress. Until the 1920s, tweed was commonly associated with leisure activities and worn only in the countryside; in the city it was considered inappropriate and out of place. The Prince, however, refused to conform to the strict sartorial rules of his social position. In this photograph he is captured attending a British Legion rally at the Crystal Palace in London. In stark contrast to the dark morning suits of the men around him, Edward stands out in one of his favoured Glen plaid suits.

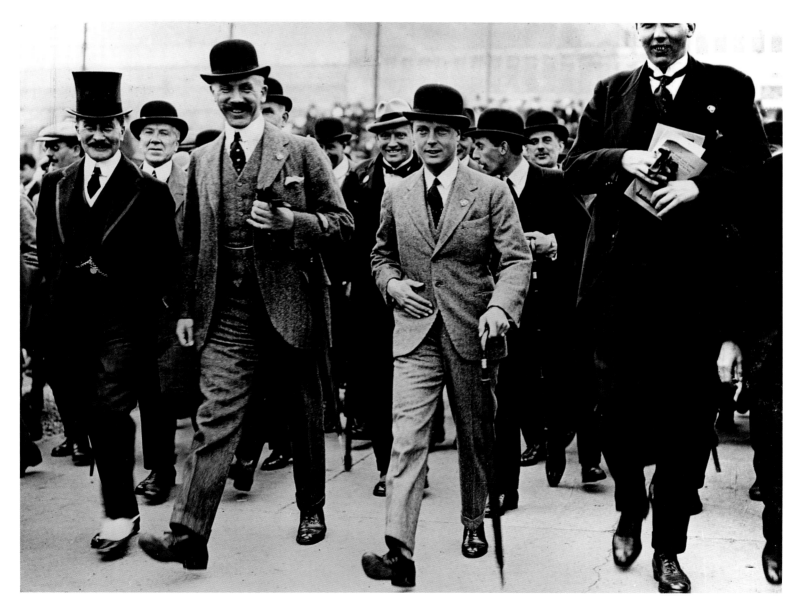

**'When The King Shot The Shooters',
1932**

BELOW
**The assembled press
photographers**

**Albert, Duke of York (later
King George VI) (1895–1952)**

OPPOSITE
**Albert, Duke of York (later
King George VI; far left)**

Photographer unknown

The interwar years witnessed the birth of modern photojournalism. As cameras became smaller, more discreet and able to produce high-quality photographs without the need for bulky equipment, so photographs became an integral part of news reportage. The Royal Family understood the need to cultivate a mutually beneficial relationship with the photographic press, but their increasing presence at royal engagements took some getting used to.

The Duke of York's initiative, Camps for Boys, proved particularly apt for a good picture story. Founded after the First World War, it was designed to bring together young men from all backgrounds through outdoor activities. The camps attracted significant media attention thanks to the Duke's own enthusiastic involvement. During a visit to the Southwold Boys' Camp in 1932, he demonstrated his ease with press photographers and his good-natured response to their growing prevalence. Rather than capturing a few choice moments, press photographers now began taking large numbers of photographs. An enthusiastic amateur photographer himself, the Duke usually brought his own camera to public events and decided to play the press at their own game. 'You fellows are always photographing me', he was reported to have said. 'Now I'll show you what it feels like. Line up!' He then joked, 'I'll just take one more – in case', teasingly referring to the photographers' usual line to him.

Images of the moment as well as the resulting photograph were published five years later in the souvenir book for the Duke's coronation as King George VI. The caption read 'When the King shot the shooters'. These photographs helped to establish an image of the new monarch as humorous, approachable and, importantly, media savvy.

Prince George, Duke of Kent, in *Tatler*, 22 November 1933

Photographer unknown

OPPOSITE
Princess Marina of Greece and Denmark, in *Vogue*, 28 November 1934

Horst P. Horst (1906–1999)

ANIMATED PHOTOGRAPHY

H.R.H. PRINCE GEORGE IN MANY MOODS

A series of delightful pictures, taken by the new and original Polyfoto process, of our charming and popular sailor-Prince, who shares with his brothers the very arduous duties of representing His Majesty the King on so many civic and social occasions. H.R.H. Prince George is thirty-one, and joined the Royal Navy in 1921 ; his present rank is that of a Lieutenant. H.R.H. will leave England on his tour of South Africa on January 19th, 1934, and he will be absent till the end of April

This is the first of a series of examples of this new and interesting form of photography by which we propose to illustrate other prominent personalities

Prince George, Duke of Kent and his glamorous fiancée, Princess Marina of Greece and Denmark, were among the first British royals to engage actively with the press in order to shape their public image. Until this point, interviews had been largely discouraged, and photocalls only rarely permitted. George and Marina agreed to a series of carefully chosen interviews and photo opportunities, and were the first royal couple to be photographed kissing in public, and also

the first to broadcast their wedding on the radio.

New printing methods meant that photography had established the younger generation of royals as part of the cult of celebrity, something which the Kents embraced. The fashionable pair captured the nation's imagination and in 1937 were dubbed 'the best-looking well-known young couple of to-day' by American *Vogue*.

The couple frequently featured in the pages of *Vogue*, *Harper's Bazaar* and *Tatler*;

in 1933 the Duke was the first to be photographed for a new feature in *Tatler* celebrating Polyfoto technology. The series, entitled 'Animated Photography', showed a dynamic display of well-known figures 'in different moods'. The following year, to mark the couple's highly anticipated wedding, British *Vogue* commissioned renowned German-American fashion photographer Horst P. Horst to make a series of portraits of Princess Marina in outfits from her fashionable trousseau.

A poster of Dorothy Wilding's photograph of Prince George, Duke of Kent and Princess Marina of Greece and Denmark about to be erected in preparation for the royal couple's wedding, 1934

Photographer unknown

In 1934 Prince George, Duke of Kent and his fiancée, Princess Marina of Greece and Denmark, sat for society photographer Dorothy Wilding. Wilding had previously photographed the Duke and, evidently satisfied with the results, he selected her relaxed and glamorous approach to mark his engagement. The shoot resulted in the most informal official photographs of a royal couple to date. Wilding's distinctive head-and-shoulder shots showed an emotionally expressive couple, closely composed and physically comfortable in each other's presence.

Prince George and Princess Marina gave their express permission for Wilding's photographs to be widely reproduced, helping to stem the trade in unofficial royal photographs and enabling them to better shape their public image. The photographs were printed on souvenir postcards, appeared on the cover of *Tatler* magazine, among others, in October 1934 and, as seen here, were even blown up into a poster erected above a shopfront in London's Theatreland. The widespread publication of these intimate shots of the Duke and his fiancée confirmed their celebrity status and established Wilding as a popular royal photographer for a new age. She went on to become one of King George VI and Queen Elizabeth's preferred photographers and in 1943 became the first female photographer to receive an official Royal Warrant.

Princess Marina, Duchess of Kent, sitting for a portrait by Philip Alexius de László, 1934

James Jarché (1890–1965)

As well as being widely photographed, Princess Marina regularly sat for leading painters of the day. In 1934 she was painted by the internationally famous portraitist Philip de László (1869–1937). This photograph captures her sitting with the artist and beautifully demonstrates the frisson between the disciplines of both photographic and painted portraiture.

The advent of photography in the nineteenth century had freed painting from the prosaic portrayal of realism, yet established conventions around royal portraiture continued to root the sitter within a long tradition of royal representation. Amid the growing ubiquity of photographic images of the Royal amily in the early twentieth century, painted portraiture continued to be a way of symbolizing the splendour, tradition and continuity of monarchy.

This photograph highlights the complementary but distinct potential of both media. While the painting, reminiscent of a depiction by Thomas Sully (1783–1872) of a newly crowned Queen Victoria in 1838, firmly establishes its sitter within a recognisably majestic tradition of royal image-making, the camera, in effect, can get behind the painting and offer a seemingly unmediated intimacy, which the painting alone cannot. De László had known Marina since her childhood, and the photograph was published to support the complimentary reviews of the painting as a very good likeness.

Edward, Prince of Wales (later King Edward VIII), 19 April 1935

Photographer unknown

The accession of Edward VIII on 20 January 1936 was greeted with widespread public enthusiasm, but his reign was short-lived: less than a year later he renounced his right to the throne. Edward had fallen in love with American socialite Mrs Wallis Simpson, but as head of the Church of England he was prevented from marrying a divorcee. His suggestion of a morganatic marriage – one in which Mrs Simpson and any children they may have together would receive neither his hereditary titles nor property – was rejected by Parliament for fear of undermining the carefully crafted image of the House of Windsor as the domestic ideal, and he was left with no choice but to either abdicate or reject her.

Gentlemanly conventions of secrecy between monarchy and media, which continued into the 1930s, meant that discussions were kept out of the British press until a week prior to the abdication, but internationally the affair was already being widely reported.

Edward abdicated on 10 December 1936. The following day the *News Chronicle* ran this image on its front cover, edited to remove the microphone. The photograph had in fact been taken the previous year, during a radio broadcast to mark his father's Silver Jubilee, but was widely published after the abdication in response to the King's broadcast to the nation. Photography had now become an essential tool of newspaper editors.

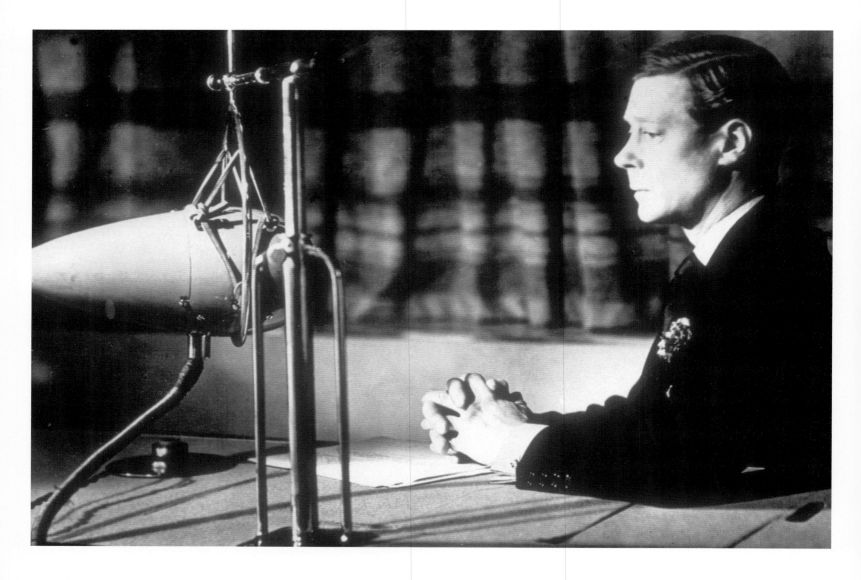

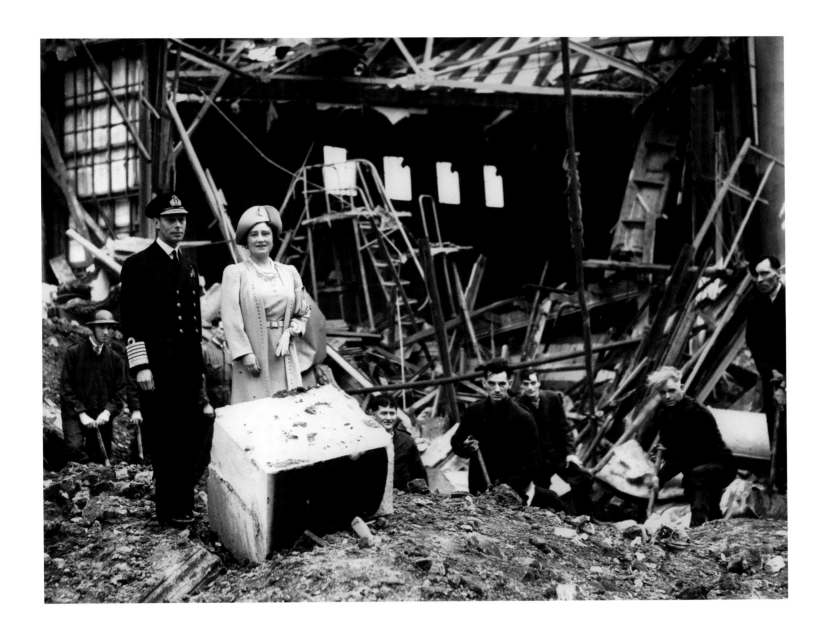

King George VI and Queen Elizabeth inspecting bomb damage at Buckingham Palace, 11 September 1940

Photographer unknown

During the Second World War King George VI and his consort, Queen Elizabeth, carefully shaped their image as wartime leaders on the home front, united with their subjects in the suffering and hardships of war. The couple were frequently pictured visiting bomb sites around the country and engaging with wartime activity with a greater intimacy and informality than had ever been seen before. Although this was a conscious effort to continue to promote the image of a dutiful, family monarchy established by his father, King George VI and Queen Elizabeth placed greater emphasis on promoting their 'ordinariness' to create a picture of a close bond with their subjects.

Buckingham Palace was bombed sixteen times during the Blitz, and the Queen is famously reported to have said of the bombing that she could now 'look the East End [of London] in the face'. In addition, the King and Queen's decision to send their children away to safety but remain living in London themselves was widely promoted as an example to other parents and a show of patriotism and public service.

Princess Elizabeth (later Queen Elizabeth II; foreground), April 1945

Photographer unknown

An expanding media played an important part in reinforcing the role of the Crown as head of both the armed forces and the nation during wartime. As in the First World War, photographs of the new generation of the Royal Family engaging in the war effort were widely circulated as part of a propaganda machine to boost morale and the war effort.

In October 1940 a fourteen-year-old Princess Elizabeth gave her first radio broadcast, in which she expressed sympathy for British children separated from their parents: 'My sister Margaret Rose and I feel so much for you as we know from experience what it means to be away from those we love most of all.'

The Princesses were photographed in uniform, working their allotments or sewing scarves for the troops. In 1945 Princess Elizabeth joined the Auxiliary Territorial Service as Second Subaltern Elizabeth, where a fellow recruit recalled: 'Her uniforms were better tailored than ours, and even her overalls were pressed and laundered every day.' A press call was organized to record her first day of training at the No. 1 Mechanical Training Centre in Camberley. The images released and the confidence the young Princess acquired would set her up well for her future role.

TOP
Princess Elizabeth (later Queen Elizabeth II) in her office at Buckingham Palace, 11 July 1946

Lisa Sheridan (1894–1966) for Studio Lisa

BOTTOM
Princess Elizabeth (later Queen Elizabeth II), 21 April 1947

Photographer unknown

In the aftermath of the Second World War and a continuing policy of austerity in Britain, a royal tour was organized to South Africa in 1947. The highly choreographed event created ample photo opportunities to reassert the British monarchy's place in a rapidly changing world, to continue to promote the image of a strong nuclear family and to bring the younger generation to centre stage.

The three-month tour culminated with Princess Elizabeth's twenty-first birthday, celebrated by a live broadcast from Government House in Cape Town, her greatest moment of public exposure to date (right). The broadcast and accompanying press photographs were designed to promote the queen-in-waiting and smooth the transition from old-world Empire to a new Commonwealth 'family' of nations with monarchy at its centre.

During her speech the Princess pledged, 'I declare before you all that my whole life whether it be long or short shall be devoted to your service and the service of our great imperial family to which we all belong.' Presented by the young Princess, the message spoke to a new, modern generation and reinforced the idea of a reigning family.

Queen Elizabeth II and Prince Philip, Duke of Edinburgh, on the front cover of *Picture Post*, **February 1954**

Photographer unknown

Within five months of Queen Elizabeth II's coronation on 2 June 1953, she and the Duke of Edinburgh set out on the most ambitious royal tour to date. Between November 1953 and March 1954 the pair visited ten Commonwealth nations. The gargantuan tour was designed to acquaint the new Queen with as many of her people as possible, and to capitalize on the rapid dissemination of mass media so as to promote her devotion to the Commonwealth.

The years following the Second World War were considered to be a golden age for press photography. Images could now be sent electronically from remote locations, almost instantaneously, creating a new style of reportage in which the photograph told the story rather than simply accompanying it. This demand for stories to be illustrated rather than narrated led to the establishment of several weekly magazines, which usually carried images of celebrities on their front covers to attract a wide readership. The American publication *Life* was established in 1936, followed in quick succession by *Picture Post* in the United Kingdom and *Paris Match* in France.

Featuring images of royal personalities in such publications proved mutually beneficial. For publishers, royal tours provided a wealth of exciting, exotic imagery, and editions carrying photographs of the royals on their covers were best-sellers. For the Royal Family they proved an invaluable means through which they could boost the monarchy's appeal to a broad audience.

Princess Margaret and Antony Armstrong-Jones on the front cover of *Life* magazine, March 1960

Photographer unknown

On 14 March 1960 Princess Margaret appeared on the cover of American magazine *Life*, to mark her engagement to photographer Antony Armstrong-Jones. The announcement three weeks before had caught the press off guard as the pair had been careful to keep their romance under wraps.

After the widely reported scandal of Margaret's ill-fated affair with Group Captain Peter Townsend in the 1950s, the Royal Family were keen to promote this new match. Armstrong-Jones was perhaps not an obvious choice for the Princess but in 1960, during a period in which the monarchy was on a campaign to democratize its image, this cover picture of the relaxed, happy pair, captioned 'Margaret and Tony at Windsor Lodge', could not have been more effective. Despite being an Etonian and the stepson of an earl, Armstrong-Jones was distinctly un-aristocratic and lent further weight to the monarchy's efforts to present a more modern image.

MARGARET AND TONY
AT WINDSOR LODGE

MARCH 14, 1960
AVERAGE WEEKLY CIRCULATION: 6,700,000

Queen Elizabeth II greets dancers at a state dinner in New Delhi, India, February 1961

Hank Walker (1921–1996)

Foreign tours have long been used by members of the government and the Royal Family as a means of 'soft power' diplomacy, a way of strengthening the bonds of friendship and business between two nations. After her first Commonwealth tour as monarch in 1953, The Queen announced in her Christmas broadcast: 'I want to show that the Crown is not merely an abstract symbol of our unity, but a personal and living bond between you and me.' Since then she has visited more than 120 countries in an official capacity, the most of any reigning monarch in the world, and as Head of the Commonwealth has made visits to all the member states.

In 1961 The Queen and the Duke of Edinburgh made a state visit to India and Pakistan, the first visit by a British monarch since the two countries had gained independence in 1947. The visit also marked fifty years since the Delhi Durbar of 1911 (see page 185), which saw The Queen's grandparents, George V and Queen Mary, crowned as Emperor and Empress of India. By the time of Queen Elizabeth II's visit, the photograph had become the central component of news stories, and the increasing institutional respect for photojournalism was leading to demand for beautiful as well as purely documentary photographs. Photographers from around the world covered the events of the royal tour, sending images to their respective news outlets.

Left to right: Lord Snowdon, American First Lady 'Lady Bird' Johnson, Princess Margaret and American President Lyndon B. Johnson at the White House, Washington, DC, 17 November 1965

Photographer unknown

In November 1965 Princess Margaret and Lord Snowdon visited the USA. What began as a private trip proved a valuable diplomatic opportunity to ease mounting political tensions between the two countries. Closely followed by the international press, the couple's whirlwind itinerary of parties with Hollywood stars was, however, seen by some as a misuse of public funding.

The tour culminated in a dinner-dance hosted by President and First Lady Johnson (1908–1973 and 1912–2007) at the presidential residence, the White House. The Princess and the President reportedly struck up an immediate rapport and he invited her to open the evening's dancing with him.

The following day the *New York Times* ran an unusually relaxed photograph on its cover, the two couples evidently in high spirits: 'Everybody was talking today about the brilliant party ... Margaret and her husband did not leave until 1:35 this morning.'

Despite its scandals, the tour imbued the seemingly outdated institution of monarchy with a sense of modernity and fun, and endeared Margaret to many Americans. By aligning monarchy so closely with celebrity and revealing the individuals behind the Crown, the couple helped to create a modern royal brand with a global appeal.

Prince Charles, Prince of Wales and Diana, Princess of Wales, 19 August 1981

John Shelley (b. 1932)

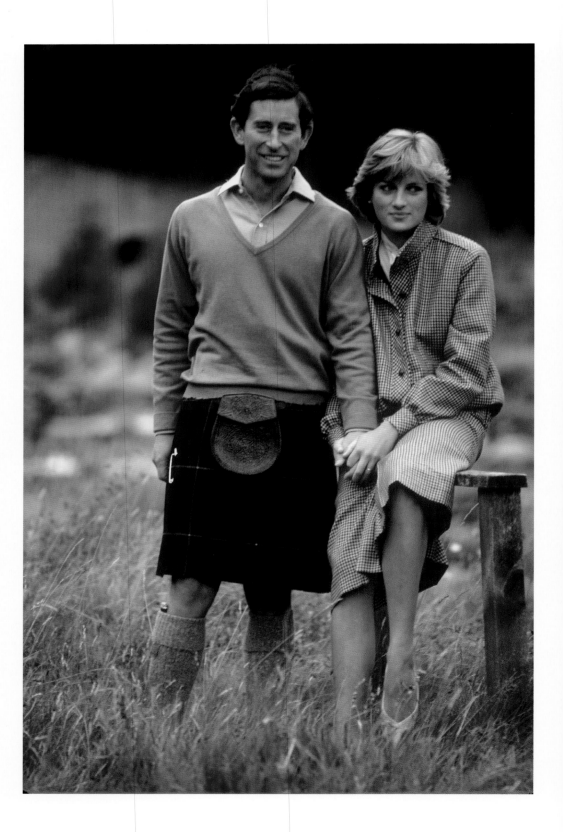

By the time of the marriage of the Prince and Princess of Wales in 1981, official royal wedding photographs had become a staple part of royal image-making, but the growth of the tabloid press from the late 1960s and growing interest in the private lives of public figures prompted another photocall during their honeymoon. This was also an attempt to deter uninvited intrusion and allow the newlyweds some period of privacy amid avid global interest, as had been the case with Queen Elizabeth II and Prince Philip, who posed for official photographs while on their honeymoon at Broadlands House, Hampshire, in 1947. The pre-arranged photocall during otherwise private family moments became a core part of the Prince and Princess of Wales's strategy for managing their relationship with the increasing encroachment of the tabloid press.

During their honeymoon, Charles and Diana posed for photographers in the grounds of Balmoral Castle. In contrast to the formality of official wedding photographs, the couple appeared relaxed and at ease in the Scottish countryside. Their casual, sporting attire was chosen to show an affinity with the outdoor life. In accordance with royal tradition, Charles was pictured in Scottish dress and Diana in a suit made of tweed, the conventional textile of British country dress, designed by Bill Pashley (1934–2014).

Diana, Princess of Wales and Ivan Cohen, 9 April 1987

Anwar Hussein (b. 1938)

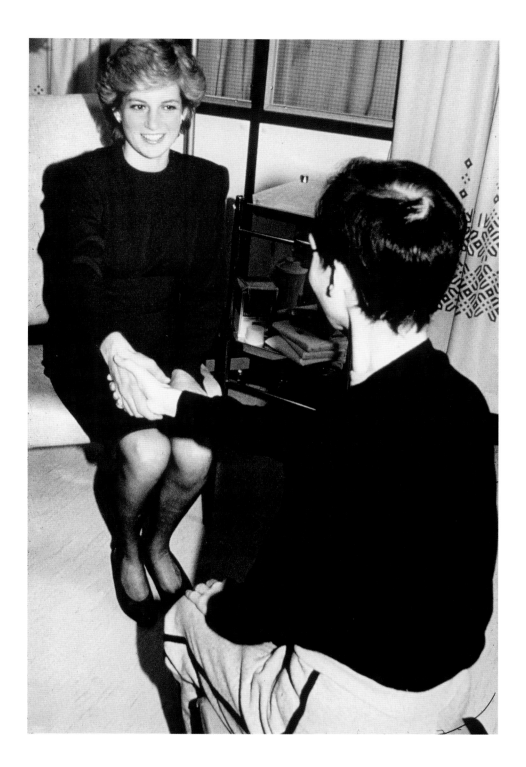

Following her marriage to the Prince of Wales, Diana began to carefully craft a position and a public image for herself as a devoted philanthropist and charitable patron. Faced with constant press surveillance, Diana quickly learned to use her public profile to draw attention to causes she believed in, developing a fine-tuned sensibility to the power of the static image to convey messages and inspire the public. One of her most potent tools of communication through photography was her careful use of clothing and gesture. When visiting hospitals or schools, she dressed in colourful clothes that conveyed approachability and warmth, and if meeting young children she always wore chunky accessories that they could play with.

In 1987 she visited the London Middlesex Hospital to open the first purpose-built HIV/Aids unit in Britain. Knowing that the event would be widely reported, the Princess requested to be photographed shaking hands with patient Ivan Cohen, who agreed on the condition that his back was to the camera. At the height of the epidemic, there was considerable fear surrounding the disease and sufferers were widely stigmatized.

In a break with royal protocol, Diana conspicuously removed her gloves in order to make direct contact with Cohen. The moment, captured on camera and widely circulated, had a profound impact on public attitudes towards the disease; by removing her glove, Diana challenged the widely held misapprehension that HIV/Aids could be transmitted through touch.

Prince Charles, Prince of Wales (facing the crowd of photographers) and Diana, Princess of Wales arriving at the Cannes Film Festival, France, 15 May 1987

Tim Graham (b. 1948)

By the 1980s the market for news photography was in decline, replaced instead by a voracious demand for photographs of celebrities and high-profile figures at public engagements and, increasingly, when going about their day-to-day lives.

The Princess of Wales's reputation as a style icon and a uniquely authentic royal figure attracted unprecedented interest, and the gargantuan apparatus of the mass media was mobilized to ensure that she was endlessly surveyed by the press. By the late 1980s, Diana was reputed to be the most photographed person in the world and the resulting images were pored over by a global audience.

Official royal engagements allowed the Prince and Princess of Wales to mediate the messaging of the moment through their choice of events, their clothing and their interaction with the public. In 1987 they were photographed walking the red carpet at the Cannes Film Festival, Diana in a Catherine Walker dress inspired by Grace Kelly's film *To Catch a Thief* (1955). The unusual angle of this shot by royal press photographer Tim Graham, who travelled with the royals on many of their international tours, reveals the intimidating scene frequently confronting royals and celebrities: a wall of press photographers, which Prince Charles has turned towards. Although these official engagements allowed Diana to maintain a public platform from which she could draw attention to charitable causes, she also found herself subject to invasive and often aggressive paparazzi scrutiny.

Diana, Princess of Wales in Angola, 5 January 1997

Tim Graham (b. 1948)

After her separation from the Prince of Wales in 1992, Diana focused her attention on her work as a philanthropist. No longer required to undertake royal duties, she instead used her considerable public profile to shine a spotlight on humanitarian and charitable issues. Despite unprecedented, and at times dangerous, levels of press intrusion into her personal life, Diana found ways of using the media interest to bring attention to under-represented causes.

In January 1997 Diana visited Angola to lend her support to a campaign against the use of landmines. During her visit she was photographed in protective clothing walking through a recently cleared minefield, and meeting adult and child amputees with anti-landmine charity the HALO Trust. The photographs were immediately disseminated through the international press, and Diana's advocacy for mine clearance brought the issue to global attention and contributed to international policy change.

Diana's son Prince Harry, the Duke of Sussex, continues to be a patron of the HALO Trust. In 2019 he made a similar trip, allowing almost identical photographs to be taken of himself walking through a cleared mine site in honour of his mother's work and reinforcing royal alignment to the cause through a visual continuity across two generations.

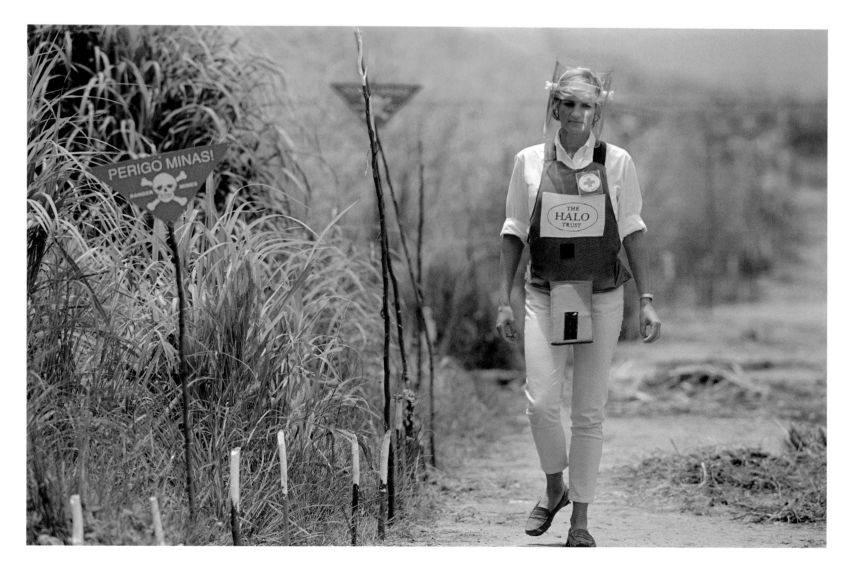

Queen Elizabeth II inspects Prince Harry's passing-out parade at the Royal Military Academy Sandhurst, 12 April 2006

Tim Graham (b. 1948)

The resurgence of grand royal and military spectacles in the twentieth century has created a wealth of opportunities for exciting royal photographs rooted in a long visual tradition linking monarchy and the military. Among the annual calendar of events is the Sovereign's Parade at the Royal Military Academy Sandhurst, in which the sovereign inspects the 'passing out' of the commissioning – or graduating – officer cadets.

Generations of British royals have served in the armed forces and both Prince William and Prince Harry trained at Sandhurst. Photographs such as this, of The Queen encountering her grandson Prince Harry during his passing out in

2006, beautifully encapsulate the marriage of the personal and the professional that underpins the most successful royal photographs. As The Queen moved past Prince Harry their faces lit up, giving the viewer a small insight into their bond as, momentarily, the façade slipped.

In the nineteenth century, there was public amazement at the notion that photography could capture more than the human eye could see. In the twenty-first century close photographic surveillance of such occasions allows a more personal insight to the spectacle, capturing intimate fleeting moments that once would have gone unnoticed and reveal the people behind the public persona.

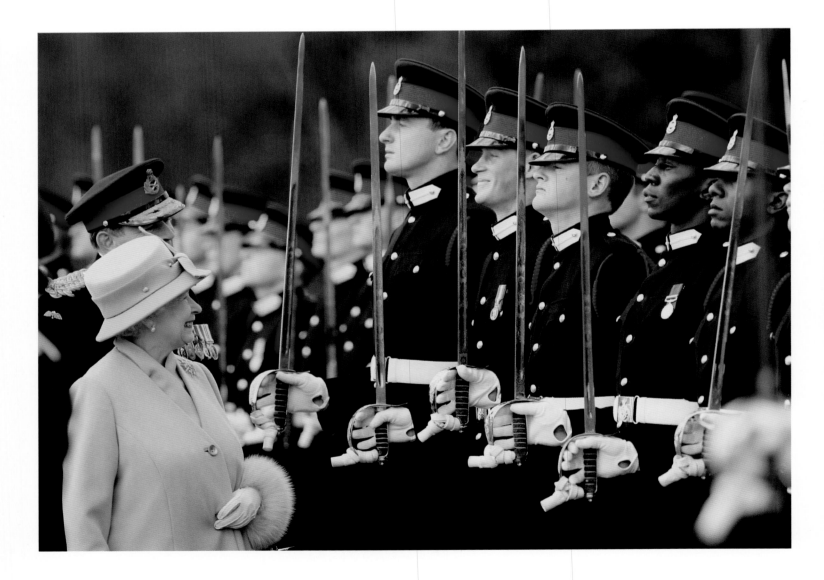

Prince William, Duke of Cambridge and Catherine, Duchess of Cambridge on their wedding day, 29 April 2011

Peter Macdiarmid (b. 1964)

The Buckingham Palace balcony photograph has now become a hallmark of the British royal image. The first balcony appearance was made by Queen Victoria in 1851 for the opening of the Great Exhibition, and to this day the balcony remains an important and iconic site from which monarchy can greet the masses in person and in print.

Victoria and Albert's decision to add a balcony here during their renovations of the palace in the 1840s demonstrated their acute understanding of the importance of the monarch's visibility. Their subsequent embrace of new photographic technologies helped to extend this visibility beyond the crowds assembled in London, to the nation and the world.

Today the annual calendar of royal events includes frequent appearances on the Palace balcony, from which the Royal Family can be captured by press and public en masse. Queen Victoria's eldest daughter, Victoria, was the first royal bride to greet the crowds that had assembled outside Buckingham Palace to celebrate her nuptials in 1858. Some 150 years later, in 2011, Prince William and Catherine Middleton did the same (below), but marked the modernity of the moment with not one but two kisses. The balcony, an emblem of royal image-making, has helped to establish a visual continuity from one reign and one generation to the next, providing a regular reminder to the public of the tradition and longevity of monarchy.

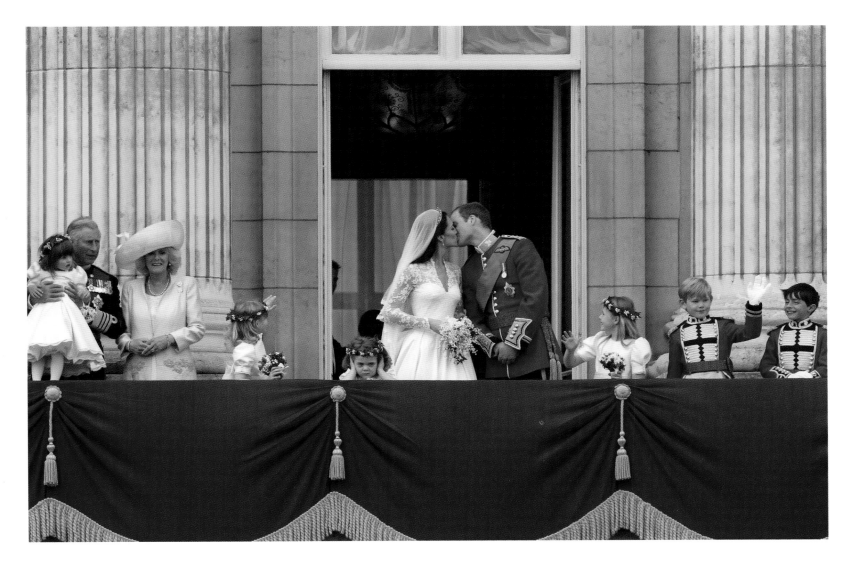

Following the success of her 2007 sitting (see page 170), Annie Leibovitz was invited to photograph The Queen again in 2016 for *Vanity Fair* to mark her ninetieth birthday. In a striking contrast to the stately portraits taken in 2007, this official sitting captured The Queen as a woman, wife and mother. 'The most moving, important thing about this shoot is that these were all her ideas', Leibovitz commented. 'She wanted to be photographed with her grandchildren and great-grandchildren; her husband, her daughter, and her corgis.'

In the resulting images, Leibovitz masterfully blended emblems of tradition and modernity. The location for the sitting was Windsor Castle, both a private retreat and an ancient symbol of the British monarchy. The Queen, Leibovitz observed, was noticeably more relaxed here and this is visible in the four images produced (see pages 174–75). The portrait chosen for the cover shows The Queen surrounded by her beloved clutch of corgis and dorgis. Although the image is a surprisingly informal depiction of the monarch herself for recent years, dogs have been a traditional emblem of royal portraits for centuries. The photograph also makes a lovely reference to Lisa Sheridan's portrait of a ten-year-old Princess Elizabeth cuddling her first corgi, Dookie, in 1936 (see page 101).

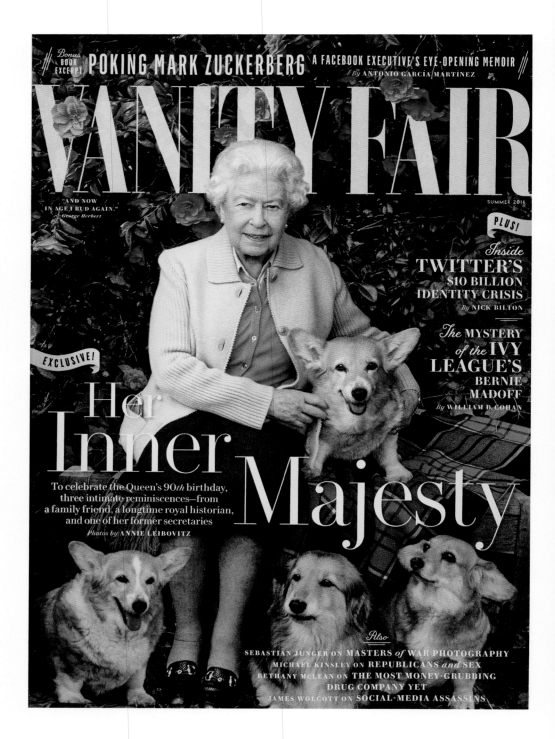

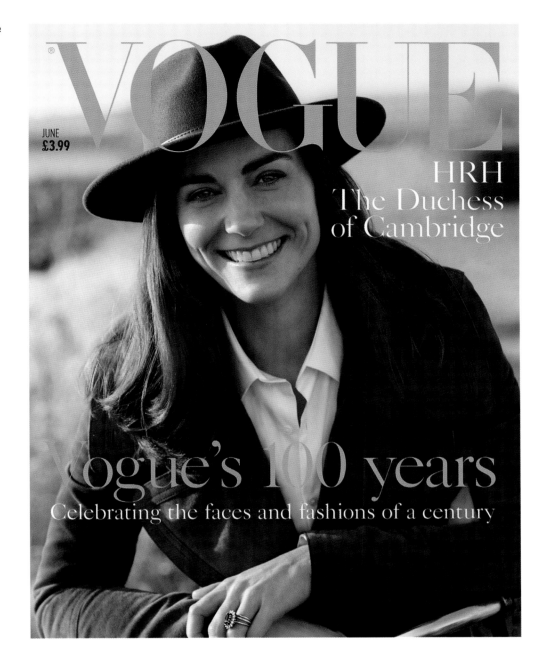

In a collaboration between British *Vogue* and London's National Portrait Gallery, the Duchess of Cambridge appeared on the cover of the centenary edition, celebrating British fashion, life and culture. The Duchess was the latest in a long line of royal women to appear on the cover of the magazine, but in a new departure, she requested that the portraits taken for the magazine be relaxed and informal, reflecting her private life away from the pomp and pageantry of royal engagements. The then editor-in-chief of British *Vogue*, Alexandra Shulman, wrote that the intention was to capture photographs of 'the woman herself rather than of a figurehead'.

The Duchess, patron of the National Portrait Gallery since 2012, had the final say over the choice of photographer and, according to Shulman, was keen to give the assignment to 'a British photographer for whom this would be a new opportunity'. The understated, natural elegance of Josh Olins's style was chosen for the commission, and one of the photographs was added to the National Portrait Gallery's collection.

Prince William, Duke of Cambridge on the front cover of _Attitude_ magazine, July 2016

Leigh Keily (b. 1982)

In July 2016 the Duke of Cambridge appeared on the cover of gay lifestyle magazine _Attitude_. The edition was marketed as 'Making history', and the cover image was released with a statement from the Prince that read: 'No one should be bullied for their sexuality or any other reason ... You should be proud of the person you are and you have nothing to be ashamed of.'

Although the Prince was not the first member of the Royal Family to have spoken out on controversial subjects (Princess Diana famously supported charities for HIV and Aids in the 1980s, see page 205), it marked the first time one of them had spoken out so publicly on LGBTQ+ issues. It was widely reported in the media as evidence of an 'evolving monarchy' representing the diversity of modern society and modelling itself as a moral exemplar of tolerance and unity.

The photographer Leigh Keily said of the sitting, 'My approach was to take a portrait that was really simple and showed William without any fancy tricks or lighting; nothing that detracted from showing him as a regular guy [who] cares about LGBT rights and has taken an active involvement in saying, "I am an ally".'

The Duke of Cambridge invited _Attitude_ magazine to bring members of the LGBTQ+ community to Kensington Palace to discuss mental health problems and bullying they experienced. In the same year, the Duke and Duchess of Cambridge signed the condolence book for members of the LGBTQ+ community murdered in a nightclub shooting in Orlando, USA.

From left: Prince William, Duke of Cambridge, Catherine, Duchess of Cambridge, Meghan Markle and Prince Harry, Sandringham, December 2017

Karen Anvil (b. 1978)

The new millennium brought with it a new photographic age. The first camera phone was launched in 2000 and it quickly became a ubiquitous feature of mobile phone technology, placing a camera into the pockets of much of the world's population. The result is that everyone can now be a press photographer.

On Christmas Day 2017 Karen Anvil, a member of the public, snapped the Duke and Duchess of Cambridge during their first public appearance alongside Prince Harry and his then fiancée,

Meghan Markle. Although seasoned press photographers were present outside the church in Sandringham, it was Anvil's opportune shot that caught the media's attention and it has since been purchased by major news outlets around the world.

The 360-degree surveillance created by camera phones has served to bring both monarchy's work and its public image to an ever broader audience, but it continues to pose challenges for royals, and others in the public eye, in negotiating the boundaries between public and private life.

Camilla, Duchess of Cornwall (centre left), Andrew Dalton (School Principal) and Raja Zarith Sofiah, Queen Consort of Johor, at the International School in ParkCity, Kuala Lumpur, Malaysia, 3 November 2017

Chris Jackson (b. 1980)

The need to be visible has always been integral to the successful continuation of monarchy, and international tours form an important part of the royal public relations strategy, ensuring that the British Royal Family are seen by and able to engage with as broad an audience as possible. Since the reign of King George V, the Royal Family have been accompanied on these tours by journalists and press photographers who document and report on their diplomatic and charitable work. In recent years Chris Jackson has become one of their most trusted and prolific press collaborators, thanks to his respectful, warm and informal approach to capturing the royals as people and professionals.

In 2017 the Prince of Wales and the Duchess of Cornwall undertook a ten-day tour of Singapore, Malaysia, Brunei and India. One of the Duchess's engagements in Malaysia was designed to promote The Queen's Commonwealth Essay Competition, an international contest aimed at encouraging children to write. The Duchess, who is a keen advocate for improving child literacy levels, visited the International School in ParkCity, Kuala Lumpur, to observe a writing workshop. This striking image shows the Duchess surrounded by the children in attendance and suggests the potential scale of the impact that such royal initiatives can have.

Prince Charles, Prince of Wales on the front cover of *GQ* magazine, October 2018

Matthew Brookes (b. 1971)

Celebrations surrounding the Prince of Wales's seventieth birthday in 2018 were carefully designed to reflect a period of transition taking place within the Royal Household (see pages 171, 179 and 180–81). In recent years Prince Charles has stepped increasingly to the fore, delivering a growing number of The Queen's official duties on her behalf and taking on a more prominent role in royal public relations. To mark his birthday in 2018, the Prince of Wales agreed to an interview and photoshoot for *GQ* magazine, who bestowed on him their lifetime achievement award for services to philanthropy. The Prince's Trust, which he founded in 1976 using his severance pay from the Royal Navy, has helped more than 950,000 young people turn their lives around.

Throughout the Prince of Wales's life, the media has created many public personas for him, from sensitive young schoolboy to 'Action Man' Prince of the 1970s, devoted father of the early 2000s and now passionate philanthropist, studious future monarch and doting grandfather. *GQ*'s October 2018 issue depicts nearly all of these versions of the Prince, to mark his birthday and to look to the future of monarchy under his reign.

Simplified Family Tree

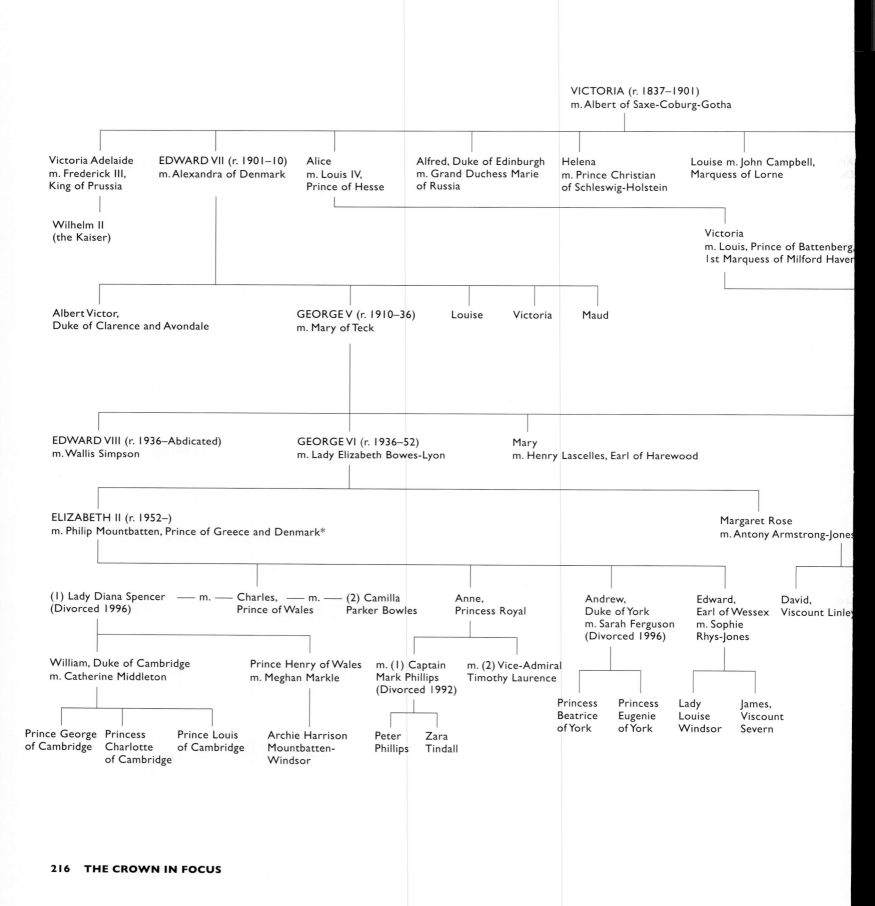

VICTORIA (r. 1837–1901)
m. Albert of Saxe-Coburg-Gotha

Victoria Adelaide
m. Frederick III,
King of Prussia

EDWARD VII (r. 1901–10)
m. Alexandra of Denmark

Alice
m. Louis IV,
Prince of Hesse

Alfred, Duke of Edinburgh
m. Grand Duchess Marie
of Russia

Helena
m. Prince Christian
of Schleswig-Holstein

Louise m. John Campbell,
Marquess of Lorne

Wilhelm II
(the Kaiser)

Victoria
m. Louis, Prince of Battenberg,
1st Marquess of Milford Haven

Albert Victor,
Duke of Clarence and Avondale

GEORGE V (r. 1910–36)
m. Mary of Teck

Louise Victoria Maud

EDWARD VIII (r. 1936–Abdicated)
m. Wallis Simpson

GEORGE VI (r. 1936–52)
m. Lady Elizabeth Bowes-Lyon

Mary
m. Henry Lascelles, Earl of Harewood

ELIZABETH II (r. 1952–)
m. Philip Mountbatten, Prince of Greece and Denmark*

Margaret Rose
m. Antony Armstrong-Jones

(1) Lady Diana Spencer
(Divorced 1996)
—— m. ——
Charles,
Prince of Wales
—— m. ——
(2) Camilla
Parker Bowles

Anne,
Princess Royal

Andrew,
Duke of York
m. Sarah Ferguson
(Divorced 1996)

Edward,
Earl of Wessex
m. Sophie
Rhys-Jones

David,
Viscount Linley

William, Duke of Cambridge
m. Catherine Middleton

Prince Henry of Wales
m. Meghan Markle

m. (1) Captain
Mark Phillips
(Divorced 1992)

m. (2) Vice-Admiral
Timothy Laurence

Prince George
of Cambridge

Princess
Charlotte
of Cambridge

Prince Louis
of Cambridge

Archie Harrison
Mountbatten-
Windsor

Peter
Phillips

Zara
Tindall

Princess
Beatrice
of York

Princess
Eugenie
of York

Lady
Louise
Windsor

James,
Viscount
Severn

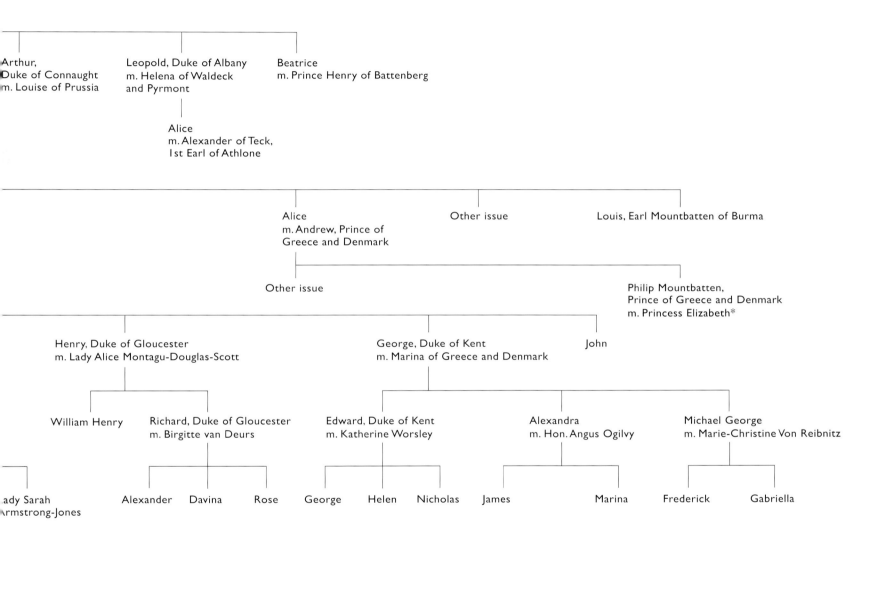

Arthur,
Duke of Connaught
m. Louise of Prussia

Leopold, Duke of Albany
m. Helena of Waldeck
and Pyrmont

Beatrice
m. Prince Henry of Battenberg

Alice
m. Alexander of Teck,
1st Earl of Athlone

Alice
m. Andrew, Prince of
Greece and Denmark

Other issue

Louis, Earl Mountbatten of Burma

Other issue

Philip Mountbatten,
Prince of Greece and Denmark
m. Princess Elizabeth*

Henry, Duke of Gloucester
m. Lady Alice Montagu-Douglas-Scott

George, Duke of Kent
m. Marina of Greece and Denmark

John

William Henry

Richard, Duke of Gloucester
m. Birgitte van Deurs

Edward, Duke of Kent
m. Katherine Worsley

Alexandra
m. Hon. Angus Ogilvy

Michael George
m. Marie-Christine Von Reibnitz

Lady Sarah
Armstrong-Jones

Alexander Davina Rose

George Helen Nicholas

James Marina

Frederick Gabriella

b. born
d. died
m. married
r. reigned
* see elsewhere on family tree

Glossary

Albumen print A type of photographic print made from paper coated with a layer of egg-white (albumen) and salt. The process was introduced in 1850 and was the most common type of print until the end of the nineteenth century.

Calotype An early process for making paper negatives, developed by William Henry Fox Talbot (1800–1877) in 1840.

Collodion (wet-plate collodion) process A technique for producing glass-plate negatives, developed by Frederick Scott Archer (1813–1857) in 1851. Unlike the calotype, collodion negatives gave a high degree of detail, and they would dominate photography for the next thirty years.

Contact sheet/print A photographic image produced directly from a negative. The negative is laid on to photographic paper and exposed to light, creating an image of the same size and allowing the whole film to be viewed on a single sheet.

Crop marks Markings made on an image to indicate where to trim it.

Daguerreotype The first reliable and commercial photographic process invented by Louis Daguerre (1787–1851) in 1839. The daguerreotype was a unique, positive image whose delicate nature meant that the plate had to be mounted behind protective glass.

Dry-plate process A major development in photography invented in 1871 by Richard Leach Maddox (1816–1902) and first marketed in the 1880s as an alternative to the collodion process. A glass plate could be coated in a gelatine emulsion of silver bromide and left to dry, allowing plates to be prepared in advance and making them easily portable.

Exposure The amount of light that reaches a light-sensitive surface. It is controlled through aperture, shutter speed and – in digital photography – ISO (the light sensitivity rating of a digital image).

Glass plate Prior to the invention of photographic film (paper in the mid-1880s, celluloid from the late 1880s), glass plates were used as a medium for capturing an image.

Halftone printing A printing process that breaks up an image into a series of dots so as to reproduce the full tonal range of a photograph.

Hand-colouring The process of adding coloured dyes to a black-and-white photograph by hand, generally to make it look more realistic.

Kodak Brownie This simple cardboard box camera designed by Frank Brownell (1859–1939) was introduced in 1900. It sold for $1 and was easy to use, leading to huge commercial success. The camera produced 2¼-inch pictures on roll film.

Kodak No. 1 A simple box camera using roll film, manufactured by the Eastman Kodak Company from 1889. The easy-to-use camera marked a significant development in amateur photography. It was pre-loaded with 100 exposures and the entire machine was sent back to Kodak for processing.

Monochrome A single colour, usually black-and-white, or varying tones of the same shade.

Negative A unique master image produced in a camera on glass or a sheet of chemical-coated plastic, from which multiple positives can be printed. It is the tonal inversion of a positive image: light areas appear dark and dark areas appear light.

Photocollage Photograph fragments that are assembled and mounted on a flat surface to make a new picture. Handwork techniques such as painting or drawing can also be added to the surface.

Photogravure A photomechanical printing process invented in 1879 for reproducing photographs in large quantities. The image is transferred from a photographic negative to a copper printing plate, then etched in and coated in ink ready for printing.

Reportage A photographic style, sometimes referred to as documentary photography, that captures a moment or event through a series of factual, accurate images, in a narrative way.

Roll film Photographic film with a protective and lightproof paper backing that is wound on to a spool.

Rotary press A printing press that prints on paper that passes between two rotating cylinders. Rotary presses are used mainly in high-speed operations, such as newspaper printing.

Stereoscope A device for viewing a pair of images, depicting left-eye and right-eye views of the same scene, in a single three-dimensional image.

Tableau/Tableau-vivant (plural tableaux/tableaux-vivants) A 'living picture' in which the subjects are arranged for visually pleasing or dramatic effect and appear oblivious to the existence of the viewer.

Acknowledgements

This publication accompanies a major photographic exhibition at Kensington Palace in London, *Life Through a Royal Lens*. Both the exhibition and the book are indebted to a great many individuals and institutions who have generously contributed their time and expertise.

My greatest thanks are due to the Royal Household for allowing me to reproduce photographs from the Royal Collection and elsewhere. I would like to acknowledge the gracious permissions of Her Majesty Queen Elizabeth II, TRH the Prince of Wales and the Duchess of Cornwall, TRH the Duke and Duchess of Cambridge, the Duke and Duchess of Sussex and HRH the Duke of York.

I am immensely grateful to colleagues at Royal Collection Trust, in particular Director Tim Knox and Curators of Royal Photographs Sophie Gordon, Helen Trompeteler and Alessandro Nasini, who have been enormously generous in support of the project, sharing their expertise and giving considerable advice and time. Karen Lawson, Picture Library Manager, has also been extremely helpful in supplying many of the publication's images.

Colleagues at the Victoria and Albert Museum were exceptionally helpful with the early research. Particular thanks must be given to Ella Ravilious, Curator of Word and Image, and Ruth Hibbard, Registrar, for guiding us to new and interesting material and responding to countless queries. At the National Portrait Gallery, Senior Curator of Photographs Magda Keaney, Curator Clare Freestone and Assistant Curator Georgia Atienza were very supportive and generous with their time.

I am also indebted to Matthew Butson and Melanie Llewellyn at Getty Images, Hulton Archive. Melanie has generously spent time and energy on the book's behalf and guided us through the archive's vast contents. Likewise, Iain Lewis and Penny Breia at the Lichfield Archive and Geoffrey Munn have been enormously helpful.

The scholarship of former Historic Royal Palaces (HRP) Trustee David Cannadine has long been a source of inspiration and we were delighted that he agreed to write the foreword to this publication.

Many of my colleagues within HRP have worked extremely hard to bring this book to publication in a very short time frame.

Firstly, my sincerest thanks must be given to the tireless work of contributing authors, curators Isabella Coraça, James Crawford-Smith and Matthew Storey. Their exceptional research, written contributions and hours of debate have enriched and made possible the publication, and I am enormously indebted to them.

I am very grateful to my HRP editors, Clare Murphy and Sarah Kilby, for their endless patience, and especially to Clare for championing the book. Annie Heron in the publishing team has been instrumental in the image sourcing and in diligently clearing all the copyright permissions.

Head of Collections Sebastian Edwards has been a thoughtful proofreader and a wise mentor, and I would like to thank him and the rest of the curatorial team at Kensington Palace, Emma Shepley and Aisha Tahir, for allowing me the time to write. I have also been expertly assisted by the talented researchers and writers Colleen Ross and Cecil Beaton specialist Julia Rea.

Sincerest thanks are also due to the team at Merrell Publishers, particularly Nicola Bailey and Marion Moisy for their beautiful design and careful edits and for bringing the book to publication.

This book has drawn on both primary source material and secondary literature. In particular, it is indebted to the scholarship of Frances Dimond, Roger Taylor, Susan Sontag, Sir Roy Strong, John Plunkett, David Cannadine, Susanna Brown, Sophie Gordon, Tarnya Cooper and Louise Stewart.

Finally, I would like to thank my family, who are an endless source of support, inspiration and encouragement.

Picture Credits

Abbreviations:
b = bottom; l = left;
r = right; t = top

Attitude Magazine/Leigh Keily: page 212;

HRH The Duchess of Cambridge: pages 18, 173;

Camera Press, London: pages 97, 129l (Marcus Adams), 138 (Cecil Beaton), 160-61 (John Swannell), 164 (HRH Prince Andrew, Duke of York), 176 (Matthew Richard Holyoak), 212 (Leigh Keily);

Condé Nast: Horst P. Horst, Vogue, © Condé Nast: page 193; Annie Leibovitz, Vanity Fair © Condé Nast: 210; © Josh Olins/Vogue © The Condé Nast Publications Limited: 211; © Matthew Brookes/GQ © The Condé Nast Publications Limited: 215;

Getty Images: back cover (Bob Thomas/Popperfoto), pages 8 (Bert Hardy/Stringer), 13t (Topical Press Agency), 14 (Lisa Sheridan for Studio Lisa), 16 (Lichfield), 17 (John Stillwell), 19 (Chris Jackson), 51 (Charles Clifford), 52 (Hughes & Mullins), 65, 69 (Keystone/France Gamma Keystone), 100, 101, 108, 109, 114, 122, 123 (Lisa Sheridan for Studio Lisa), 134 (Lichfield), 136 (Central Press), 137 (Hulton Archive), 140 (Central Press), 147 (Norman Parkinson), 148, 150-51, 152, 153, 154-55 (Lichfield), 156 (Chris Jackson), 158, 159 (Tim Graham), 172 (Michael Middleton), 178-79, 180, 181 (Chris Jackson), 182, 184 (Charles Knight), 187 (API), 188, 189 (Popperfoto), 190 (Albert, Duke of York), 191 (Print Collector), 194 (General Photographic Agency), 195 (James Jarché), 196, 197 (Print Collector), 198 (Popperfoto), 199t (Lisa Sheridan for Studio Lisa), 199b (Topical Press Agency), 200 (IPC Magazines/Picture Post), 202 (Hank Walker), 203, 204 (John Shelley), 205 (Anwar Hussein), 206, 207, 208 (Tim Graham), 209 (Peter Macdiarmid), 214 (Chris Jackson);

GoffPhotos.com: page 213;

© Historic Royal Palaces www.images.hrp.org. uk: pages 6, 13b, 90;

© Nadav Kander. Courtesy Flowers Gallery: page 171;

Annie Leibovitz: pages 170 (Trunk Archive), 174-75, 210 (© 2016 Annie Leibovitz);

© Chris Levine: page 169;

LIFE logo and cover design © 1960 The Picture Collection Inc. LIFE and the LIFE logo are registered trademarks of TI Gotham Inc., used under license: page 201;

© Magnum Photos (Philippe Halsman): page 133;

Mary Evans Picture Library: pages 98 (© Yevonde Portrait Archive/Mary Evans) 192;

© Geoffrey Munn: page: 79t;

© National Portrait Gallery, London: pages 49 (John Jabez Edwin Mayall), 57 (James Lafayette), 59 (Queen Alexandra), 75 (Dorothy Wilding © William Hustler and Georgina Hustler), 91 (Vandyk), 104l (Cecil Beaton), 113 (Maryon Parham), 115 (Dorothy Wilding © William Hustler and Georgina Hustler), 132 (Dorothy Wilding © William Hustler and Georgina Hustler), 186 (Speaight);

Norman Parkinson/Iconic Images: pages 141, 143, 149;

Matt Porteous at The Studio_M: page 177;

Rankin/Trunk Archive: page 165;

Royal Collection Trust © HM Queen Elizabeth II 2020: front cover, pages 2, 4, 10, 11, 12, 21, 22, 24, 25, 26, 27, 28, 29, 30, 31, 32, 33, 34, 35, 36, 37, 38, 39, 40, 41, 42, 44, 45, 46, 47, 48, 50, 53, 54, 55, 58, 60, 62, 63, 64, 66, 67, 68, 70, 71, 72, 73, 74, 76, 78, 79b, 80, 81, 82, 83, 84, 85, 86-87, 88, 92, 93, 94, 95 (All Rights Reserved), 96, 99, 107, 112 (All Rights Reserved), 116l, 120, 121, 129r (All Rights Reserved), 142t, 185;

© Mario Testino: pages 163, 166, 167;

The Times/News Licensing: page 201;

Victoria and Albert Museum, London: pages 15 (© Cecil Beaton), 56 (Lafayette), 102, 103, 104r, 105, 106, 110, 111, 116r, 117, 118, 119, 124t (© Cecil Beaton), 124b (Patrick Matthews), 125, 126, 127, 128 (© Cecil Beaton), 131, 139, 142b, 145 (© Cecil Beaton).

The publishers have made every effort to trace and contact copyright holders of the illustrations reproduced in this book; they will be happy to correct in subsequent editions any errors or omissions that are brought to their attention.

Index

Claudia Acott Williams is a Collections Curator at Historic Royal Palaces, specializing in royal, court and dress history from the eighteenth century to the present day. She is currently Curator of Kensington Palace, responsible for the presentation of the palace interiors and the displayed and stored collections, and curated the exhibition that this book accompanies. She is a contributing lecturer on the online course 'A History of Royal Fashion', and gives regular lectures on the royal palaces, their collections, and court and dress history at universities and special interest groups around the UK.

Professor Sir David Cannadine is a British author and historian. He is currently a Dodge Professor of History at Princeton University and a Visiting Professor of History at Oxford University. He is the author of fifteen books, and his interests range widely across the economic, social, political and cultural history of modern Britain and its empire, capitalism, collecting and philanthropy in nineteenth- and twentieth-century America, and the history of history. He is also the editor of the Oxford Dictionary of National Biography and President of the British Academy.

Isabella Coraça is a Dress Historian and Assistant Curator at Historic Royal Palaces, specializing in royal and court dress, eighteenth- to twentieth-century fashion and ethnic dress.

James Crawford-Smith is a journalist and Curatorial Assistant at Historic Royal Palaces, specializing in royal and court dress history.

Matthew Storey is a Collections Curator at Historic Royal Palaces, specializing in royal art, design and history from the sixteenth century to the present day.

First published 2020 by Merrell Publishers Limited, London and New York

Merrell Publishers Limited
70 Cowcross Street
London EC1M 6EJ

merrellpublishers.com

In association with

Historic Royal Palaces
Hampton Court Palace
Surrey KT8 9AU

hrp.org.uk

Published on the occasion of the exhibition *Life Through a Royal Lens*, held at Kensington Palace, London, May 2020 to January 2021.

British Library Cataloguing in Publication data:
A catalogue record for this book is available from the British Library.

ISBN 978-1-8589-4686-3 (hardcover edition)
ISBN 978-1-8589-4685-6 (softcover edition)

Produced by Merrell Publishers Limited
Designed by Nicola Bailey
Edited by Marion Moisy
Proofread by Victoria Richards
Indexed by Hilary Bird

Printed and bound in China

Jacket/cover front:
Queen Elizabeth II, Prince Charles and Princess Anne, Marcus Adams, 1954; see p. 129

Jacket/cover back:
Queen Elizabeth II, Bob Thomas (b. 1958), 1982

Page 2:
Queen Victoria, W. & D. Downey, 1893; see p. 64

Page 4:
Princess Margaret, Cecil Beaton, 1949; see p. 116

Page 21:
Queen Elizabeth II, Dorothy Wilding, 1952; see pp. 120–21